Mission Statement : **Graphis** is committed to presenting exceptional work in international Design, Advertising, Illustration & Photography

Published by **Graphis** Inc. | CEO & Creative Director: B. Martin Pedersen | Publishers: B. Martin Pedersen, Danielle B. Baker | Editor: Anna N. Carnick
GraphicDesigner: Yon Joo Choi | Support Staff: Rita Jones, Carla Miller | Interns: Joanna A. Guy, Eno Park, Jong Yoon Park, Meaghan E. Tirondola

Contents

OppositePage | Leslie Chan Design Co., Ltd.

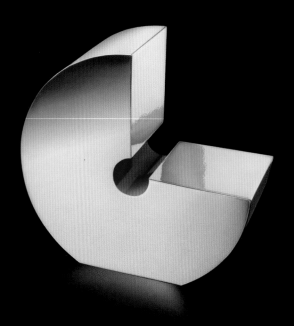

Since 1944, Graphis has been a beacon for outstanding work in the visual arts. With the introduction of the Annuals, each piece selected for inclusion was always considered an award winner. This year, we further recognize any piece included in the Annuals as a Gold Medal winner, and a limited few as Platinum Award winners, with accompanying certificates and awards. We congratulate and thank each and every one of our talented contributors for the amazing work we continue to see every year, and proudly present you with this year's winners.

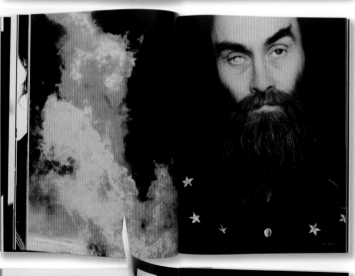
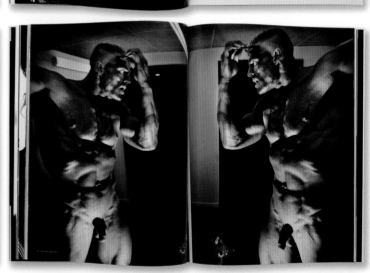

Designbolaget : Vol. 1

Designbolaget was established in 2002 by Art Director Claus Due.
They have two regular employees, and the studio is based in the city of
Copenhagen, Denmark. They share an old building with Illustrators,
Fashion Designers and Animators. Designbolaget works in the fields of
Art, Fashion, Music and Corporate Identities with award-winning work
within Book Design and Corporate Identities.

Project: Vol. 1 *Client: SUMO*
Art Director: Claus Due *Designbolaget*
Creative Director: Claus Due *Ryesgade 3F, 2nd floor*
Designer: Claus Due *2200 Copenhagen N, Denmark*
Photographer: SUMO *www.designbolaget.dkv*

What was the client's directive?

SUMO is a collaboration of 6 different Copenhagen-based Photographers, each working in a different area, from press Photography to the fields of Fashion and Advertising. They wanted to look like a strong unit, but also show their individual skills and style. The target-group for the book is mostly Art Directors and/or buyers.

What was the solution?

At first we tried to mix everything together to give the feel of a coffee-table book, rather than the portfolio of work that it actually was. The thought was tempting – just making a nice-looking photo book would hide the fact that we actually wanted to sell these Photographers. But it turned out to be aesthetically difficult. With this first solution, Designbolaget had to make dialogues between, for example, stylish food Photography and horrifying pictures from the war in Sarajevo.

So we decided to break the book up in chapters, highlighting each Photographer. We decided not to do any graphics in the photos section, letting each Photographer's individual style do the chaptering. We also decided to skip the written introduction for the same reason.

How involved was the client?

Most Photographers, like Graphic Designers, have a strong opinion about how their work is presented, and doing a book with six of them could have turned into a Designer's nightmare. But being aware of that, SUMO decided to give us creative freedom as long as we did not manipulate any of the pictures.

Besides doing the graphic, we also did the editing - the Photographers gave us hundreds of pictures to choose from, trusting us with the job of selecting which pictures were strong enough to be in the book.

How successful was the solution?

Getting creative freedom is both a blessing and a curse. When you can go in any direction you want, it can be hard to choose—and these Photographers just put all of their faith in our art direction. As a Design studio, we actually were the target group for this publication, so we would know best, they said.

The material was very well received; people who work in Advertising or in Graphic Design get a lot of more or less creative direct mail from Photographers. Most of it is thrown out without being read – but because of the finish of SUMO, people tend to keep it on their bookshelves.

What was the relationship with the client?

SUMO came to us because of our portfolio. Designbolaget is known for work in Fashion and Fine Arts. Our books for museums and galleries and catalogues and campaigns for the Fashion industry demonstrate our ability to work well with pictures and Photographers.

Please describe the physical nature of the brochure.

112 pages.

W: 9.85 x H: 12.8 inches.

Printed in 4 colors on coated paper with matte water-varnish on all of the content.

The cover is 3 mm. double coated cardboard.

The title on the front cover has a glossy spot uw-varnish.

Work philosophy?

When I am working in the fields of Art, or in this case, Photography, I see Graphic Design doing the same job as a great film score: letting the great work speak for itself and supporting the weaker parts. And I guess there is something true to the old saying, "God is in the details."

emerystudio : Black Intentions

A consistent contributor to Graphis over the years, emerystudio is a Design practice undertaking work in Australia, Asia, the Middle East, the UK and America. They say they are Communications Designers, but they are much more than that. What they do encompasses a broad scope of Design activities, including designing for the written word and for the moving image, designing exhibitions, the ordering and identity of urban spaces from the scale of single buildings to whole cities, and designing for corporate communications and branding. They are clear on how they can make a positive difference culturally as well as professionally, and on where they will take the practice. emerystudio's development will be based on their own interests, capabilities and beliefs, underpinned by a youthful, enthusiastic team of 26 or so people, and balanced by experience and rigor that's grounded in investigation. They perceive no barriers or boundaries.

Project: Black Intentions
Art Director: Garry Emery
Designers: Garry Emery, Tim Murphy
Photographer: Shannon McGrath
Writers: Justin Clemens, Virginia Trioli
Client: Susan Cohn: Workshop 3000

emerystudio / Melbourne studio
80 Market Street
SouthBank
Victoria
Australia 3006
www.emerystudio.com

What was the client's directive?
The purpose of the catalogue was to document and showcase the content of an exhibition of the work of Susan Cohn, held at the National Gallery of Victoria. The work was photographically recorded in detail as well as in an exhibition context, and supported by various theoretical essays. The exhibition investigated the notion of blackness in the literal and emotional senses, and referred to notions of the wicked, the sinister, the erotic and to shadows of beauty. The catalogue aimed at being a true representation of the Artist's intentions.

What was the solution?
The exhibition installation and the work is physically based on the geometry of the circle. In being square, the format of the catalogue responds to this basic geometric principle. Essentially, the small square catalogue signifies itself as a black object, dark and shrouded in an enigmatic, mysterious, almost blank slip-case.

How successful was the solution – both in terms of creativity and finance?
The view of the Artist is that exhibition catalogues are an important extension of the work, and as such, the accuracy of the Designer's interpretation of the Artist's intentions is imperative. Therefore, the creative solution can be considered successful. As with most cultural publishing,

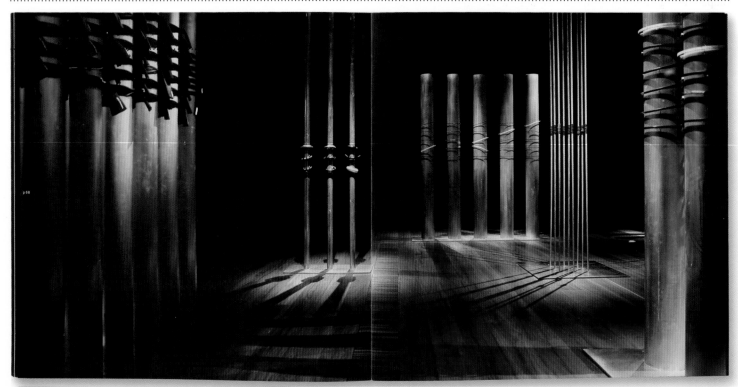

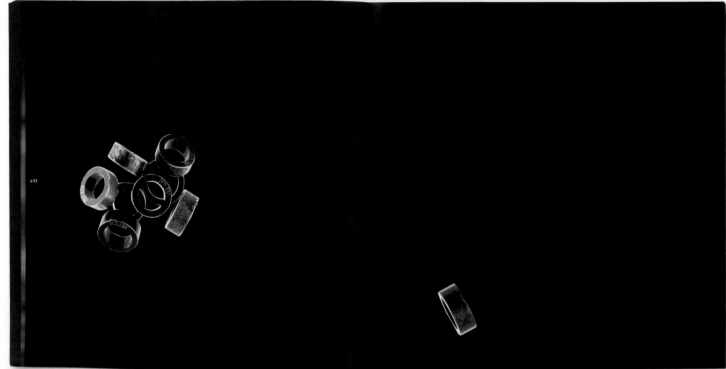

What is your relationship with the client?
The relationship is professional and a longstanding friendship. The Artist came to our Design practice under an apprenticeship arrangement, and then went on to study gold and silversmithing, emerging as a leading Australian jewelry Designer/Artist. There is a long-term understanding, many collaborations and a shared commitment to excellence.

To ensure an alignment between the Artist, the installation content and the Design outcome for the catalogue, a seamless collaboration was essential.
Please describe the physical nature of the piece.
A square black catalogue, 210 x 210 mm of 80 pages, and with a simple die-cut slipcase. The overall impression of the piece is as a black enigmatic object, comprising mostly two types of contrasting matte and gloss finishes. Silver coloured text refers to the metallic nature of the work and is presented on black surfaces, as are the luminous anodised colours of the metallic objects.
How long has your firm been in the business?
emerystudio has been part of the Design industry since 1970's.
What other awards have you received?
Numerous national and international awards from prestigious Design institutions such as New York Type Directors Club, Society of Environmental Graphic Design, Art Directors Club of New York, D&A UK, The Chicago Athenaeum Museum of Architecture&Design, International Biennale of Graphic Design Moscow, Biennale of Graphic Design Czechoslovakia, Tokyo Type Directors Club and Australian Graphic Design Association.
What do you love about Design?
We are interested in the cultural imperatives of Design as well as the commercial, and to each commercial project we aim to bring a cultural dimension. Design provides an opportunity to see inside the private and the public sectors of communities both nationally and internationally. An exposure that opens up a broader understanding of the world with which we engage.
Finally, what is your work philosophy?
There is a way of thinking that suggests that everything precedes you, already exists and is just waiting to be revealed; that it's not so much about creation as it is about discovery and expression. Discovery has a temperate connotation, whereas creation refers to original thought, to genius. We don't claim that what we do is by any means entirely original.

Our objective is to discover the essence of something, take it out of the ordinary, explain why it is plain and ordinary the way it is; then transform it by placing it into a new realm that's inexplicable and extraordinary. The aim is to reveal the essence of that thing, give it expression, meaning and trigger emotional connections that will provoke the desired response from the audience. It's about throwing the viewers' certainties out of balance, challenging pre-conceptions and established conventions.

emerystudio / Melbourne studio
80 Market Street SouthBank, Victoria, Australia 3006
Tel +61 3 9699 3822 / www.emerystudio.com

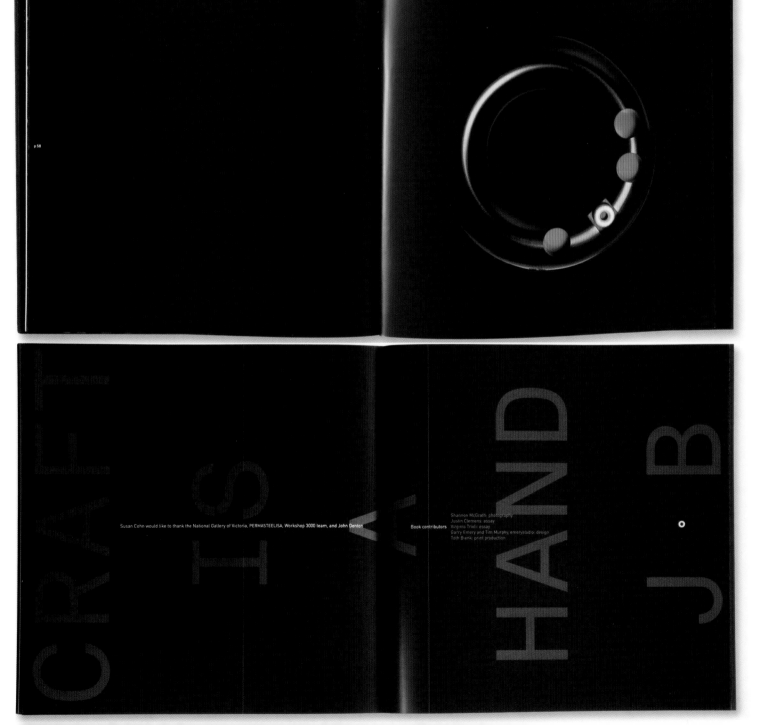

A man came upon a construction site where three bricklayers were working, building what appeared to be identical walls. He asked the first, "What are you doing?" The bricklayer replied, "I am building a wall." He asked the second, "What are you doing?" and the bricklayer answered, "I am building a cathedral." Finally, he asked the third man, "What are you doing?" The bricklayer surveyed his wall and thought carefully before replying,

"I am helping to create a place for the kingdom of heaven on earth."

Rigsby Hull: Six Short Stories and a Parable

Rigsby Design is a Houston-based Graphic Design firm specializing in brand communications strategy and identity development for corporations throughout the US. On January 1, 2007, Rigsby Design became Rigsby Hull. Their solutions help organizations of all kinds compete better by finding and expressing their own unique stories. Rigsby Design has long been known for creating engaging, intelligent communications. The firm's work has been consistently honored by international Design forums such as Graphis, Communication Arts, American Institute of Graphic Arts, New York Art Directors' Club, AR 100 (top US Annual Reports), the Mead Annual Report Show and the Art Directors' societies of Houston and Dallas. They are profiled in Communication Arts volume 37, Graphis volume 313, and Critique volumes 10&11. Their work appears in commercially available books by Chronicle Books, TimeLife Books and is included in the Cooper-Hewitt National Design Museum's exhibition "Mixing Messages: Graphic Design in Contemporary Culture." In its Fortieth Anniversary edition, Communication Arts magazine cited Rigsby Design as one of the most influential American Design firms of the past forty years.

Project: Six Short Stories and a Parable
Art Director: Lana Rigsby
Creative Director: Thomas Hull
Designers: Lana Rigsby, Thomas Hull
Photographer: Terry Vine
Print Producer: Steve Woods Printing Company

Client: Walter P Moore
Rigsby Hull
2309 University Boulevard
Houston, Texas
United States
www.rigsbyhull.com

Description

For over 75 years, Walter P Moore has been engineering places and the flow of movement and activity in and around them. Walter P Moore's work enables much of daily life to take place. Whether the facility is one of America's busiest airports or an ultra-modern play palace such as the new Arizona Cardinal's stadium, Walter P Moore understands that their projects embody the collective pride, individual spirit, indelible memories and aspirations of their clients and of those who ultimately live, work and travel through them.

The importance of place cuts through all social strata and every neighborhood. And they are often multi-billion dollar investments. Walter P Moore engineers places to support—literally and figuratively—their colossal role in today's world.

Rigsby Hull's *Six Stories and a Parable: Engineering and Why it Matters* brochure is designed to create and enhance brand awareness for Walter P Moore.

Measuring 23 x 17.5 inches, the piece is a high-impact, one-time communication introducing Walter P Moore to Architects, Project Managers, land and property owners and government and civic leaders.

Designed to generate immediate impact, awareness and buzz, the booklet doesn't provide a comprehensive information packet about the firm, but is a 30,000 foot view of the company and engineering's impact on the built environment.

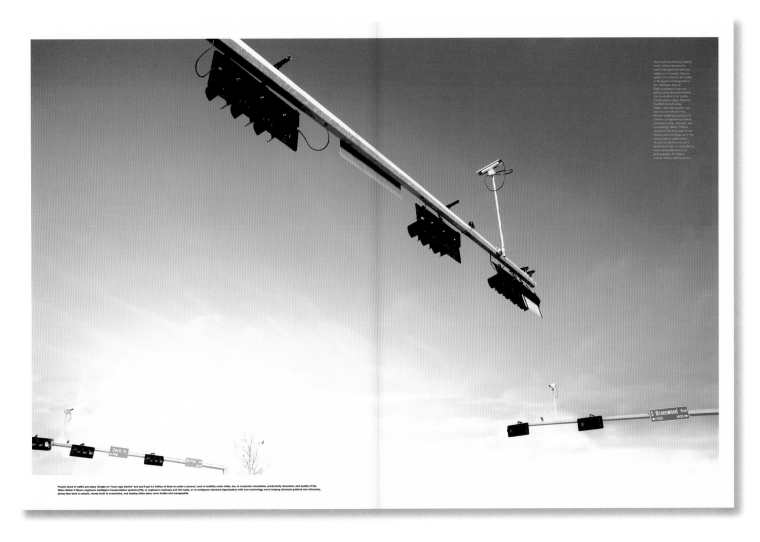

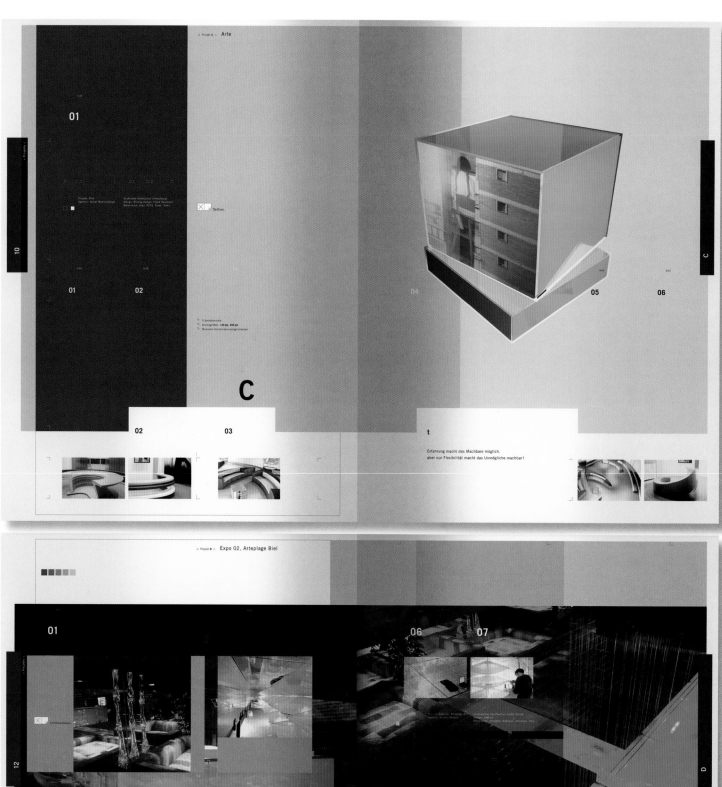

01

01 02

02 03

C

t

Erfahrung macht das Machbare möglich,
aber nur Flexibilität macht das Unmögliche machbar!

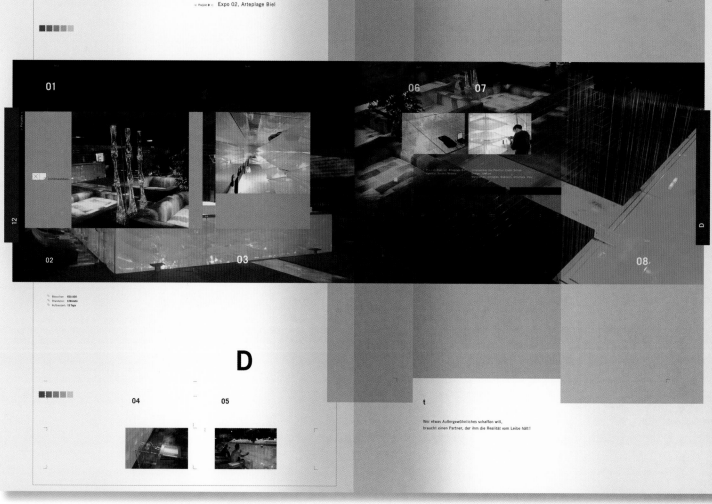

01

06 07

02 03 08

D

04 05

t

Wer etwas Außergewöhnliches schaffen will,
braucht einen Partner, der ihm die Realität vom Leibe hält!

Sonner, Vallée u. Partner : Under Construction!

Carolin Sonner and Patrick Vallée met in Art school, where they worked together on a Design magazine published by a group of students. Still in school, they started working together on Design jobs. At first this was mainly friends and family, but soon it became real clients and contacts that helped them later when they started their company.

After school they went seperate ways for a couple of years but always stayed in contact. At the end of 1999 both quit their jobs (He was employed in a small Design studio, Carolin was a junior partner at another two-man-Design studio) and did freelance work together. In August 2000 they founded Sonner, Vallée u. Partner.

They do not work with employees but with a larger network of freelance Designers, Writers and Programmers.

Project: Under Construction!
Art Director: Sonner, Vallée u. Partner
Creative Director: Sonner, Vallée u. Partner
Designer: Sonner, Vallée u. Partner
Photographer: Gecco Scene
Construction Company

Writer: Gecco Scene Construction Company
Client: Gecco Scene Construction Company
/ Cologne, Germany
Sonner, Vallee u, Partner
Eduard-Schmid-Str. 2, Muenchen, Germany
www.sonnervalle.de

Description: The client's directive was very simple. A new image brochure with "impact" to leave an impression before it's thrown into the trashcan.

He was looking for a brochure that expresses the strength of his company, and shows examples of the its work. Right from the beginning, the client was highly involved in the project. There is a strong interest in Design on the client's side, although his own job is to build things and not to design them. So, it was the client's idea, for example, to have a really big format instead of doing the typical A4 brochure.

Design-wise he didn't come up with ideas, but always took the time to listen and pay attention to (and understand, agree or disagree) every visual idea we came up with. Also, the text mainly came from the client's side. Since the founder of Gecco is both a friend and a client, the whole project was a very comfortable one, despite of all the discussions, fights about Design and all of the things that naturally come with every project. When the final Design was shown, it seemed our client might be faced with the challenge of producing an image brochure withoug the support of his employees. But, as it should be, in the end everybody (the client just as much as us) was very happy with the result. The title "Under Construction!" symbolizes the offered services, namely the planning and completion of quality sets and Interior Design. These themes were applied graphically using symbols such as construction lines and measurements. To optimize the attraction to our target group (Archi-

tects, Agencies, Marketing Directors), we applied the Design using inserted transparent paper, Japanese folding and binding, and UV spot varnishing, reflecting the variety of materials with which the business works and the precise craftmanship offered.

24 pages, 12 1/2 x 16 1/8 inch (315 x 410 mm), perfect-bound, 4-color. PMS and varnish on the cover, printed vellum sheets.

What is your Design philosophy?

At the beginning of every Design is an idea. Think before you draw, so that every line, letter and color has a purpose. Good Design is hard work. There is always a way for improvement. Never stop looking for it. Understand the rules of Design and Typography. These rules have been developed over many years, and each one of them has a purpose…therefore if you want to break one, know that you're breaking it!

We live in a designed world. Posters, Advertising, signage systems, commercials, magazines, books, etc. are everywhere around us. The moment we decide what clothes to wear on what occasion, we design our own appearance. Once you are aware of that, you should recognize that, as a Designer, you're at least jointly responsible for this world's appearance. This awareness brings cultural responsibility with it. Since Design is our profession, it's not the client's job to take that responsibility, but ours!

Stay curious. There is always something new to discover and learn. This possibility is part of what makes creating and designing one of the most beautiful things you can possibly do for a living.

Awards and publications:

Art Directors Club of Germany (Carolin Sonner for "Atelier Beinert & Sonner")
Type Directors Club: Typography 20, TDC 45 (Patrick Vallée for "Contrapunkt")
Red Dot: International Yearbook Communication Design 1999/2000 (Carolin Sonner for "Atelier Beinert & Sonner" two times highest Design quality, Patrick Vallée for "Contrapunkt" one time high Design quality)
Kommunikationsverband.de: International Corporate Design Award 2000 (Shortlist)
Kommunikationsverband.de: International Printet Matter Contest "Berliner Type" 2001 (Gold)
b&w Editionen No. 18, 02/01
baseline international typographics magazine: No. 34/2001
Novum World of Graphic Design 09/02
Communication Arts: Design Annual 46, 2005
Communication Arts: Design Annual 47, 2006
Type Directors Club: Typography 28, TDC 53

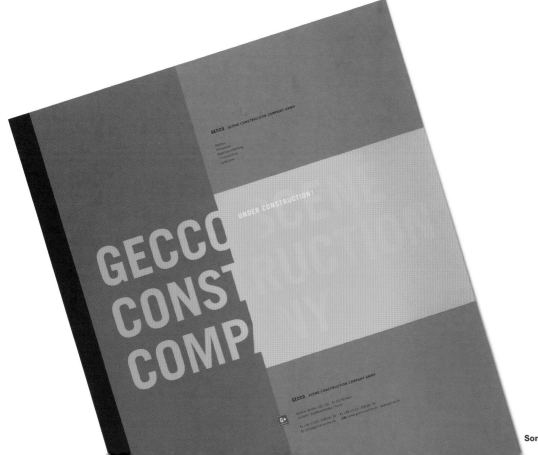

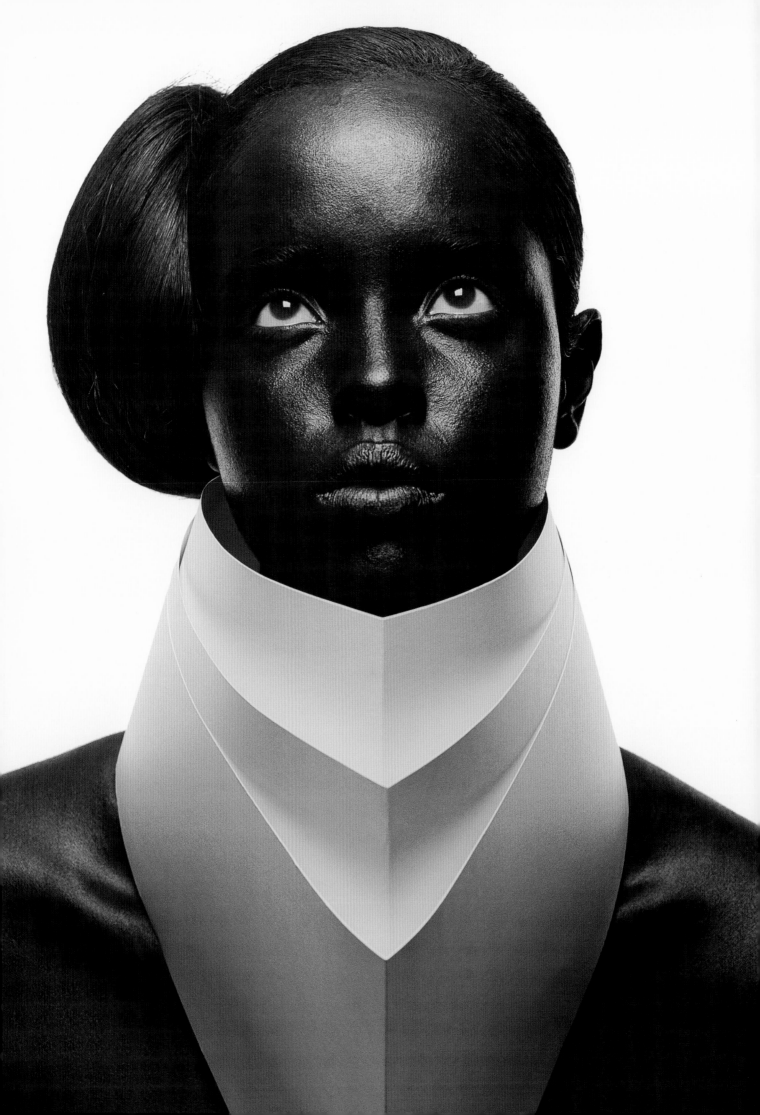

Viva Dolan Communications & Design : Curious : The Pin Up Collection

Viva Dolan develops Branding strategy, and creates Marketing and corporate Design/Communications for a broad range of international clients. Equally at home in both print and interactive media, they combine creative problem-solving, smart analysis and meticulous execution to work that truly differentiates and gets results.

They work closely with clients to develop, plan, direct, design, write, edit, produce and manage every manner of communications—from catalogues, brochures and annual reports to websites and CD-ROM presentations. Their Toronto-based firm has grown steadily since opening its doors in 1992. Viva Dolan's full-time team of 10 people now conducts more than 60% of their business with clients outside Canada.

Project: Curious:The Pin Up Collection
Designer: Frank Viva
Illustrator(pins): Frank Viva
Writer: Frank Viva
Photographer: Ron Baxter Smith
Garment Designer: Dean Horn
Hair & Makeup: Jackie Shawn

Printer: Hemlock
Client: ArjoWiggins
Viva Dolan Communications & Design
99 Crown's Lane
Suite 500 Toronto, ON
Canada
www.vivadolan.com

What was the problem?
The new chief of fine papers at ArjoWiggins saw potential in promoting the Curious Collection line of fine printing papers as a "luxury brand", ideal for use in the Fashion industry.

What was the client's directive?
He wanted a promotion that would send this message to target audience.

What was the solution?
Our response was to use samples of our client's actual products (printing papers) to design and photograph paper garments that referenced moments in the history of contemporary Fashion. Straight pins were used to hold the paper garments together and to also create a series of "pin illustrations."

How successful was the solution – both in terms of creativity and finance?
Outside contributors (Print and Photography in particular) were excited to work on the Curious brochure, allowing us to deliver this ambitious project on budget. Our client was very happy with the process and with the response.

What is your relationship with the client?
Our relationship with this client goes back 15 years. We have continued to work with them through changes of personnel from the top down; several rounds of major restructuring and a merger between two large European fine paper companies.

How involved was the client?
The client is a good partner and was involved in all key decisions.

Please describe the physical nature of the piece.
13 different papers with some complex print and production challenges.

How long has your firm been in the Design business?
15 years.

How many people does the firm employ?
8 people.

What other awards have you received?
More than 350 Design and Illustration awards from Graphis, Communication Arts, The D&AD, New York Type Director's Club, American Illustration, AIGA and many others.

Have you had work featured in other publications?
Viva Dolan was profiled in the September/October 2001 issue of Communication Arts Magazine and the work has been reviewed in many international industry publications and books.

What do you love about Design?
Problem solving.

Finally, what is your work philosophy?
We create high quality, imaginative Design that professionally responds to our client's business objectives.

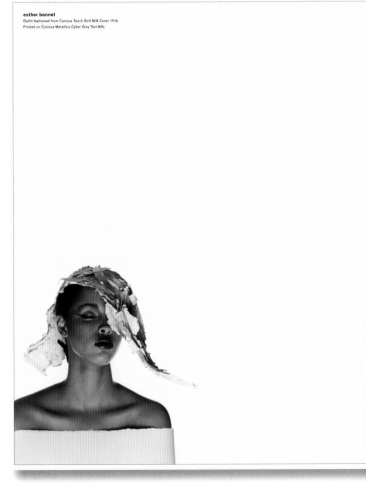

esther bonnet
Outfit fashioned from Curious Touch Soft Milk Cover 111lb.
Printed on Curious Metallics Cyber Grey Text 80lb.

Following Page | Photography by Phil Marco

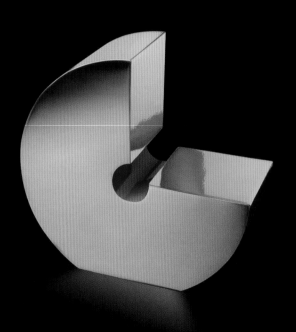

GraphisGold&PlatinumAwardWinners

GraphisGold&PlatinumAwardWinners

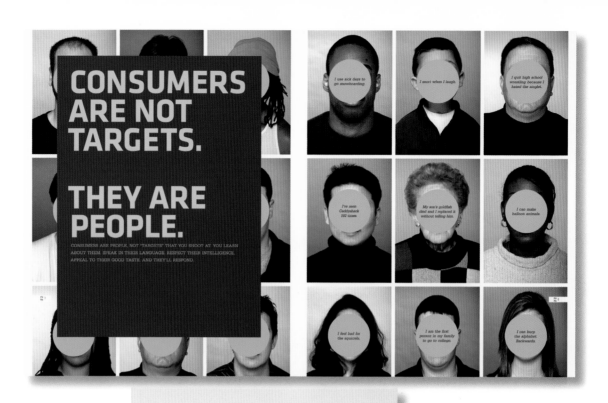

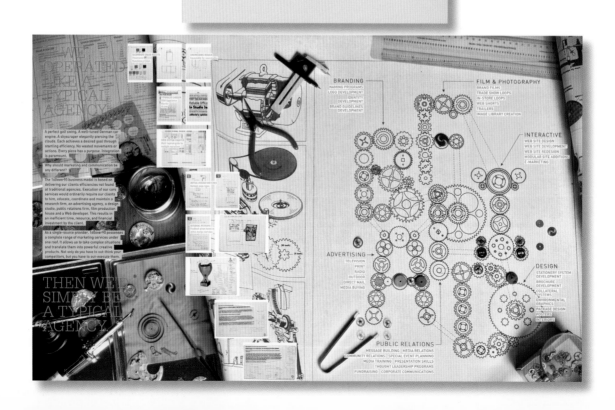

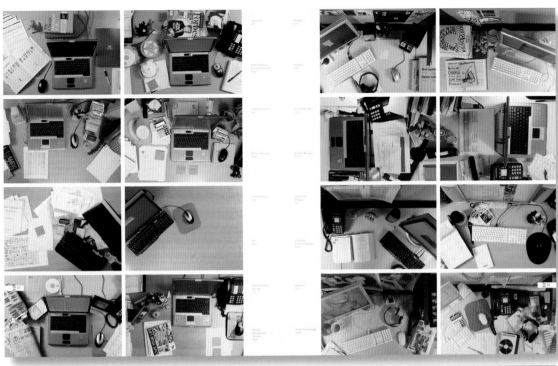

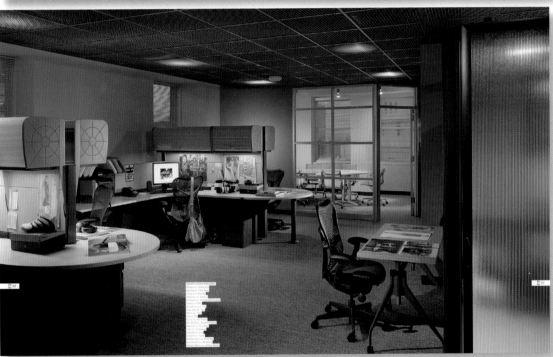

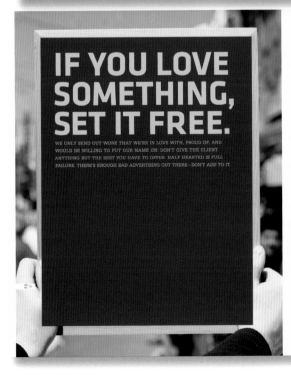

IF YOU LOVE SOMETHING, SET IT FREE.

WE ONLY SEND OUT WORK THAT WE'RE IN LOVE WITH, PROUD OF, AND WOULD BE WILLING TO PUT OUR NAME ON. DON'T GIVE THE CLIENT ANYTHING BUT THE BEST YOU HAVE TO OFFER. HALF HEARTED IS FULL FAILURE. THERE'S ENOUGH BAD ADVERTISING OUT THERE—DON'T ADD TO IT.

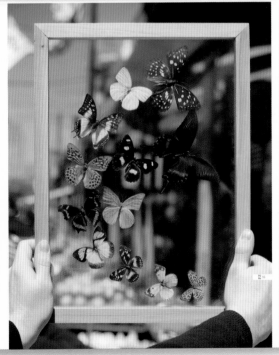

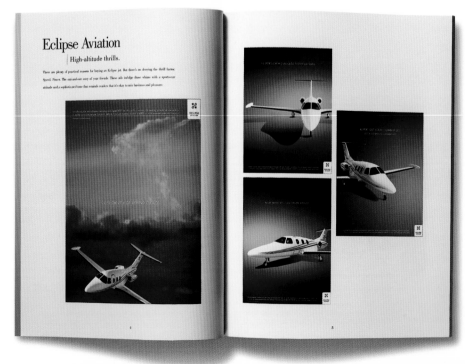

Kodak

Giving photographers a club all their own.

Customer relationship programs are great ways to build traffic to your web site and loyalty to your brand. Kodak's ProPass program features a web site and magazine devoted to professional photographers, a place of their own to share ideas, display their best work, and learn how others manage their businesses.

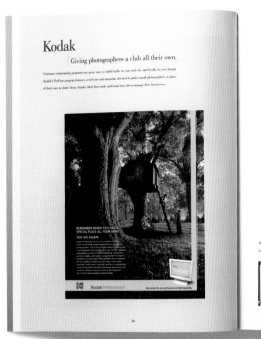

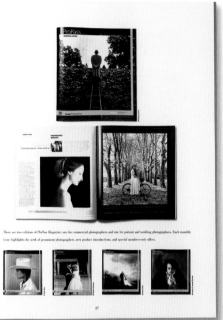

There are two editions of ProPass Magazine, one for commercial photographers and one for portrait and wedding photographers. Each monthly issue highlights the work of prominent photographers, new product introductions, and special members-only offers.

GE Aircraft Engines

Saluting the centennial of flight.

From the first turboprop engine to the world's most powerful commercial jet engine, GE Aircraft Engines has a history of aviation firsts. So it was fitting that the company salute the two men who got the industry off the ground back in 1903, the Wright Brothers. To celebrate the 100th anniversary of flight, GE Aircraft Engines ran this campaign honoring these innovators of aviation, and celebrating its own role in the history of flight.

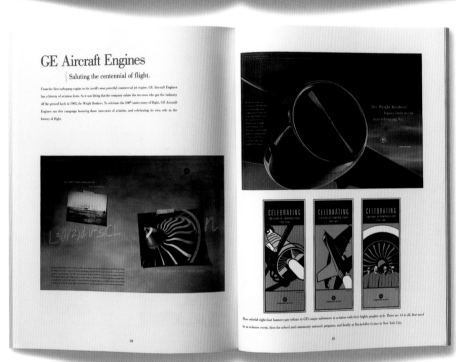

These colorful eight-foot banners pay tribute to GE's major milestones in aviation with their highly graphic style. There are 14 in all, first used for an in-house event, then for school and community outreach programs, and finally at Rockefeller Center in New York City.

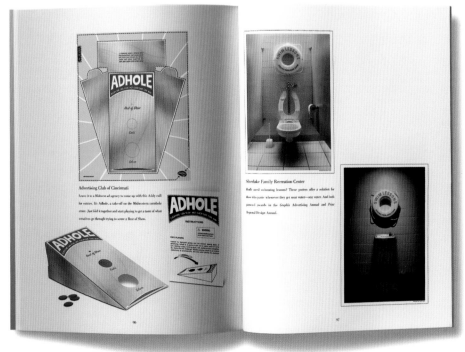

Advertising Club of Cincinnati

Leave it to a Midwest ad agency to come up with this Addy call for entries. It's Adhole, a take-off on the Midwestern cornhole craze. Just fold it together and start playing to get a taste of what creatives go through trying to score a Best of Show.

Silverlake Family Recreation Center

Radž need swimming lessons? These posters offer a solution for those who panic whenever they get near water—stay water. And both posted awards in the Graphic Advertising Annual and Print Beyond Design Annual.

TIR has over twenty years of experience developing specialty lighting systems and a multi-disciplinary research team focused on making the technological advancements required to reach our goal of Solid State Lighting for general illumination, everywhere.

We provide energy efficient, longlife Solid State Lighting technology which replaces conventional lighting and helps save the environment through energy conservation.

TIR 04

TIR Systems Ltd. 2004 Annual Report

For any technology-based company, the gap between innovative ideas and marketable realities is bridged by research and development.

From breakthroughs in product design to the development and implementation of streamlined, automated manufacturing processes, our investment in research is the strategic engine that powers an ever growing, successful enterprise.

The technological advances being made by our research team represent the most sustainable competitive advantage for the company and reinforce our leadership in the development of Solid State Lighting.

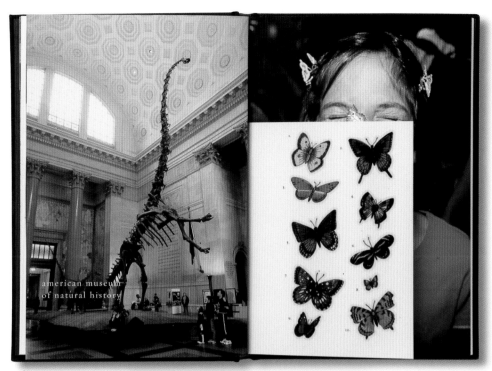

pay attention

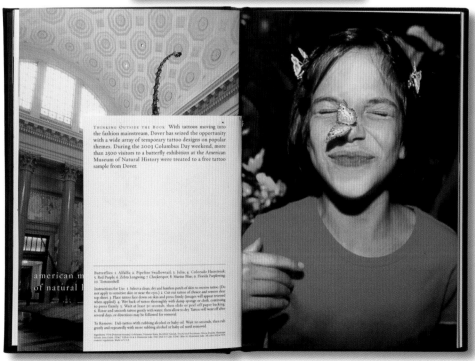

SYDANCEY COMPANY

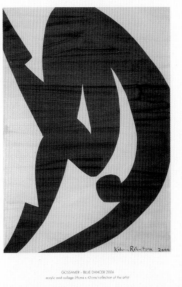

BACKBEND KALEIDOSCOPIC 2005
acrylic and collage 59cms x 42cms/collection of the artist

GOSSAMER - BLUE DANCER 2006
acrylic and collage 59cms x 42cms/collection of the artist

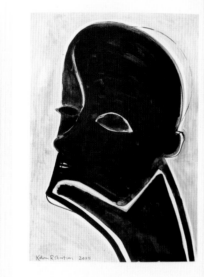

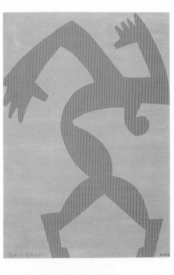

GRAEME MURPHY 2005
ink and wash 59cms x 42cms/collection of the artist

JASON WILCOCK RED AND GREEN 2005
acrylic and collage 59cms x 42cms/collection of the artist

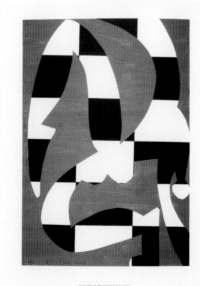

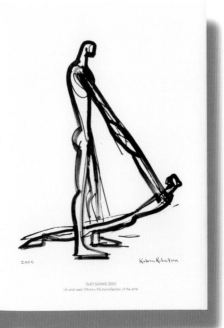

BACKBEND PROGRESSION 2005
acrylic and collage 59cms x 42cms/collection of the artist

DUO SLIDING 2005
ink and wash 59cms x 42cms/collection of the artist

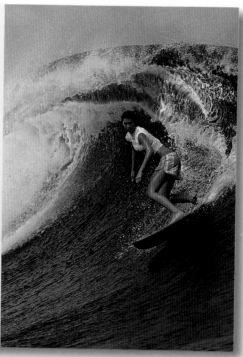

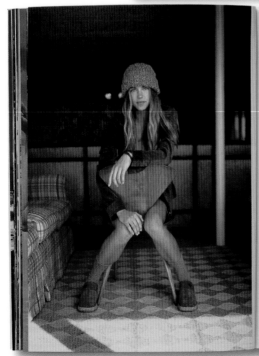
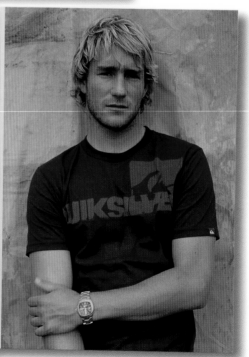

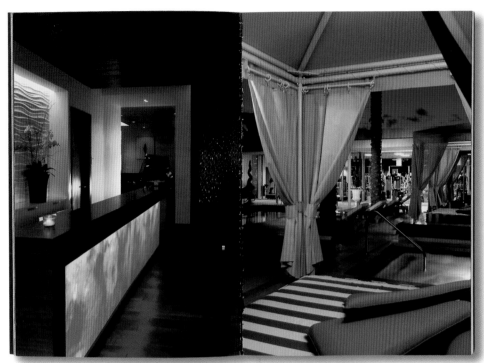

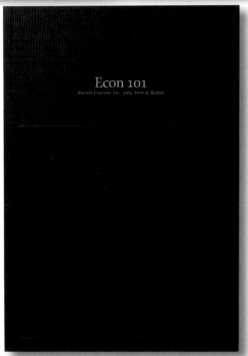

Econ 101
STATION CASINOS, INC. 2004 ANNUAL REPORT

2004 AREAS OF GIVING

STRETCHING THE BOUNDARIES

COLOURSCAN

IN OUR
SERVICE

IN OUR
CAPABILITIES

IN OUR
FACILITIES

IN OUR
WORK

QUALITY

An unblemished reputation is something like a medal – tough to earn, but once you've got it, you wear it with a smile. When it comes to quality, we have earned a reputation as one of the most renowned digital image service providers in South East Asia. Which is why 60 percent of our output is for international markets, and many global customers award us their business, including leading international publishers such as Dorling Kindersley, Harper Collins, Murdoch Books and Reader's Digest. Each of these customers represents a unique quality benchmark. We aim to match them all.

READER'S DIGEST

Having produced books that inform and entertain people of all ages and cultures, Reader's Digest has a long-established reputation as one of the world's pre-eminent publishers. Colourscan's fifteen-year track record of work for the Australian Reader's Digest illustrates the broad scope of our capabilities, as well as our international standards. Be it books on DIY, computing, gardening, nature, health, travel or geography, Colourscan has played an integral role in the production of many titles over the years. That Reader's Digest has continually expressed satisfaction with our services is a further testament to our skills.

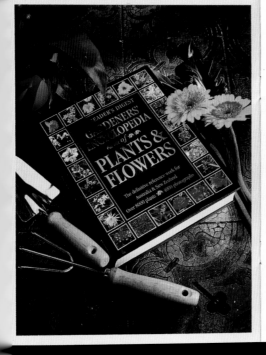

DORLING KINDERSLEY

With their strong tradition of design and reproduction excellence, Dorling Kindersley demand the very best in a colour separation house. The high-quality illustrated reference books they are famous for have set superior benchmark standards that Colourscan has been able to match, time after time. With many of their titles to our credit, Dorling Kindersley have been utilising our services for nearly two decades now, becoming in the process our biggest client, and cementing our reputation internationally for premium quality work. For us this is a very successful partnership of which we are very proud.

GECCO _SCENE CONSTRUCTION COMPANY GMBH

Setbau
Messebau
Eventausstattung
Innenausbau
Ladenbau

UNDER CONSTRUCTION!

GECCO SCENE CONSTRUCTION COMPANY

GECCO _SCENE CONSTRUCTION COMPANY GMBH

Niehler Straße 102 -105 · D- 50733 Köln
(Zufahrt) Bannerstraße · Tor 4)

T: +49 (0)221. 768 04- 10 · F: +49 (0)221. 768 04- 34
E: info@gecco-scene.de · URL: www.gecco-scene.de · www.gecco.tv

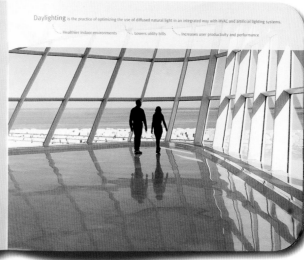

Daylighting is the practice of optimizing the use of diffused natural light in an integrated way with HVAC and artificial lighting systems.

· Healthier indoor environments · Lowers utility bills · Increases user productivity and performance

"Everything is related to everything else."

That statement is often called the First Law of Ecology. And nature provides us with countless examples of how one simple action affects countless others throughout the environment.

The same holds true in sustainable architecture. While at first glance it may seem to be simply a matter of adding solar panels or using recycled materials, it's actually much more complex. Every sustainable choice has implications for other aspects of the building and site. And often, cause and effect are not so easy to see.

What we do know is this: sustainable architecture promotes a healthier indoor environment, increased productivity, and lower utility costs. Not to mention, it makes us better stewards of the environment.

At Steed Hammond Paul, our goal is to reveal the connections in sustainable design strategies to help provide numerous benefits to the building's owner, its users, the local community, and of course, the global environment.

"The nation behaves well if it treats the natural resources as assets which it must turn over to the next generation increased, and not impaired in value." —Theodore Roosevelt, 26th President of the United States

Sustainable Architecture **Revealing the Connections**

Steed | Hammond | Paul

Finding your place on the green spectrum.

We believe building sustainably doesn't have to be an all-or-nothing approach.

You may simply want to maximize the use of daylighting, to give your building a brighter, more comfortable interior. You may want to specify environmentally friendly materials wherever possible. Or you may want to incorporate all the sustainable practices required to achieve LEED* (Leadership in Energy and Environmental Design) certification, the industry standard for sustainable architecture. Wherever you fall on the sustainability spectrum, our "Green Team" of LEED-accredited professionals will help you achieve an affordable, sustainable solution.

Our team works closely from the start with all your decision-makers to determine the specific goals for your project. They help you explore a variety of options for building sustainably, including some you may not be familiar with. Then they guide you in making the types of choices that will achieve those goals. And through our integrated design approach, your project's Green Team ensures that every choice achieves its full potential and greatest impact.

*LEED is a registered trademark of the U.S. Green Building Council

Water conservation tactics include using low- and no-flow water fixtures, and harvesting rainwater for landscape irrigation and other non-potable uses.

· Reduces stormwater runoff · Conserves potable water · Lowers utility costs

 "When we tug at a single thing in nature, we find it attached to the rest of the world." —John Muir, 19th century American conservationist

Our Green Team makes sustainability the smarter choice.

We've found that most people agree with the concept of sustainable building, but often think it'll be too difficult or expensive. But when we show them today's more affordable technologies and materials, and explain our integrated design process, they find that just the opposite is true.

For each green project, we select an interdisciplinary "Green Team" of employees and associated partners that may include experts in architecture, interior design, site planning, all aspects of engineering, master planning, landscape architecture, and others. This Green Team works closely together from the start, which helps them discover opportunities and quickly avert problems, to keep your project on schedule and on budget. Their combined expertise in sustainable design helps ensure that your project achieves its full potential, with minimal effect on the environment.

"All things are connected. Whatever befalls the earth, befalls the children of the earth." —Chief Seattle, 19th century Suquamish leader

Sustainable sites combine strategies such as reusing existing buildings or previously developed land along with green roof design, erosion control, and reduced surface parking to achieve multiple environmental benefits.

· Restores urban areas · Minimizes impervious surfaces and heat island effect · Improves stormwater management

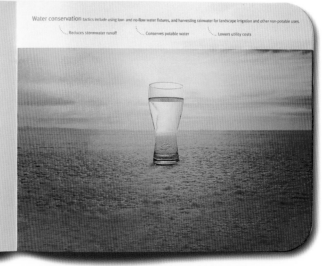

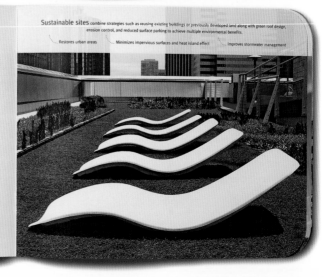

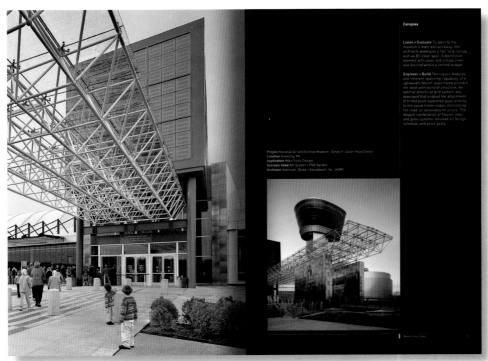

Canopies

Listen + Evaluate To identify the museum's main entranceway, the architects developed a 140' long canopy with an 85' clear span. A distinctive element with clean and simple lines was desired within a limited budget.

Engineer + Build The classic features and inherent spanning capability of a lightweight Novum space frame provided the ideal architectural structure. An optimal structural grid pattern was developed that enabled the attachment of fritted point supported glass directly to the space frame nodes, eliminating the need for secondary structure. The elegant combination of Novum steel and glass systems resolved all design, schedule, and price goals.

Project National Air and Science Museum, Steven F. Udvar-Hazy Center
Location Chantilly, VA
Application Main Entry Canopy
Systems Used KF-System + PSG-System
Architect Hellmuth, Obata + Kassabaum, Inc (HOK)

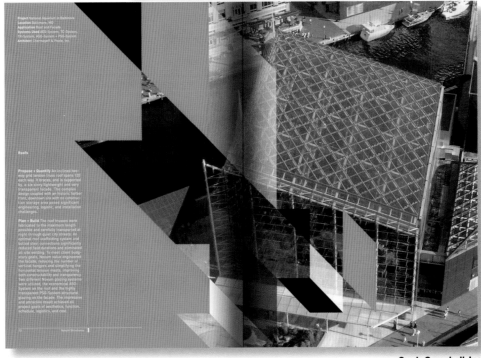

Project National Aquarium in Baltimore
Location Baltimore, MD
Application Roof and Facade
Systems Used ASG-System, TC-System, TR-System, ASG-System + PSG-System
Architect Chermayeff & Poole, Inc

Roofs

Propose + Quantify An inclined two-way grid tension truss roof spans 120' each way. It braces, and is supported by, a six-story lightweight and very transparent facade. The complex design coupled with an historic harbor front, downtown site with no construction storage area posed significant engineering, logistic, and installation challenges.

Plan + Build The roof trusses were fabricated to the maximum length possible and carefully transported at night through quiet city streets. An optimal roof scaffolding system and bolted steel connections significantly reduced field durations and eliminated all on site welding. To meet client budgetary goals, Novum value-engineered the facade, reducing the number of vertical hangers and simplifying the horizontal tension masts, improving both constructability and transparency. Two different Novum glazing systems were utilized, the economical ASG-System on the roof and the highly transparent PSG-System glazing on the facade. The impressive and attractive result achieved all project goals of aesthetics, function, schedule, logistics, and cost.

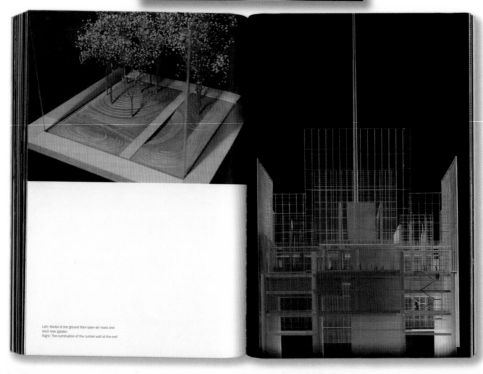

Left: Model of the ground floor open-air moss and
birch tree garden.
Right: The culmination of the curtain wall at the roof.

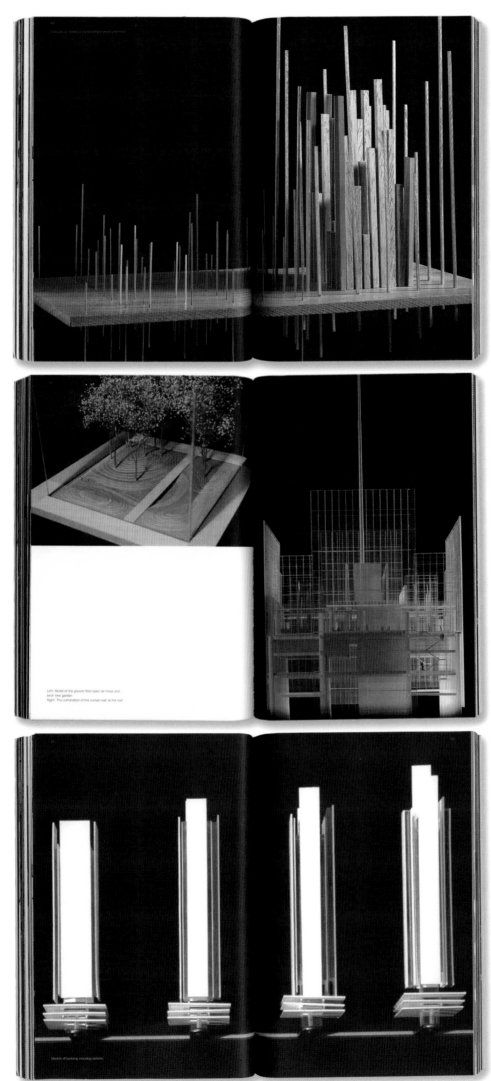

Left: Model of the ground floor open-air moss and birch tree garden
Right: The culmination of the curtain wall at the roof

Models of lighting mockup options

HOLDINGS

Drawings

Drawings by architects, engineers, and consultants including both built and unbuilt works primarily of the twentieth century. Plans, sections, elevations and perspectives are held.

Specifications

Specifications relating directly to the architectural drawings and providing written documentation stipulating materials, quality of finishes, and the manner of construction.

Correspondence

Professional and personal correspondence relating to specific buildings, professional affairs and architects' overseas travel.

Photographs

Photographic items, including slides and photographic prints of architects, built work and overseas ...

Notebooks and Diaries

Business and personal notebooks, sketches and diaries relating to buildings...

Rolfe V. Boehm	F. Kenneth Milne
Robert Burden	Jack McConnell
Jack D. Cheesman	Charles A. Russell
Max Chenoweth	Colin Schumacher
Dickson and Platten	Peter C. Simpson
Russell S. Ellis	Marjorie Simpson
Harold T. Griggs	Louis Laybourne Smith
and James Engineers	Robert Viney
James Irwin	Gavin Walkley
Johnson	Gordon Young

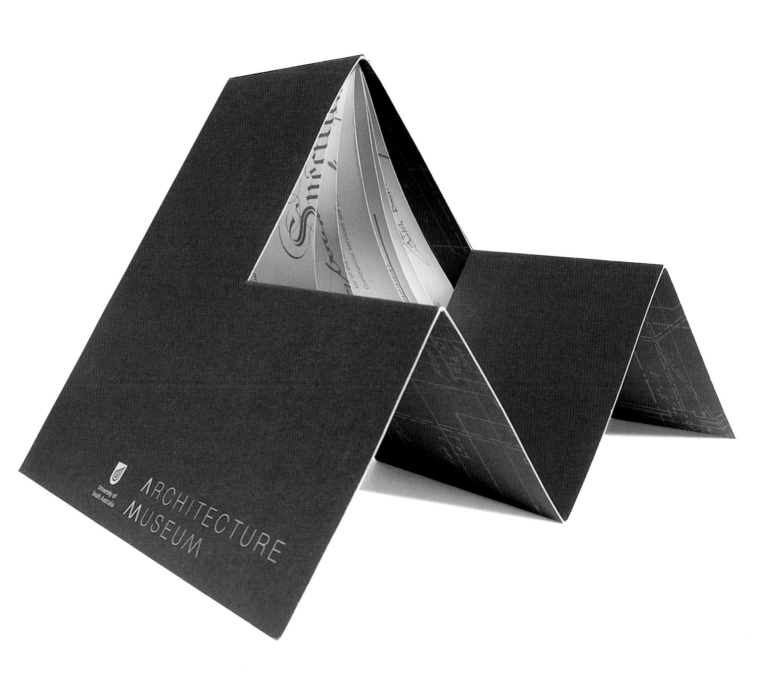

ARCHITECTURE
MUSEUM

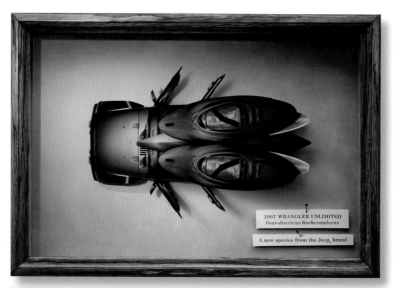

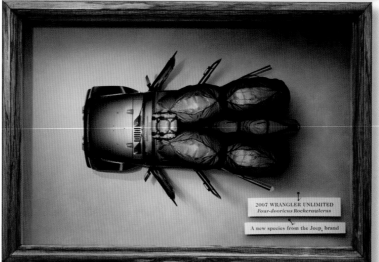

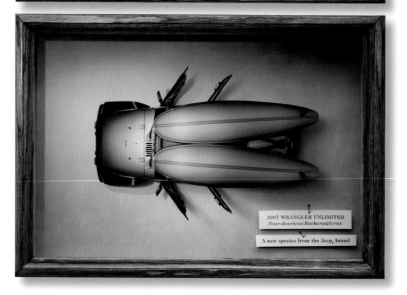

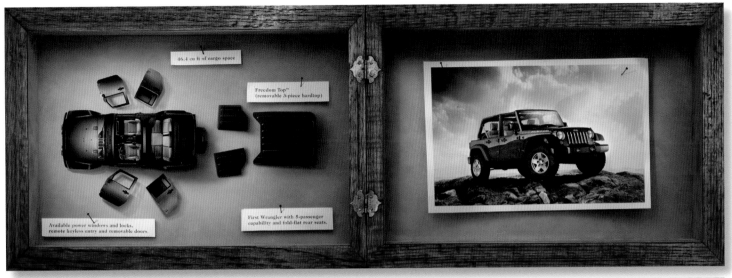

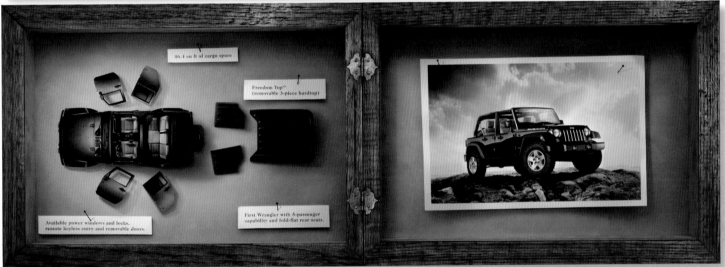

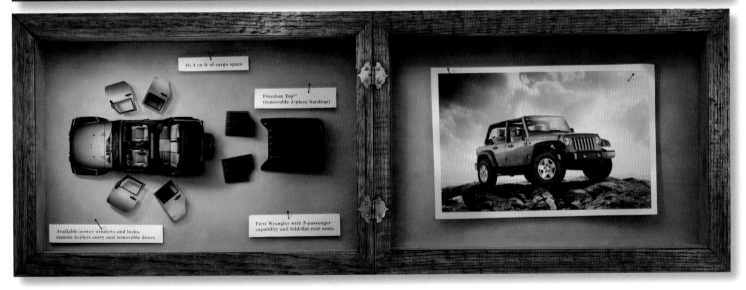

The legend behind the world's most famous star.

 In 1888, Bertha Benz jumped into one of her husband's prototypes to visit her mother. Little did she know that her family outing was to make history. Assisted by her two sons, as no one really knew how to drive a car, she notched-up the world's longest test drive – 190 bone-shaking kilometres. Life would never be the same again.

The story behind the star

Affectionately called the "Gullwing" after its signature upward-opening doors, the 300 SL combined cutting-edge technology, breathtaking performance and sublime handling in an exquisitely detailed body.

These qualities remain at the heart of every SL–and there have been just five generations, an indication of its enduring, some say timeless, appeal.

Around 1,000 of the 1,400 Gullwings made survive to this day. Back in the 1950s, an American owner said: "I object to the fact that so many people want to look at my car." Just imagine the attention he'd receive today.

Three years after the first SL, Mercedes-Benz introduced an even more beautiful version. The 300 SL Roadster captured the glamour and romance of open-top motoring.

An all-new SL was introduced in July 1963. The "Pagoda" model (so-called because of its roof shape) focussed on elegance and comfort. Featuring a range of engines producing up to 190bhp, some 49,000 were sold.

This car's successor, however, was to prove the best-selling SL of all-time. Launched in April 1971, the third-generation model had an 18-year lifespan that embraced eight different variants.

After such an illustrious run, the third SL was always going to be difficult to replace; however, a worthy successor appeared in early 1989. One of the most significant new safety features on the fourth-generation SL was a hidden roll-over bar that sprang instantly into action when required.

Today's fifth-generation SL, introduced in July 2001, is even safer yet more enjoyable to drive. With its vario-roof system, it converts from a coupé to a roadster in just 16 seconds. This SL was the first car to offer a folding hard top made of glass for an unprecedented feeling of freedom. Today, the SL65 AMG remains the world's most powerful roadster, its V12 twin-turbo 612 bhp engine propelling it from 0-100km/h in just a mere 4.2 seconds.

The last 50 years saw Mercedes-Benz revolutionise the sports car, with each successive SL sporting more performance, luxury, comfort and glamour. The next half-century promises to be no different.

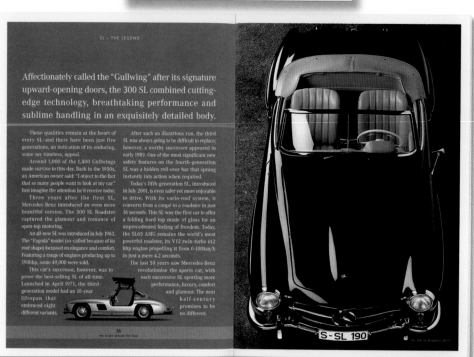

S-SL 190

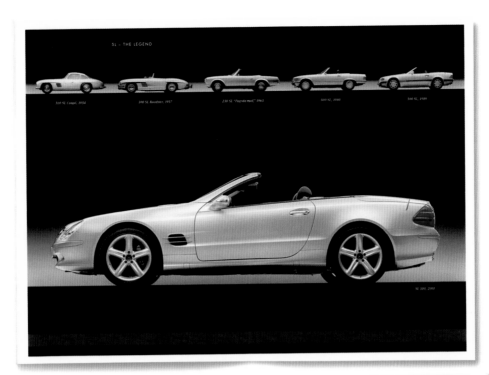

300 SL Coupé, 1954 300 SL Roadster, 1957 230 SL "Pagoda roof", 1963 500 SL, 1980 500 SL, 1989

SL 500, 2001

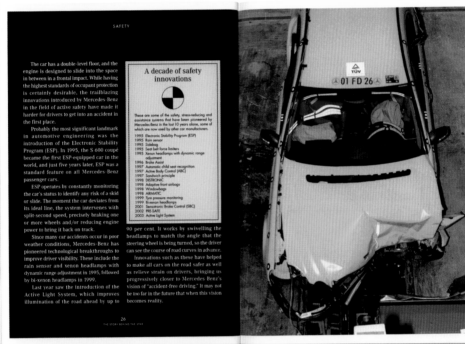

The car has a double-level floor, and the engine is designed to slide into the space in between in a frontal impact. While having the highest standards of occupant protection is certainly desirable, the trailblazing innovations introduced by Mercedes-Benz in the field of active safety have made it harder for drivers to get into an accident in the first place.

Probably the most significant landmark in automotive engineering was the introduction of the Electronic Stability Program (ESP). In 1995, the S 600 coupé became the first ESP-equipped car in the world, and just five years later, ESP was a standard feature on all Mercedes-Benz passenger cars.

ESP operates by constantly monitoring the car's status to identify any risk of a skid or slide. The moment the car deviates from its ideal line, the system intervenes with split-second speed, precisely braking one or more wheels and/or reducing engine power to bring it back on track.

Since many car accidents occur in poor weather conditions, Mercedes-Benz has pioneered technological breakthroughs to improve driver visibility. These include the rain sensor and xenon headlamps with dynamic range adjustment in 1995, followed by bi-xenon headlamps in 1999.

Last year saw the introduction of the Active Light System, which improves illumination of the road ahead by up to

A decade of safety innovations

These are some of the safety, stress-reducing and assistance systems that have been pioneered by Mercedes-Benz in the last 10 years alone, some of which are now used by other car manufacturers.

Year	Innovation
1995	Electronic Stability Program (ESP)
1995	Rain sensor
1995	Sidebag
1995	Seat belt force limiters
1995	Xenon headlamps with dynamic range adjustment
1996	Brake Assist
1997	Automatic child seat recognition
1997	Active Body Control (ABC)
1997	Sandwich principle
1998	DISTRONIC
1998	Adaptive front airbags
1998	Windowbags
1998	AIRMATIC
1999	Tyre pressure monitoring
1999	Bi-xenon headlamps
2001	Sensotronic Brake Control (SBC)
2002	PRE-SAFE
2003	Active Light System

90 per cent. It works by swivelling the headlamps to match the angle that the steering wheel is being turned, so the driver can see the course of road curves in advance.

Innovations such as these have helped to make all cars on the road safer as well as relieve strain on drivers, bringing us progressively closer to Mercedes-Benz's vision of "accident-free driving." It may not be too far in the future that when this vision becomes reality.

You have read until the end, but the story will continue. That's because the magical love affairs between drivers and their Mercedes-Benz automobiles will stand the test of time. Again, and again, and again.

"The best or nothing."

Gottlieb Daimler

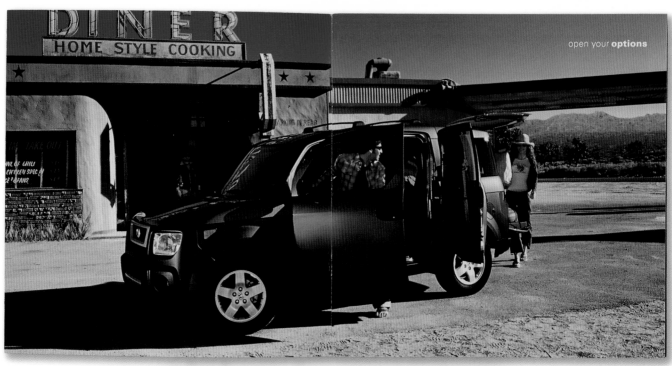

open your **options**

2004 ELEMENT

Honda

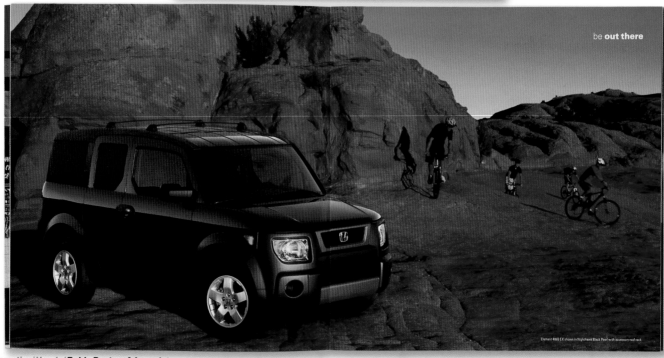

be **out there**

Element 4WD EX shown in Nighthawk Black Pearl with accessory roof rack

2007 Nissan **Titan**

2007 Nissan **Sentra**

2007 Nissan **Pathfinder**

2007 Nissan **Altima**

Sentra 2.0 SL shown in Magnetic Gray with accessory equipment

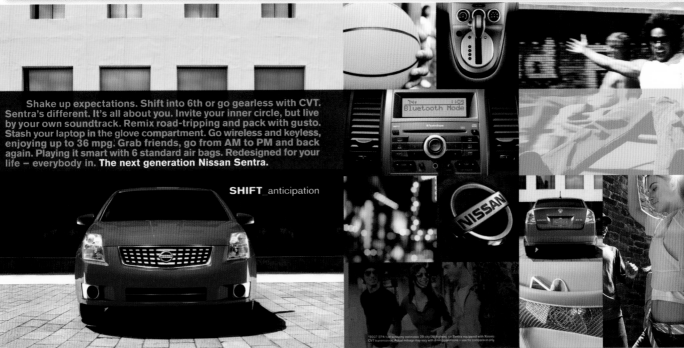

Shake up expectations. Shift into 6th or go gearless with CVT. Sentra's different. It's all about you. Invite your inner circle, but live by your own soundtrack. Remix road-tripping and pack with gusto. Stash your laptop in the glove compartment. Go wireless and keyless, enjoying up to 36 mpg. Grab friends, go from AM to PM and back again. Playing it smart with 6 standard air bags. Redesigned for your life – everybody in. **The next generation Nissan Sentra.**

SHIFT_anticipation

No matter your mood, there's a song to match. How you infuse it is all up to you. Connect your MP3 player through the auxiliary audio input. Dig state-of-the-art satellite radio. Or load 6 MP3/WMA discs for over 1,000 of your favorite songs. All of it blasting through a high-performance Rockford Fosgate-powered audio system. Musical justice, now yours.

It's All About the Music

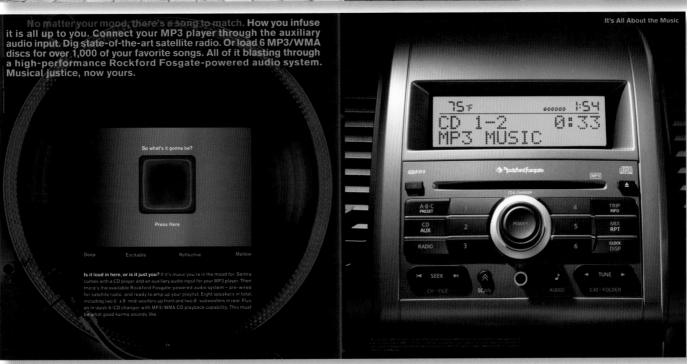

So what's it gonna be?

Press Here

Deep Excitable Reflective Mellow

Is it loud in here, or is it just you? If it's music you're in the mood for, Sentra comes with a CD player and an auxiliary audio input for your MP3 player. Then there's the available Rockford Fosgate-powered audio system – pre-wired for satellite radio, and ready to amp up your playlist. Eight speakers in total, including two 6" x 9" mid-woofers up front and two 8" subwoofers in rear. Plus an in-dash 6-CD changer with MP3/WMA CD playback capability. This must be what good karma sounds like.

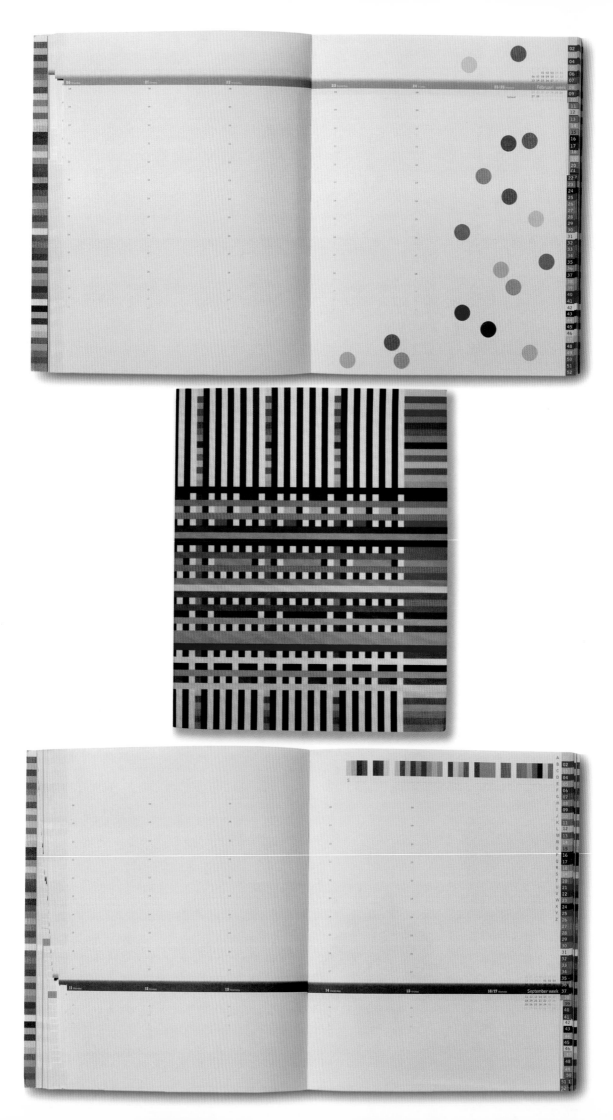

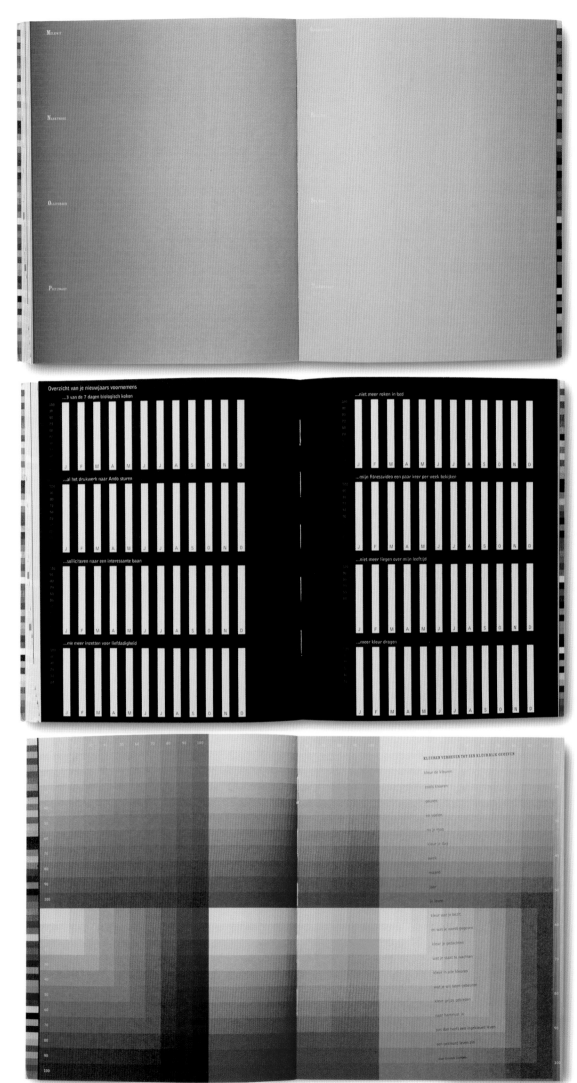

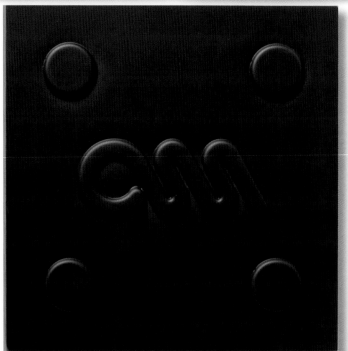

01 02 03 04 05 06 07 08 09 10 11 12

live simply ~ simply live

(365 & 36.5 COMMUNICATIONS)

2005

communication design 601BISANG

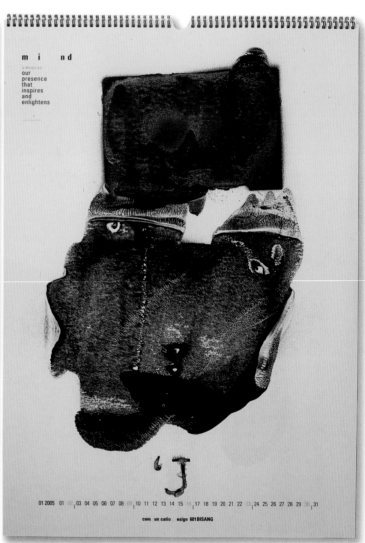

m i n d

our
presence
that
inspires
and
enlightens

'J

01 2005 01 02 03 04 05 06 07 08 09 10 11 12 13 14 15 16 17 18 19 20 21 22 23 24 25 26 27 28 29 30 31

com un catio esign 601BISANG

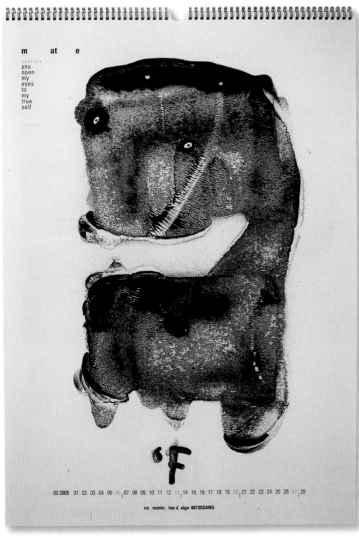

m at e

you
open
my
eyes
to
my
true
self

'F

02 2005 01 02 03 04 05 06 07 08 09 10 11 12 13 14 15 16 17 18 19 20 21 22 23 24 25 26 27 28

co munic ion d sign 601 BISANG

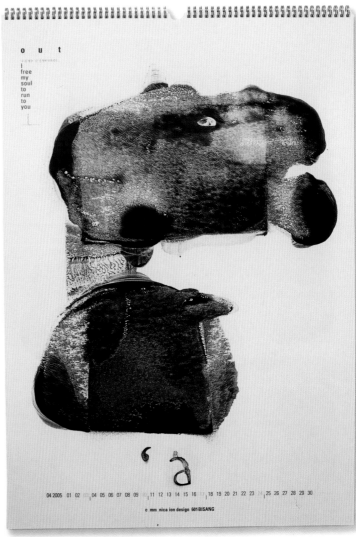

o u t

I
free
my
soul
to
run
to
you

'a

04 2005 01 02 03 04 05 06 07 08 09 10 11 12 13 14 15 16 17 18 19 20 21 22 23 24 25 26 27 28 29 30

c mm nica ion design 601 BISANG

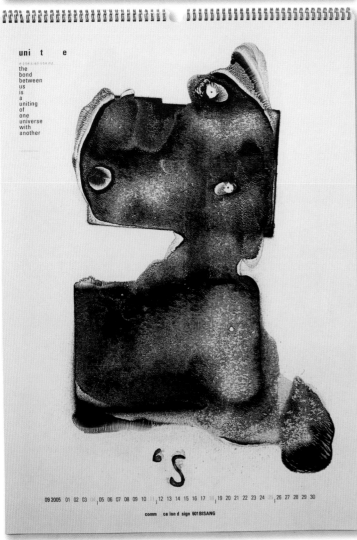

uni t e

the
bond
between
us
is
a
uniting
of
one
universe
with
another

'S

09 2005 01 02 03 04 05 06 07 08 09 10 11 12 13 14 15 16 17 18 19 20 21 22 23 24 25 26 27 28 29 30

comm ca ion d sign 601 BISANG

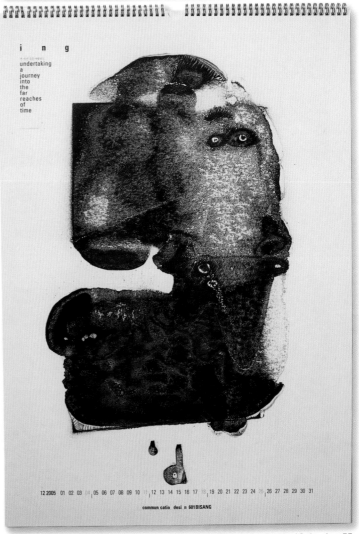

i n g

undertaking
a
journey
into
the
far
reaches
of
time

d

12 2005 01 02 03 04 05 06 07 08 09 10 11 12 13 14 15 16 17 18 19 20 21 22 23 24 25 26 27 28 29 30 31

commun catio desi n 601 BISANG

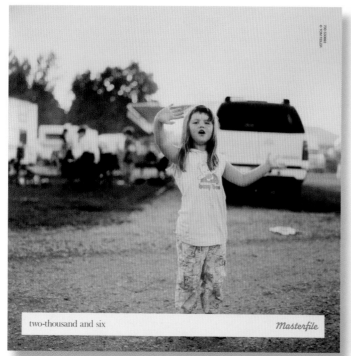

two-thousand and six — *Masterfile*

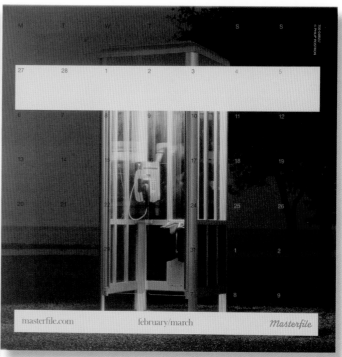

masterfile.com — february/march — *Masterfile*

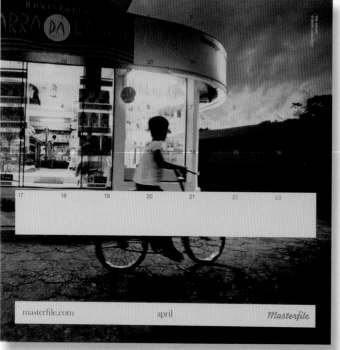

masterfile.com — april — *Masterfile*

masterfile.com — may/june — *Masterfile*

masterfile.com — september — *Masterfile*

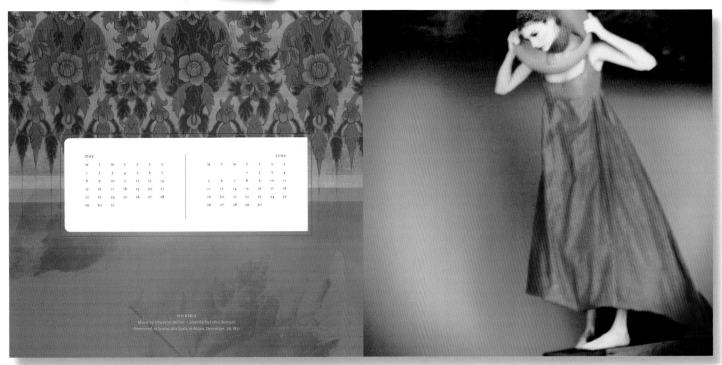

A man came upon a construction site where three bricklayers were working, building what appeared to be identical walls. He asked the first, "What are you doing?" The bricklayer replied, "I am building a wall." He asked the second, "What are you doing?" and the bricklayer answered, "I am building a cathedral." Finally, he asked the third man, "What are you doing?" The bricklayer surveyed his wall and thought carefully before replying, **"I am helping to create a place for the kingdom of heaven on earth."**

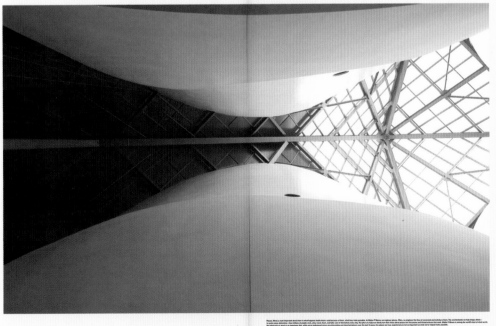

The Future For Business...

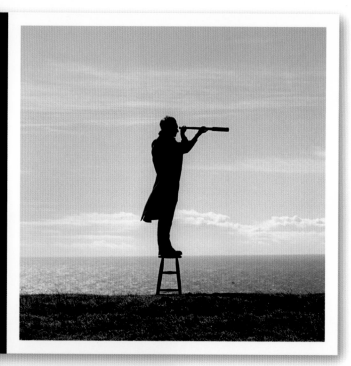

The Future For Business

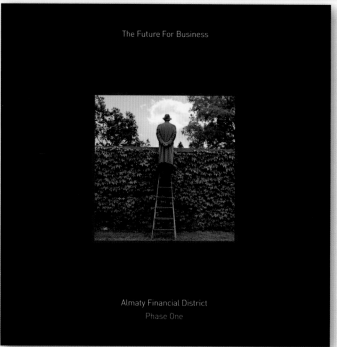

Almaty Financial District
Phase One

Is Uncompromising,

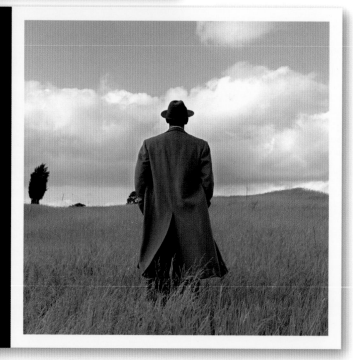

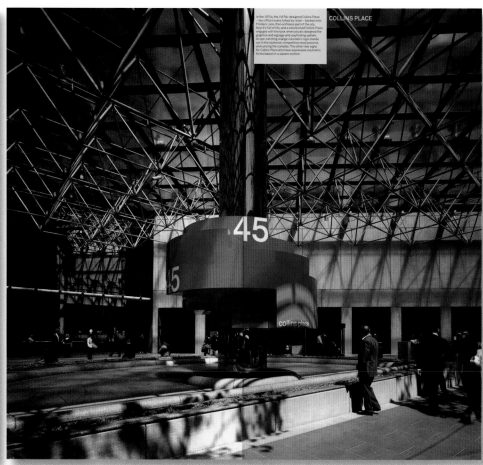

In the 1970s, the I M Pei–designed Collins Place – two office towers linked by retail – backed onto Flinders Lane, then a lifeless part of the city. Now it's full of life, and a refurbished Collins Place engages with the lane. emerystudio designed the graphics and signage and wayfinding system. An eye-catching orange volumetric sign stands out in the cluttered, competitive retail precinct, announcing the complex. The other new signs for Collins Place also have expressive volumetric forms based on a square section

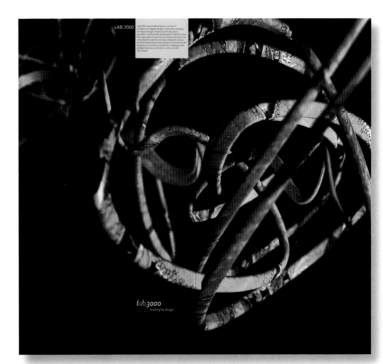

LAB.3000

lab.3000
reading by design

PMP

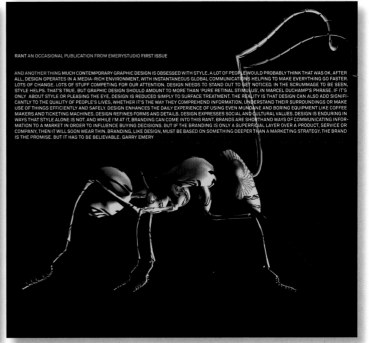

RANT AN OCCASIONAL PUBLICATION FROM EMERYSTUDIO FIRST ISSUE

AND ANOTHER THING MUCH CONTEMPORARY GRAPHIC DESIGN IS OBSESSED WITH STYLE. A LOT OF PEOPLE WOULD PROBABLY THINK THAT WAS OK. AFTER ALL, DESIGN OPERATES IN A MEDIA-RICH ENVIRONMENT, WITH INSTANTANEOUS GLOBAL COMMUNICATIONS HELPING TO MAKE EVERYTHING GO FASTER. LOTS OF CHANGE. LOTS OF STUFF COMPETING FOR OUR ATTENTION. DESIGN NEEDS TO STAND OUT TO GET NOTICED. IN THE SCRUMMAGE TO BE SEEN, STYLE HELPS. THAT'S TRUE. BUT GRAPHIC DESIGN SHOULD AMOUNT TO MORE THAN 'PURE RETINAL STIMULUS', IN MARCEL DUCHAMP'S PHRASE. IF IT'S ONLY ABOUT STYLE OR PLEASING THE EYE, DESIGN IS REDUCED SIMPLY TO SURFACE TREATMENT. THE REALITY IS THAT DESIGN CAN ALSO ADD SIGNIFI-CANTLY TO THE QUALITY OF PEOPLE'S LIVES, WHETHER IT'S THE WAY THEY COMPREHEND INFORMATION, UNDERSTAND THEIR SURROUNDINGS OR MAKE USE OF THINGS EFFICIENTLY AND SAFELY. DESIGN ENHANCES THE DAILY EXPERIENCE OF USING EVEN MUNDANE AND BORING EQUIPMENT LIKE COFFEE MAKERS AND TICKETING MACHINES. DESIGN REFINES FORMS AND DETAILS. DESIGN EXPRESSES SOCIAL AND CULTURAL VALUES. DESIGN IS ENDURING IN WAYS THAT STYLE ALONE IS NOT. AND WHILE I'M AT IT, BRANDING CAN COME INTO THIS RANT. BRANDS ARE SHORTHAND WAYS OF COMMUNICATING INFOR-MATION TO A MARKET IN ORDER TO INFLUENCE BUYING DECISIONS. BUT IF THE BRANDING IS ONLY A SUPERFICIAL LAYER OVER A PRODUCT, SERVICE OR COMPANY, THEN IT WILL SOON WEAR THIN. BRANDING, LIKE DESIGN, MUST BE BASED ON SOMETHING DEEPER THAN A MARKETING STRATEGY. THE BRAND IS THE PROMISE. BUT IT HAS TO BE BELIEVABLE. GARRY EMERY

CITY MUSEUM

city museum

MY MELBOURNE
UNTIL OCTOBER 30

EGG PRESS

WOODY PIRTLE
object lesson

#1

SISTER II

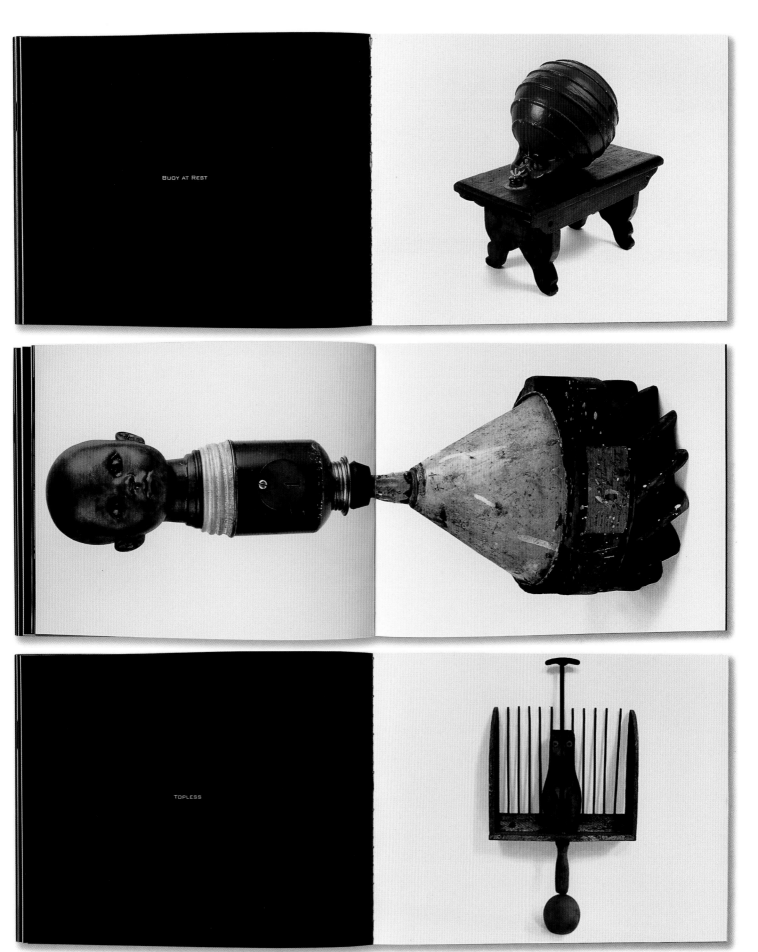

BUOY AT REST

TOPLESS

VERB

VERB YELLOWBALL.
PLAY WITH THIS BALL.

1. GO TO VERBNOW.COM,
ENTER THE CODE BELOW AND
TELL US WHAT YOU DID WITH IT
2. PASS IT TO ANOTHER KID

WW96WW5

VERB.

DIRECTORY
2006 ISSUE 1

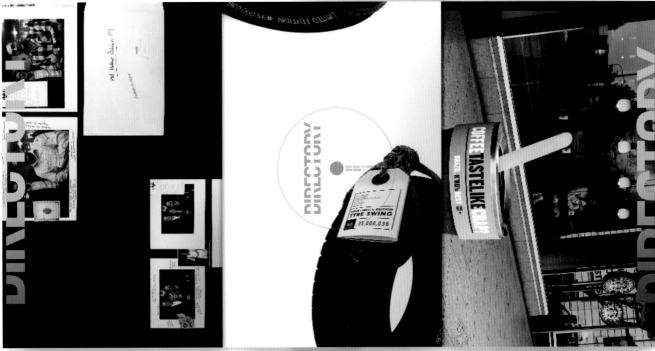

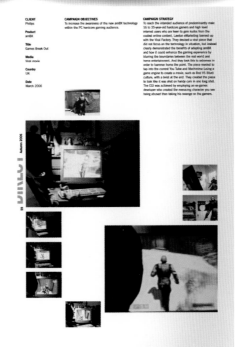

CLIENT
Philips

Product
amBX

Title
Games Break Out

Media
Viral movie

Country
UK

Date
March 2006

CAMPAIGN OBJECTIVES
To increase the awareness of the new amBX technology within the PC hardcore gaming audience.

CAMPAIGN STRATEGY
To reach the intended audience of predominantly male 16 to 35-year-old hardcore gamers and high level internet users who are keen to gain kudos from the coolest online content, Lawton eMarketing teamed up with the Viral Factory. They devised a viral piece that did not focus on the technology in situation, but instead clearly demonstrated the benefits of adopting amBX and how it could enhance the gaming experience by blurring the boundaries between the real world and home entertainment. And they took this to extremes in order to hammer home the point. The piece needed to tap into the current You Tube and Machinima (using a game engine to create a movie, such as Red VS Blue) culture, with a twist at the end. They created the piece to look like it was shot on handy cam in one long shot. The CGI was achieved by employing an ex-games developer who created the menacing character you see being abused then taking his revenge on the gamers.

RESULTS
The viral quickly became one of the top You Tube 'Most linked' virals with more than 350,000 views and more than 98,000 links (users lifting the supplied link and posting it on sites and blogs). There were more than 370,000 views on the viral's webpage www.4mBs.com in the first three weeks, 83,000 downloads of the WMV and 9,000 of the QuickTime. Throughout the campaign there were 40,000 click throughs to the amBX website (directly from the embedded Flash movie), a click through rate of 11%. The viral was also picked up on the ever-popular FHM games email as well as globally via non-paid for seeding.

AGENCY
Lawton eMarketing
The Viral Factory

Creative Team
The Viral Factory
Art Director
The Viral Factory
Copywriter
Mark Cox (Lawton eMarketing)
Account Supervisor
The Viral Factory
Producer
The Viral Factory with Ben Wheatley
Director
The Viral Factory
Production Company
The Viral Factory
Editor

Production
Alex Mallison, X-Barn
Post-Production
The Strongroom Exposure Internet
Audio Post-Production

Other
Claire Axton

To present the menswear and womenswear
together – but separately – we created a book
with a double spine and mirrored pagination.

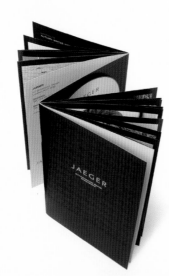

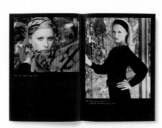

The charity's fundraising theme for 2005 was
'Colours of the World'. The invitations combine
a die-cut title and six different-coloured envelopes.

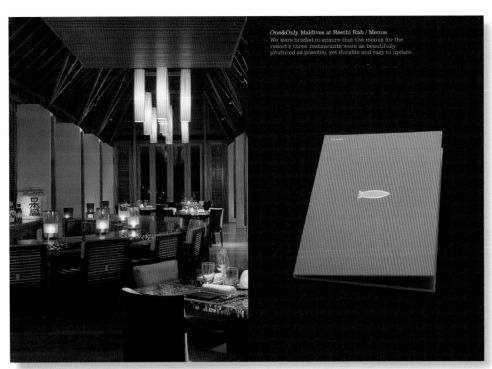

One&Only Maldives at Reethi Rah / Menus
We were briefed to ensure that the menus for the resort's three restaurants were as beautifully produced as possible, yet durable and easy to update.

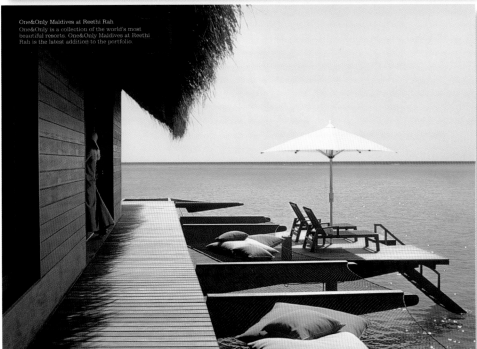

One&Only Maldives at Reethi Rah
One&Only is a collection of the world's most beautiful resorts. One&Only Maldives at Reethi Rah is the latest addition to the portfolio.

Best of the Best / Identity and Website
Since 2000, Best of the Best have run sportscar competitions at UK airports. The new identity and website is aimed at increasing online entries.

fd

01. 02. 03.

Launch Renew Envision

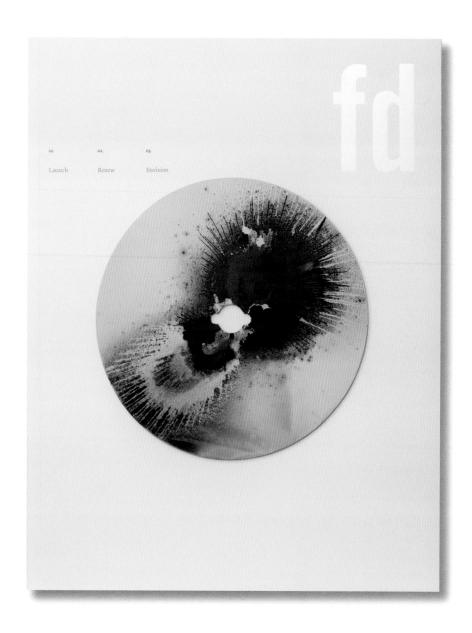

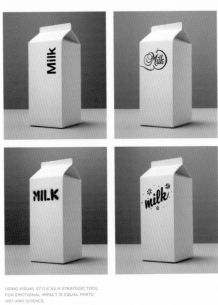
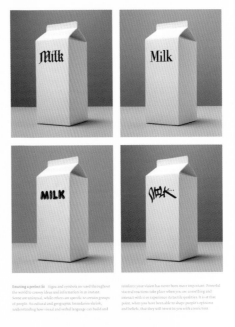

USING VISUAL STYLE AS A STRATEGIC TOOL
FOR EMOTIONAL IMPACT IS EQUAL PARTS
ART AND SCIENCE.

Ensuring a perfect fit : Signs and symbols are used throughout the world to convey ideas and information in an instant. Some are universal, while others are specific to certain groups of people. As cultural and geographic boundaries shrink, understanding how visual and verbal language can build and reinforce your vision has never been more important. Powerful visceral reactions take place when you see something and interact with it or experience its tactile qualities. It is at that point, when you have been able to shape people's opinions and beliefs, that they will invest in you with conviction.

OAK

OAKLAND

More than four decades ago Northrop Frye, Professor of English at the University of Toronto, published an influential set of essays with an evocative title — The Educated Imagination.

Today, there is no other place in Canada where the educated imagination is more alive than at U of T: it is evident in our classrooms, our research labs, our libraries, our green spaces and the multitude of other opportunities available to our students, faculty, staff, alumni and the greater community.

Our students, the reason we are here, are the best and brightest from Canada and around the world. On each of our three campuses, learners of all ages enjoy a remarkable array of scholarships and bursaries to help them pursue their dreams. Our faculty members teach with commitment and enthusiasm, while conducting research on topics that range from sustaining the Inuktitut language for future generations to the causes of cancer and Alzheimer's disease. Our dedicated staff are constantly reworking and refining the operational foundations on which the academic excellence of the institution rests. And our alumni, in all walks of life and in every part of the globe, remain our most important ambassadors and our greatest supporters.

Within these pages you will find a selection of the extraordinary educational opportunities and pioneering scholarship for which the University of Toronto is justly renowned. You will also see evidence of the commitment of various members of

Students are at the top of David Naylor's priority list.

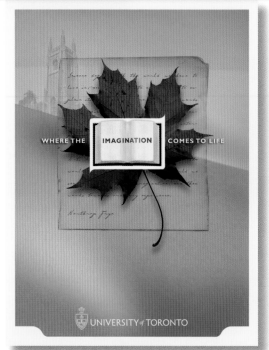

WHERE THE IMAGINATION COMES TO LIFE

UNIVERSITY of TORONTO

HELLO my name is

Kevin

"Volunteering is part of who I am, and I know that volunteering is important for many people at the University," says Rose Patten, Chair of U of T's Governing Council and Senior Executive Vice-President, Human Resources and Strategic Management at BMO Financial Group in Toronto.

Cited by U.S. Banker as one of the 25 most powerful women in banking, Patten also provides counsel and support to many other groups. "A large part of my volunteer time has been involved with education and in helping people meet their true potential," she says.

"If people see a current need they should put their talents to work to help improve things," says Trinity College undergraduate student Brian Kolenda, who is an analyst at the G8 Research Group at the Munk Centre for International Studies and was Co-Chair of the Trinity Orientation Committee.

The University also offers volunteer opportunities for seniors, including with the Soldiers' Tower Committee. "Many U of T people fought and died for the country," says Chair Lt.(N) Owen S. Williams. "It's important to preserve those memories."

Rose Patten's volunteer activities focus on education.

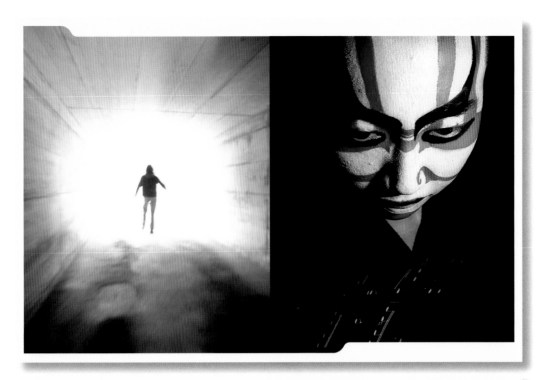

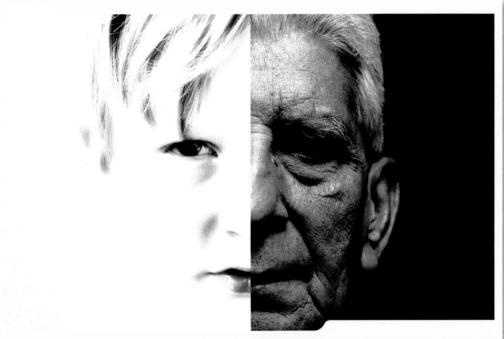

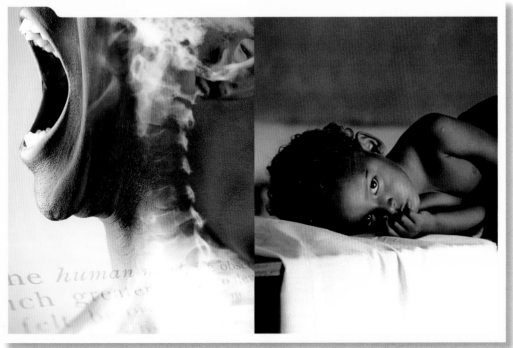

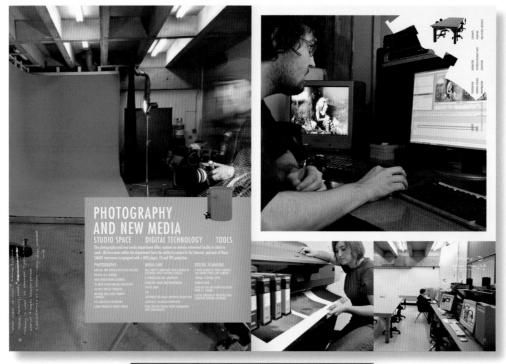

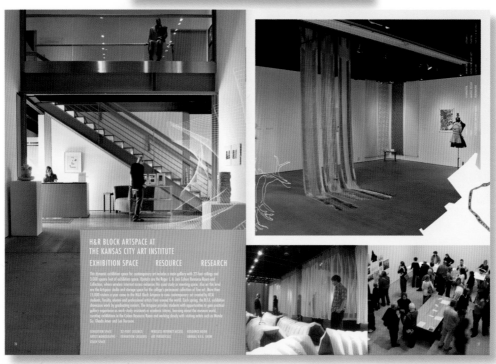

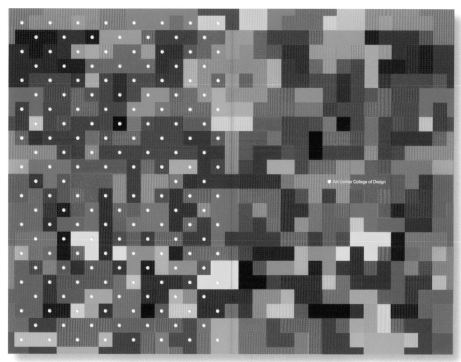

Art Center College of Design

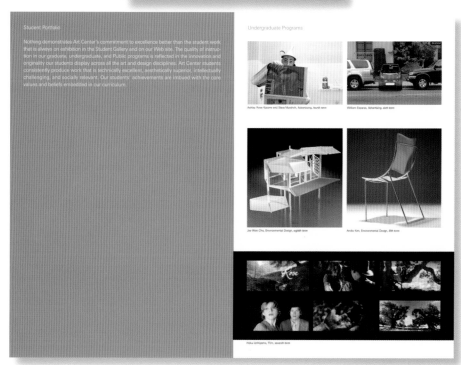

Student Portfolio

Nothing demonstrates Art Center's commitment to excellence better than the student work that is always on exhibition in the Student Gallery and on our Web site. The quality of instruction in our graduate, undergraduate, and Public programs is reflected in the innovation and originality our students display across all the art and design disciplines. Art Center students consistently produce work that is technically excellent, aesthetically superior, intellectually challenging, and socially relevant. Our students' achievements are imbued with the core values and beliefs embedded in our curriculum.

Undergraduate Programs

The Design Legends Gala is a nascent tradition, in only its second year, and already a celebratory occasion for all who respect the importance of the great design legacy. The gala is an opportunity for the community of designers to gather and honor those who have come before and whose creativity, inspiration, innovation and brilliant execution have defined the profession and every young designer's ambitions. This is an event where old friendships are renewed, new friendships are created and everyone is in awe of the sheer talent of the design profession.

The AIGA medal, the most distinguished honor in the field of communication design, is awarded to individuals in recognition of their exceptional achievements in or contributions to graphic design and visual communication in the United States. The contribution may be in the practice of design, teaching, writing or leadership of the profession.

AIGA MEDALISTS

FOR OVER 85 YEARS, THE AIGA MEDAL HAS BEEN AWARDED TO THE FEW WHO SET THE STANDARDS OF EXCELLENCE FOR DESIGN.

1920s
Norman T. A. Munder, 1920
Daniel Berkeley Updike, 1922
Stephen H. Horgan, 1924
John C. Agar, 1924
Bruce Rogers, 1925*
Burton Emmett, 1926
Timothy Cole, 1927
Frederic W. Goudy, 1927*
William A. Dwiggins, 1929

1930s
Henry Watson Kent, 1930
Dard Hunter, 1931
Porter Garnett, 1932
Henry Lewis Bullen, 1934
Rudolph Ruzicka, 1935
J. Thompson Willing, 1935
William A. Kittredge, 1939

1940s
Thomas M. Cleland, 1940
Carl Purington Rollins, 1941
Edwin & Robert Grabhorn, 1942
Edward Epstean, 1944
Frederic G. Melcher, 1945
Stanley Morison, 1946
Elmer Adler, 1947
Lawrence C. Wroth, 1948

1950s
Earnest Elmo Calkins, 1950
Alfred A. Knopf, 1950
Harry L. Gage, 1951
Joseph Blumenthal, 1952
George Macy, 1953
Will Bradley, 1954
Jan Tschichold, 1954*

P. J. Conkwright, 1955
Ray Nash, 1956
Charles J. Rosner, 1957
H. C. Spencer, 1958
May Massee, 1959

1960s
Walter Paepcke, 1960
Paul A. Bennett, 1961
Willem Sandberg, 1962
Saul Steinberg, 1963
Josef Albers, 1964
Leonard Baskin, 1965
Paul Rand, 1966*
Romana Javitz, 1967
Dr. Giovanni Mardersteig, 1968
Dr. Robert R. Leslie, 1969

1970s
Herbert Bayer, 1970*
Will Burtin, 1971
Milton Glaser, 1972*
Richard Avedon, 1973
Allen Hurlburt, 1973
Philip Johnson, 1973
Robert Rauschenberg, 1974
Bradbury Thompson, 1975*
Jerome Snyder, 1976
Henry Wolf, 1976*
Charles & Ray Eames, 1977
Lou Dorfsman, 1978
Ivan Chermayeff & Thomas Geismar, 1979*

1980s
Herb Lubalin, 1980
Saul Bass, 1981*
Massimo & Lella Vignelli, 1982
Herbert Matter, 1983

Leo Lionni, 1984
Seymour Chwast, 1985*
Walter Herdeg, 1986
Alexey Brodovitch, 1987
Gene Federico, 1987*
William Golden, 1988*
George Tscherny, 1988
Paul Davis, 1989*
Bea Feitler, 1989

1990s
Alvin Eisenman, 1990
Frank Zachary, 1990
Colin Forbes, 1991
E. McKnight Kauffer, 1991
Lester Beall, 1992*
Rudolph de Harak, 1992
George Nelson, 1992
Alvin Lustig, 1993
Tomoko Miho, 1993*
Muriel Cooper, 1994
John Massey, 1994
Matthew Carter, 1995*
Stan Richards, 1995
Ladislav Sutnar, 1995
Cipe Pineles, 1996
George Lois, 1996
Lucian Bernhard, 1997
Zuzana Licko & Rudy VanderLans, 1997
Louis Danziger, 1998
April Greiman, 1998
Steven Heller, 1999
Tibor Kalman, 1999
Katherine McCoy, 1999

2000s
P. Scott Makela & Laurie Haycock Makela, 2000
Fred Seibert, 2000
Michael Vanderbyl, 2000
Samuel Antupit, 2001
Paula Scher, 2001*
Robert Brownjohn, 2002
Christopher Pullman, 2002
B. Martin Pedersen, 2003
Woody Pirtle, 2003*
Joseph Bonsignore, 2004*
Charles Coiner, 2004*
Richard, Jean & Patrick Coyne, 2004
James Cross, 2004
Sheila Levrant de Bretteville, 2004
Jay Doblin, 2004
Joe Duffy, 2004
Martin Fox, 2004
Caroline Warner Hightower, 2004
Kit Hinrichs, 2004
Walter Landor, 2004
Philip Meggs, 2004*
James Miho, 2004
Silas Rhodes, 2004
Jack Stauffacher, 2004
Alex Steinweiss, 2004
Deborah Sussman, 2004
Edward Tufte, 2004
Fred Woodward, 2004*
Richard Saul Wurman, 2004
Bart Crosby, 2005
Meredith Davis, 2005
Steff Geissbuhler, 2005

* Indicates examples shown

AIGA

Design Archives

The AIGA Design Archives are a record of annual juried selections of design excellence and the work of designers honored by AIGA. These interactive archives provide broad accessibility to an extensive collection of contemporary design for research and reference. This definitive resource on American design will continue to expand with each year's new selections and the addition of special collections.

designarchives.aiga.org

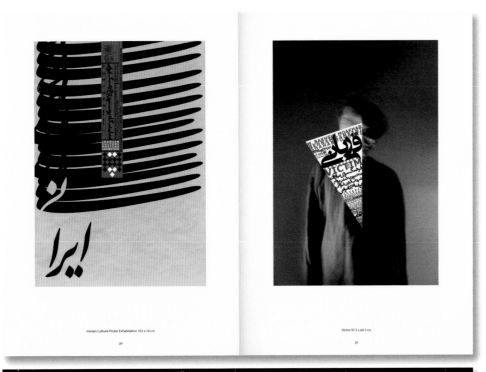

Iranian Cultural Poster Exhabitation 102 x 74 cm

30

Victim 97.5 x 68.3 cm

31

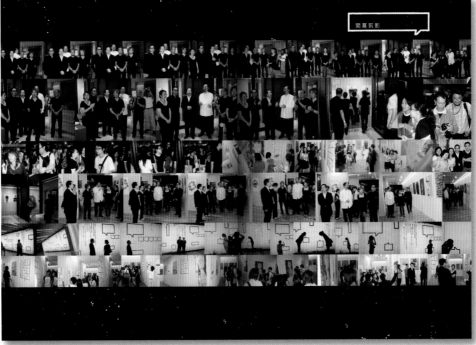

開幕剪影

一帆風順
Keep Smooth for Your Life 100 x 70 cm

88

多彩的世界・美麗的台灣
Formosa 100 x 70 cm

89

IN PIRATI NS AIGA 50

WHENEVER. WHEREVER. WHATEVER. BE INSPIRED.

NINTH BIENNIAL AIGA 50 EXHIBITION

PROJECT National Association of Realtors Plaza Totems DESIGN GROUP Smith Strategic, Inc. and Beth Singer Design, LLC CREATIVE DIRECTOR Howard Smith
ART DIRECTOR Beth Singer DESIGNERS Beth Singer, Lolan O'Rourke FABRICATOR Art in Metal USA, inc. CLIENT National Association of Realtors

PROJECT AIGA 50 Call for Inspirations DESIGN GROUP Design Army CREATIVE DIRECTOR Jake Lefebure ART DIRECTOR Pum Lefebure
DESIGNERS Lee Monroe, Dan Adler WRITER Alissa Walker PRINTER Colorcraft of Virginia CLIENT AIGA DC

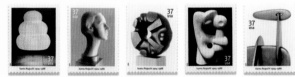

PROJECT Isamu Noguchi Stamp Design DESIGN GROUP United States Postal Service ART DIRECTOR Derry Noyes TYPOGRAPHER Derry Noyes DESIGNER Derry Noyes EXISTING ART Isamu Noguchi
PHOTOGRAPHERS Rudy Burckhardt (Margaret La Farge Osborn and Mother and Child), Nicolas H. Eckstrom (Black Sun), Bill Jacobson (Figure), Kevin Noble (Akari) CLIENT United States Postal Service

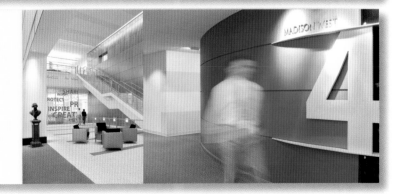

PROJECT US Patent & Trademark Offices Environmental Graphics DESIGN GROUP Gensler Architecture, Design & Planning Worldwide GRAPHIC DESIGNERS Beth Ready,
Libby Settlemeyer, Maurice Reid PRINCIPAL Paul Herrick, AIA DESIGN PRINCIPAL Chris Banks, AIA CLIENT US Patent & Trademark Offices

BLACK
INTENTIONS
SUSAN
C o HN

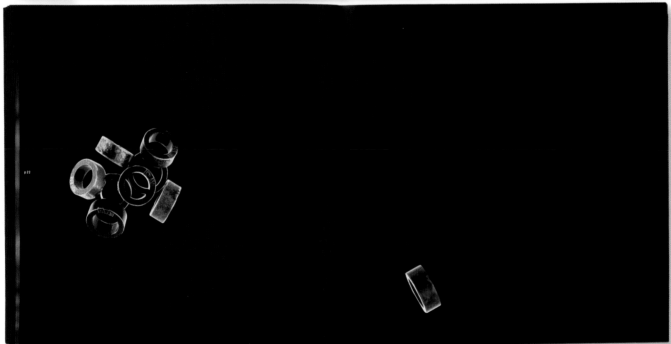

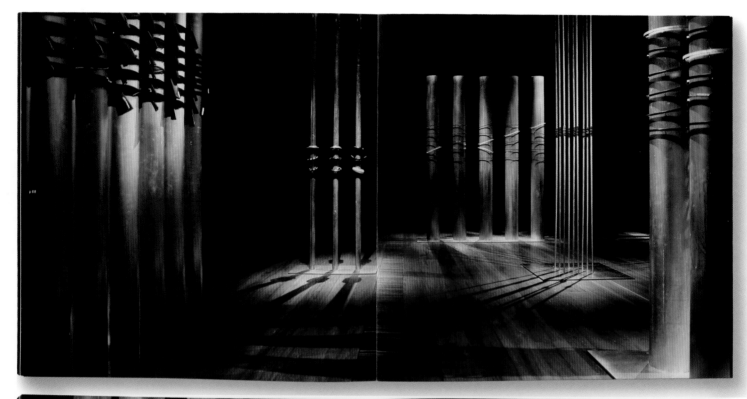

p 88

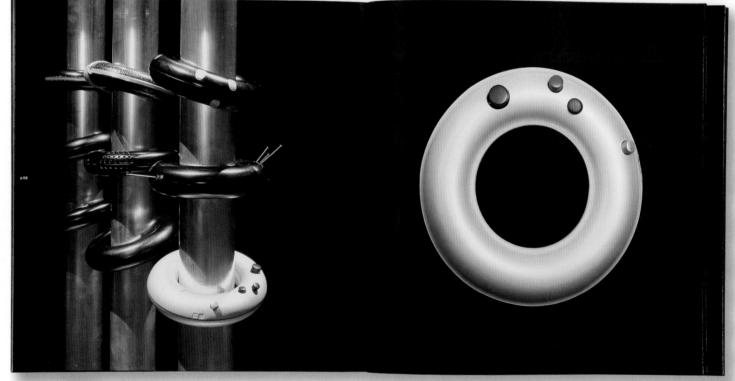

p 88

p 58

Susan Cohn would like to thank the National Gallery of Victoria, PERMASTEELISA, Workshop 3000 team, and John Denton

Book contributors

Shannon McGrath: photography
Justin Clemens: essay
Virginia Trioli: essay
Garry Emery and Tim Murphy, emerystudio: design
Tim Buenk: print production

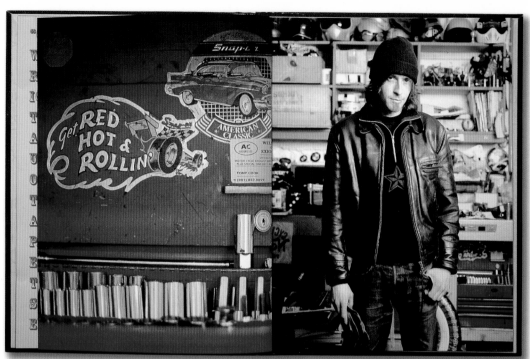

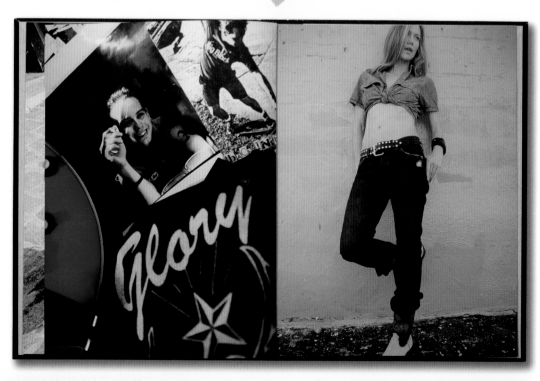

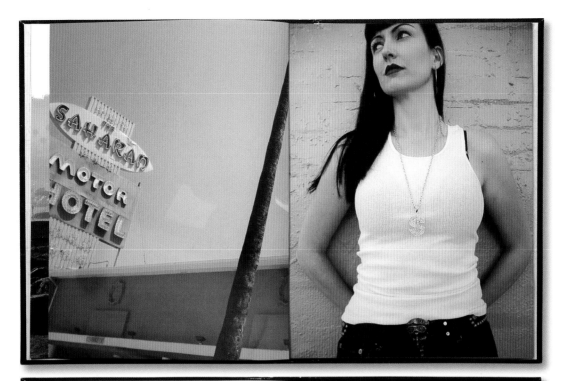

"GLORY WAS FOUNDED IN 1999 WITH AN IDEA TO TAKE INSPIRATION FROM CLASSIC AMERICAN CASUAL WEAR, UPDATE THE STYLES, AND MANUFACTURE ALL OF OUR PRODUCTS IN THE U.S.A. TO THE HIGH STANDARDS OF QUALITY THAT HAVE SEEMED TO DISAPPEAR FROM TODAY'S APPAREL INDUSTRY. AS A COMPANY, WE BELIEVE IN THE POWER OF THE INDIVIDUAL CUSTOMER, THE POWER OF THE SMALL BUSINESS, AND POWER OF THE AMERICAN DREAM.

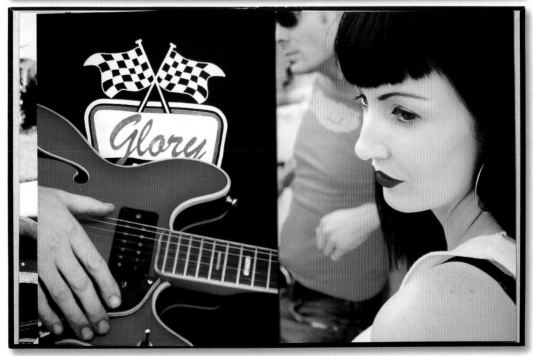

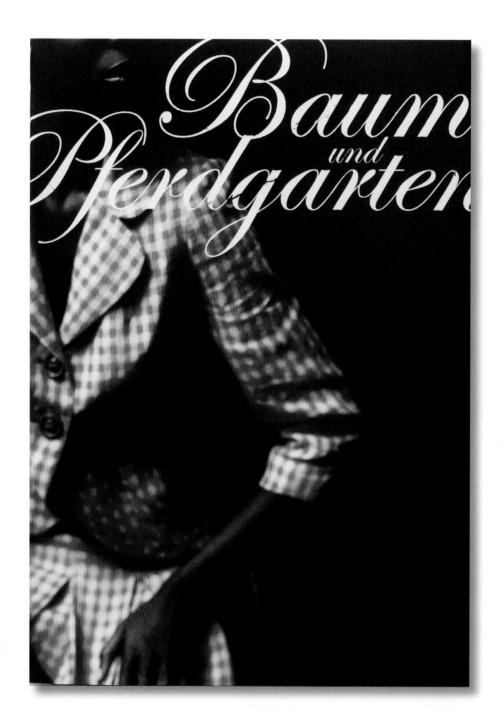

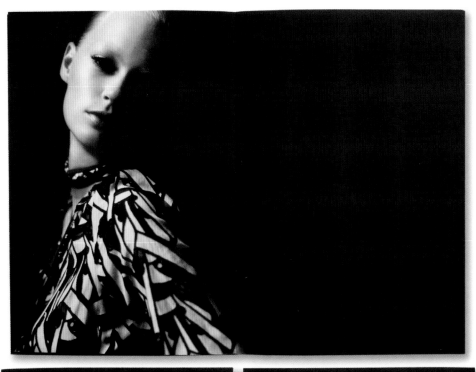

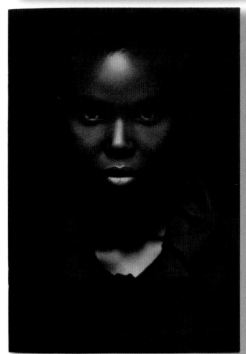

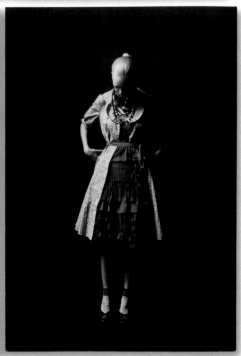

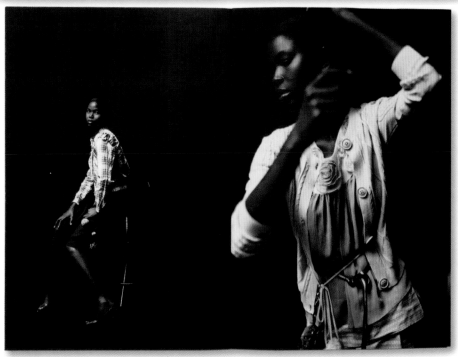

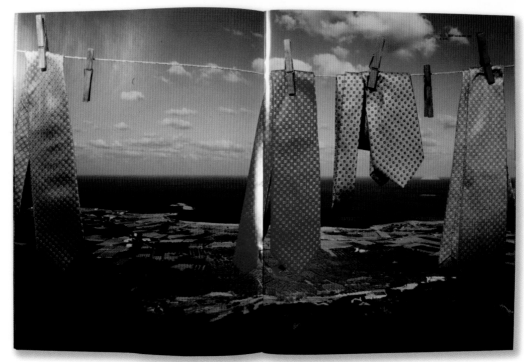

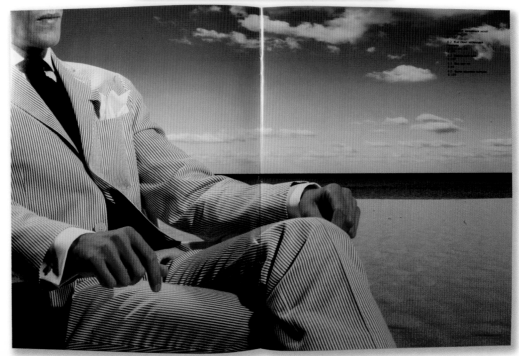

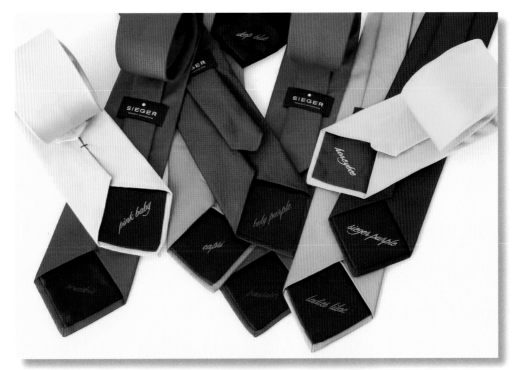

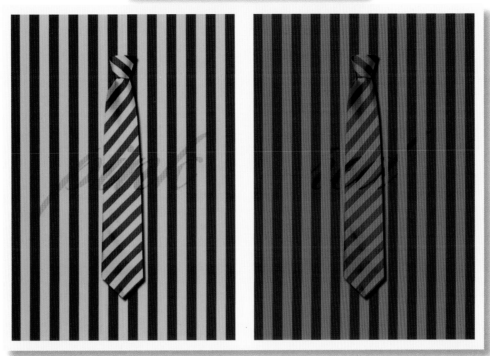

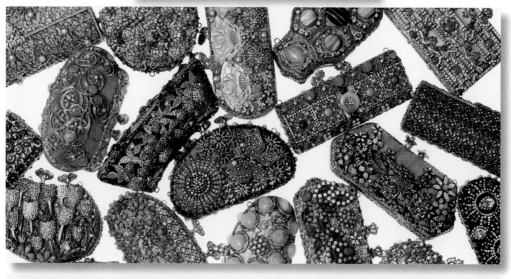

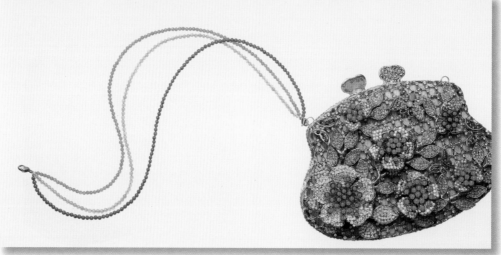

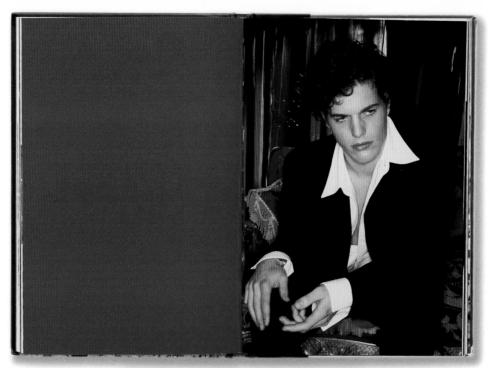

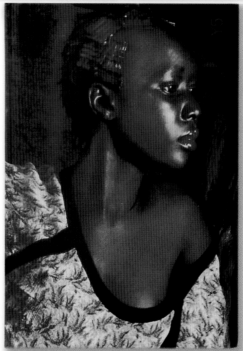

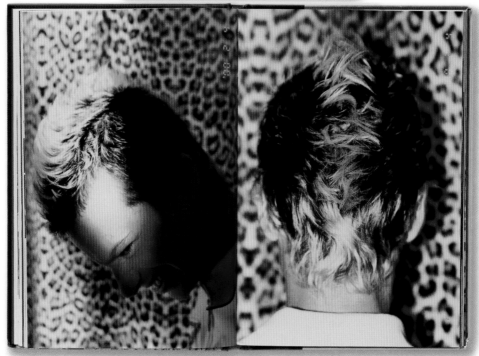

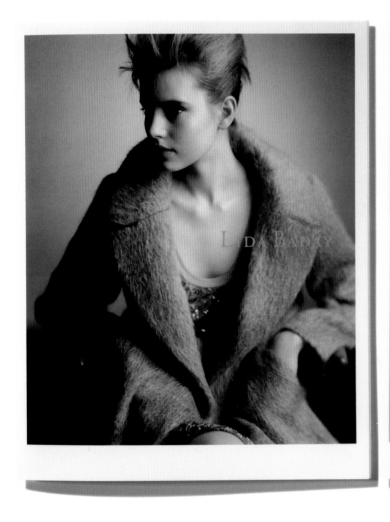

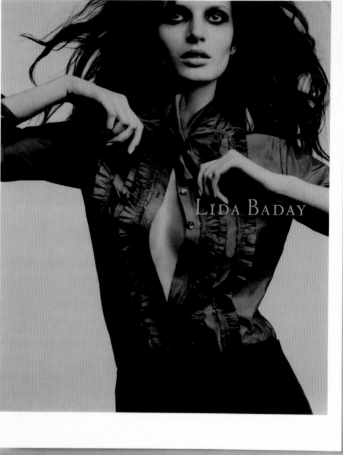

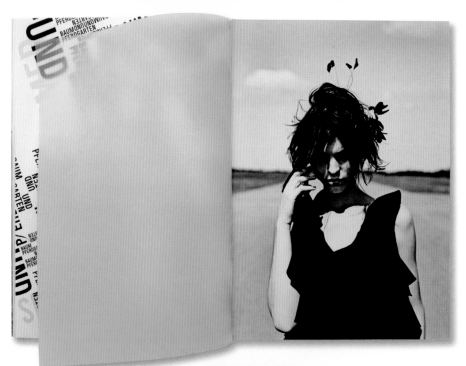

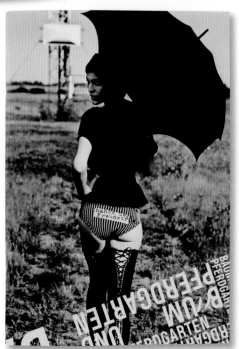

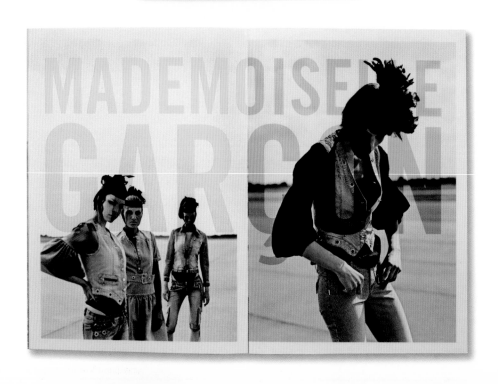

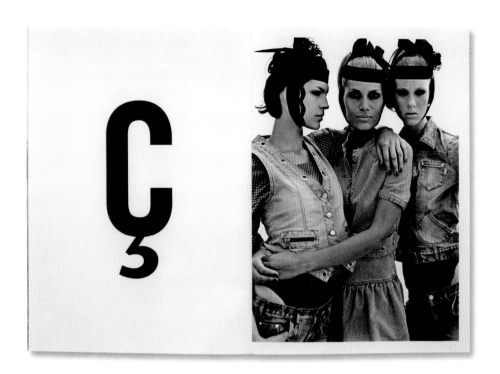

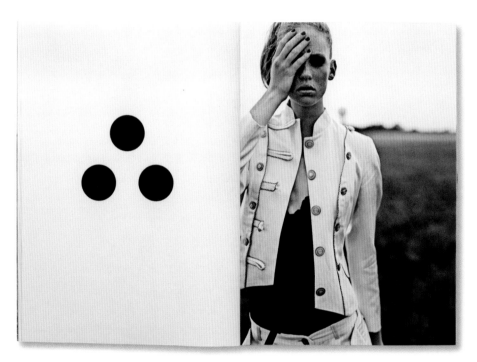

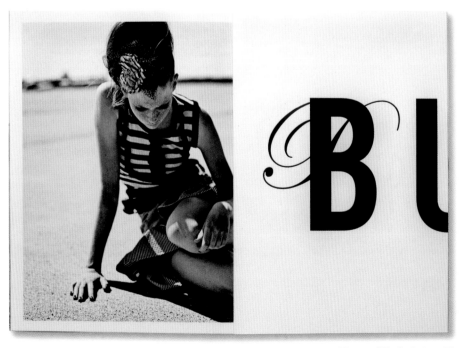

UNIQLO
PAPER N°1

FROM TOKYO TO NEW YORK

UNI
QLO

ISSUE 1 FREE COPY

O

Plus or Minus

ORGANIZED LINES,
SHARP BLACKS, AND
CLEAN WHITES CREATE
AN IMPECCABLE
SILHOUETTE FOR FALL.
MINIMAL ELEMENTS
CREATE MAXIMUM
IMPRESSION.

PLUS OR
MINUS

SOPHISTICATED MINIMALISM AT UNIQLO

Plus or Minus		Closer Look	
PHOTOGRAPHER	Alexei Hay	PHOTOGRAPHER	Ben Pogue
STYLIST	Sabina Schreder	PROP STYLIST	Molly Findlay
HAIR	Kevin Mancuso		
MAKEUP	Ric Pipino		

p.72 FALL/WINTER 2004 ISSUE 1 UNIQLO PAPER

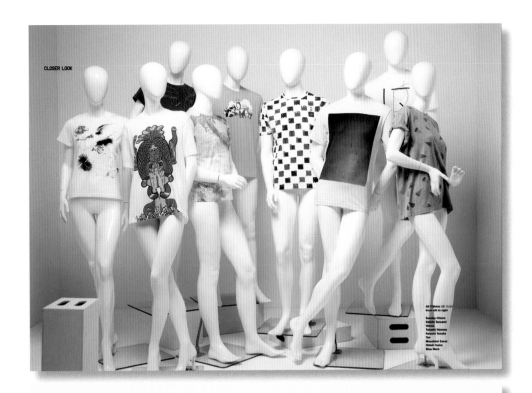

CLOSER LOOK

All T-Shirts US $15.50
from left to right

Suicide-Vision
Keiichi Tanaami
Hisui
Takashi Homma
Katschi Tezuka
Ten
Masafumi Sanai
Hideki Inaba
Sine Mark

STORE LIST

JAPAN

[dense store address listing]

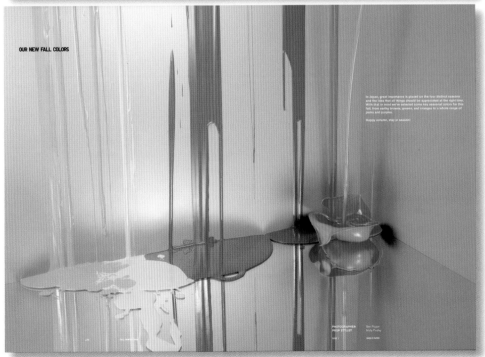

OUR NEW FALL COLORS

In Japan, great importance is placed on the four distinct seasons, and the idea that all things should be appreciated at the right time. With that in mind we've selected some new seasonal colors for this fall, from earthy browns, greens, and oranges to a whole range of pinks and purples.

Happy autumn, stay in season!

PHOTOGRAPHER
PROP STYLIST

Ben Prayer
Molly Findlay

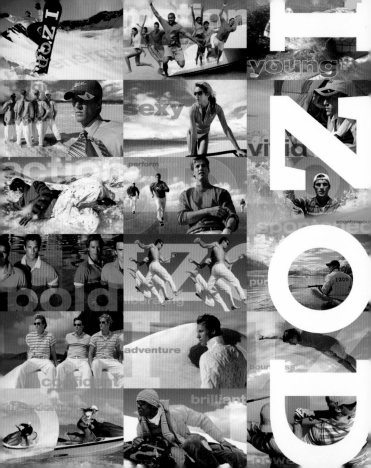

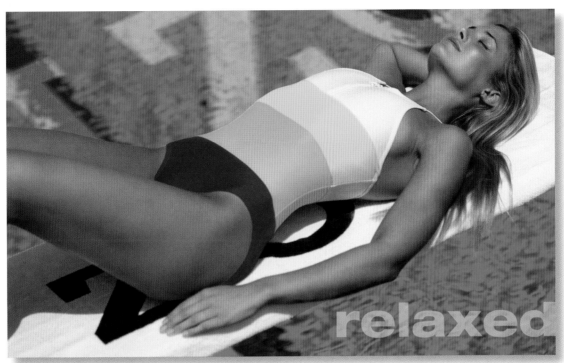

relaxed

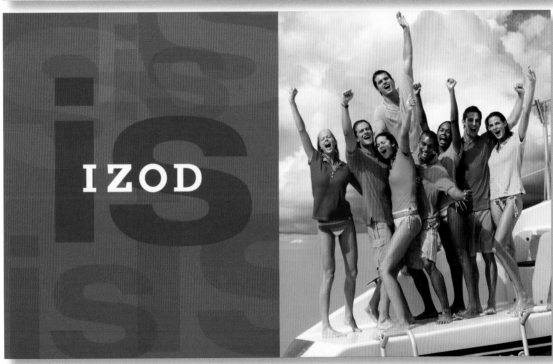

IZOD

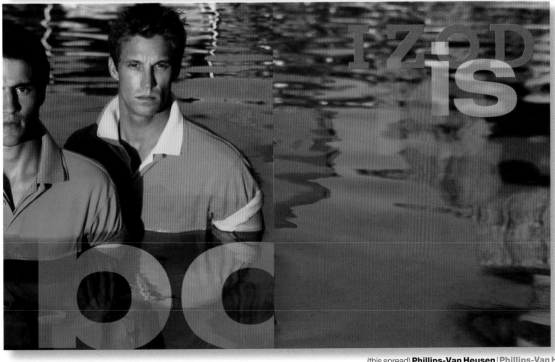

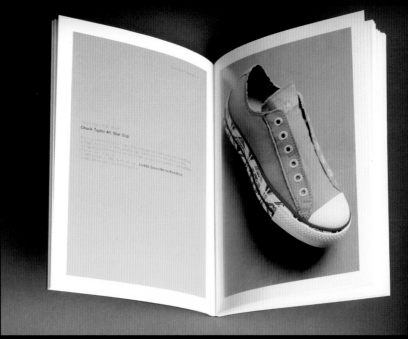

Chuck Taylor All Star Slip

1U482 Green/White/Red/Blue

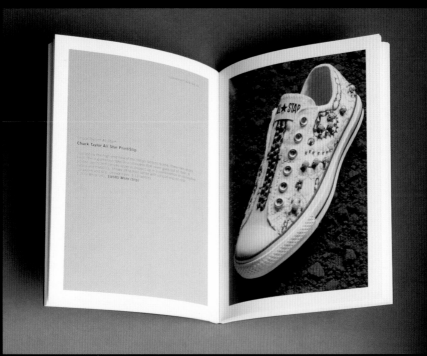

Chuck Taylor All Star Print/Slip

1U580 White /Slip

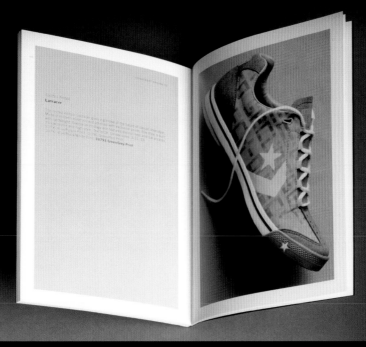

Lamracer

1U793 Green/Grey Print

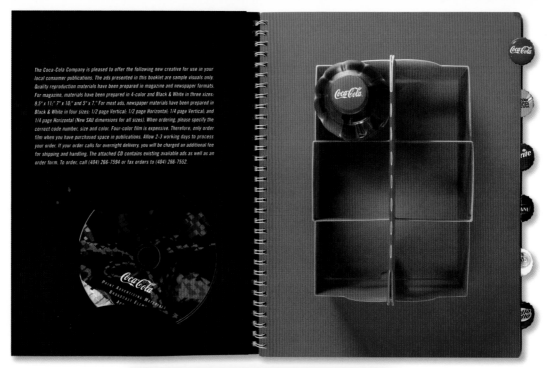

The Coca-Cola Company is pleased to offer the following new creative for use in your local consumer publications. The ads presented in this booklet are sample visuals only. Quality reproduction materials have been prepared in magazine and newspaper formats. For magazine, materials have been prepared in 4-color and Black & White in three sizes: 8.5" x 11;" 7" x 10;" and 5" x 7." For most ads, newspaper materials have been prepared in Black & White in four sizes: 1/2 page Vertical; 1/2 page Horizontal; 1/4 page Vertical; and 1/4 page Horizontal (New SAU dimensions for all sizes). When ordering, please specify the correct code number, size and color. Four-color film is expensive. Therefore, only order film when you have purchased space in publications. Allow 2-3 working days to process your order. If your order calls for overnight delivery, you will be charged an additional fee for shipping and handling. The attached CD contains existing available ads as well as an order form. To order, call (404) 266-7594 or fax orders to (404) 266-7552.

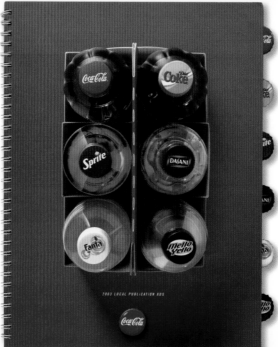

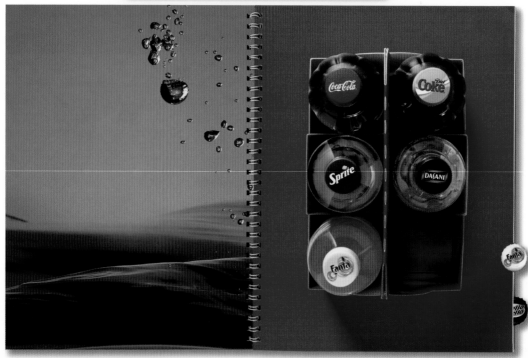

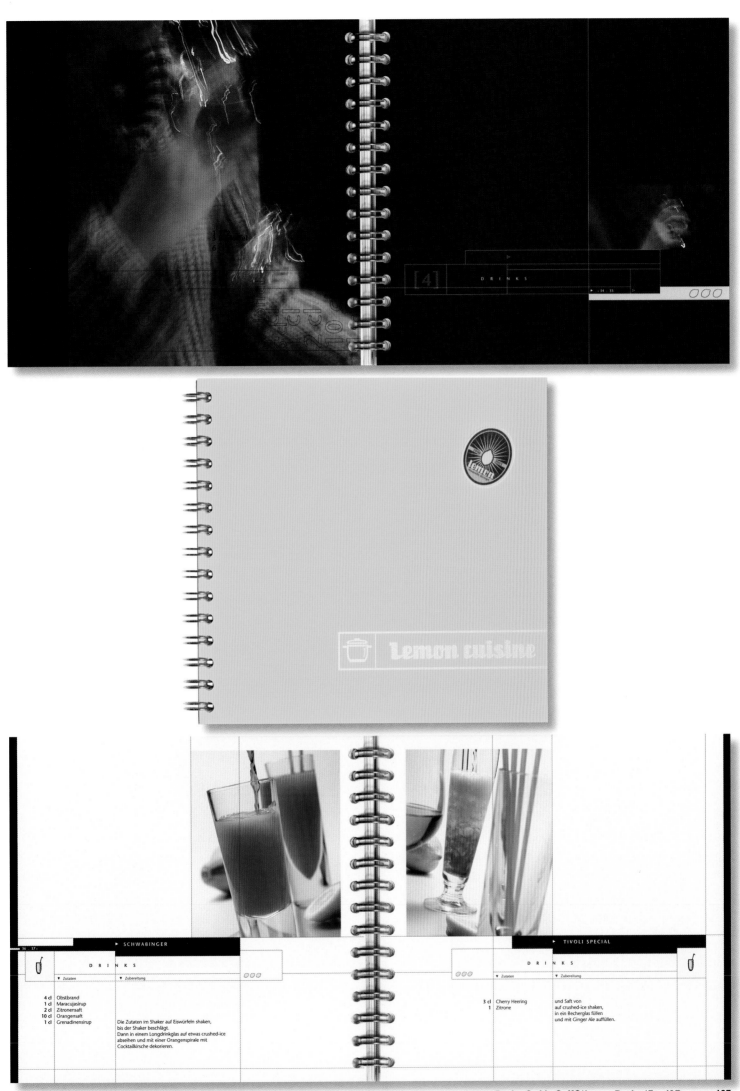

[4] D R I N K S ‹ 34 . 35 ›

Lemon cuisine

36 | 37

▸ SCHWABINGER

D R I N K S

	▾ Zutaten	▾ Zubereitung
4 cl	Obstbrand	
1 cl	Maracujasirup	
2 cl	Zitronensaft	
10 cl	Orangensaft	
1 cl	Grenadinensirup	Die Zutaten im Shaker auf Eiswürfeln shaken, bis der Shaker beschlägt. Dann in einem Longdrinkglas auf etwas crushed-ice abseihen und mit einer Orangenspirale mit Cocktailkirsche dekorieren.

▸ TIVOLI SPECIAL

D R I N K S

	▾ Zutaten	▾ Zubereitung
3 cl	Cherry Heering	und Saft von
1	Zitrone	auf crushed-ice shaken, in ein Becherglas füllen und mit Ginger Ale auffüllen.

[optimism]

amicus

Amicus® is a line of ergonomic seating designed to function for any person, task or environment; to accommodate the full range of ergonomic needs and individual workstyles. Highly adjustable, Amicus offers multiple advanced features that promote a healthy seated posture in any position. A fully integrated seating line, Amicus includes task seating, general use models and guest chairs.

In 2002, deeply in love, an elderly French couple (ages 96 and 94) were married in the town of Clapier, France.

How do we imagine the future from here? At Teknion®, we remain optimists. We envision an opportunity to create a prosperous and sustainable world; to serve the process of renewal and recovery through business solutions that elicit and harness creativity; that create smart, human-centered spaces that spark ideas and set new worlds in motion. Teknion's integrated portfolio of products is designed to enlarge the compass of planning possibilities; to serve the multiplicity of human needs from the mobile wireless workplace to a suite of private offices and everything in between. Teknion designs for the future with confidence; for the many potential forms of work as they unfold today, tomorrow and the day after.

altos

Altos® is a full-height, architectural wall system designed to create interior spaces of varied dimensions and planning requirements for today and tomorrow. Interchangeable fascias combine to meet aesthetic and functional requirements in the executive office, boardroom, team and managerial spaces. Altos also integrates seamlessly with existing office furniture and systems.

The number of doomsday predictions that have come true:

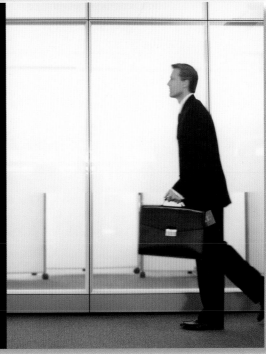

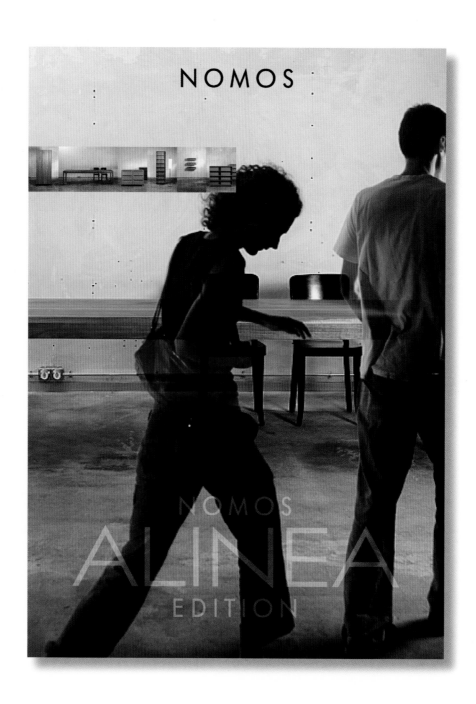

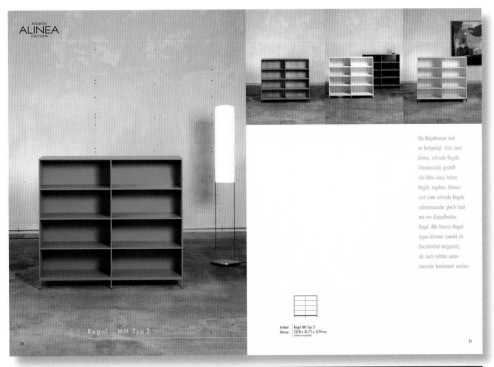

Die Regalmasse sind so festgelegt, dass zwei kleine, schmale Regale übereinander gestellt die Höhe eines hohen Regals ergeben. Ebenso sind zwei schmale Regale nebeneinander gleich breit wie ein doppelbreites Regal. Alle Nomos-Regaltypen können sowohl als Einzelmöbel eingesetzt, als auch additiv untereinander kombiniert werden.

Artikel: Regal MH Typ 3
Masse: 132/8 x 31,71 x 117 H cm
(inklusive Fussgestell)

Regal | MH Typ 3

20 21

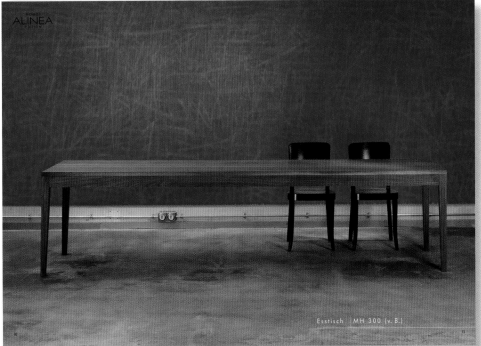

Esstisch | MH 300 (v. B.)

10 11

Massivholz. Nach Mass gefertigt. Die Nomos-Kollektion wird aus edlem, massivem Naturholz gefertigt. Grosse Festigkeit und eine hohe Tragkraft von Massivholz ermöglichen die Verarbeitung von ungewohnt schmalen Platten. Damit reduzieren wir den Holzverbrauch auf ein Minimum, ohne Stabilität, Dauerhaftigkeit und Funktionalität zu beeinträchtigen. Alle Möbel sind in Eiche, amerikanischer Kirsche und Nussbaum erhältlich.

Die Möbel werden transparent geölt oder in jeder gewünschten Farbe von Hand gestrichen. Die Maserung des Holzes bleibt sichtbar. Wir verwenden Ölfarbe, da diese die für Massivholz nötige Elastizität aufweist. Die Möbel der Nomos-Kollektion können auch auf Kundenwunsch nach Mass gefertigt werden.

9

Doing more with less is a cliche, but it's a very compelling one. As I get older and able to buy more things, I find myself wanting to pare down to the essentials. I love having things that serve more than one purpose, and having clothes I can dress up or down. I love the idea of being able to see through the clutter in my life to a place that's clearer and more productive—more me. Edison and Calvin help me simplify.

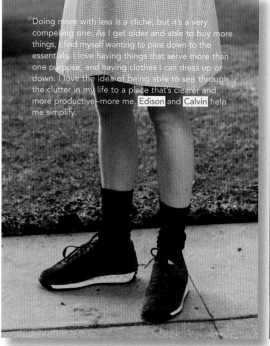

Sitting and moving are not necessarily opposites. Toddlers sure know how to move a lot in their seats. Even as an adult, I try to find ways to sit without sitting still, just to keep my joints limber and my mind active. I'm always trying to find that perfect balance—sitting long enough to collaborate and learn but not so long that things become stagnant. Izzy chairs support my moves.

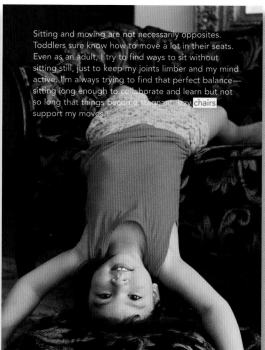

I'm very visual. At work, I organize tasks with an out-of-sight-out-of-mind mentality—some things need to be filed away so I'm not distracted by them, but other projects need to be right there where I can see them and keep my next task in view. Being a visual person also makes me a believer in the importance of personal expression. Everyone should be given choices and the freedom to demonstrate their uniqueness. Clara lets me be me.

Being predictable just isn't my thing. I don't like to stay put. I like to follow the sun as it shines in my east windows, and then travels to the south. I like to follow the activity around me, too—or sometimes avoid it. I like to get a change of scene to keep my mind and ideas fresh. If everything had wheels and complete mobility I'd be happy. Jack knows me.

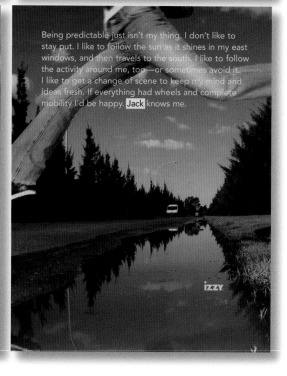

izzy

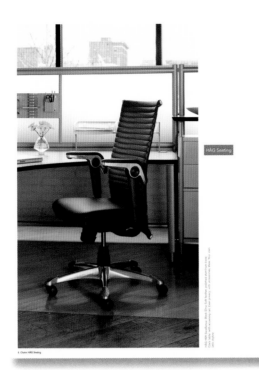

HÅG Seating

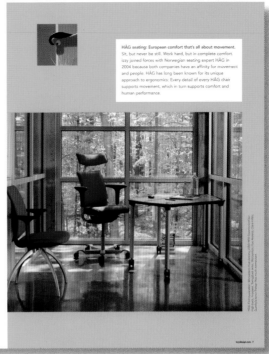

HÅG seating: European comfort that's all about movement.
Sit, but never be still. Work hard, but in complete comfort. izzy joined forces with Norwegian seating expert HÅG in 2004 because both companies have an affinity for movement and people. HÅG has long been known for its unique approach to ergonomics: Every detail of every HÅG chair supports movement, which in turn supports comfort and human performance.

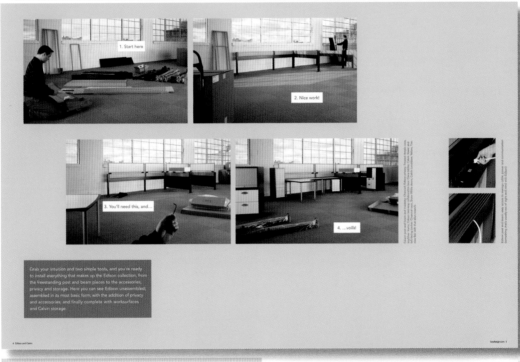

1. Start here

2. Nice work!

3. You'll need this, and...

4. ...voilà!

Grab your intuition and two simple tools, and you're ready to install everything that makes up the Edison collection, from the freestanding post and beam pieces to the accessories, privacy and storage. Here you can see Edison unassembled; assembled in its most basic form, with the addition of privacy and accessories; and finally complete with worksurfaces and Calvin storage.

Archival storage that suits you.
The need for more storage seems to always be with us. For traditional storage needs but a true izzy look, Clara Archival Storage is just the thing.

Archival Storage

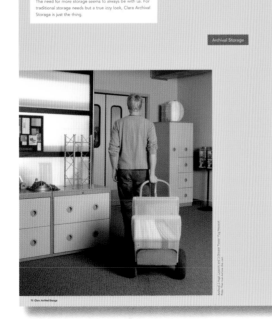

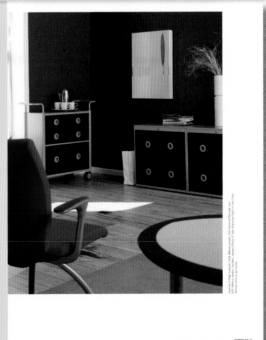

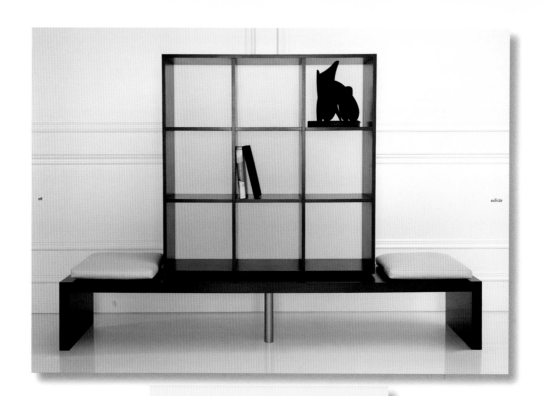

Teknion Folio

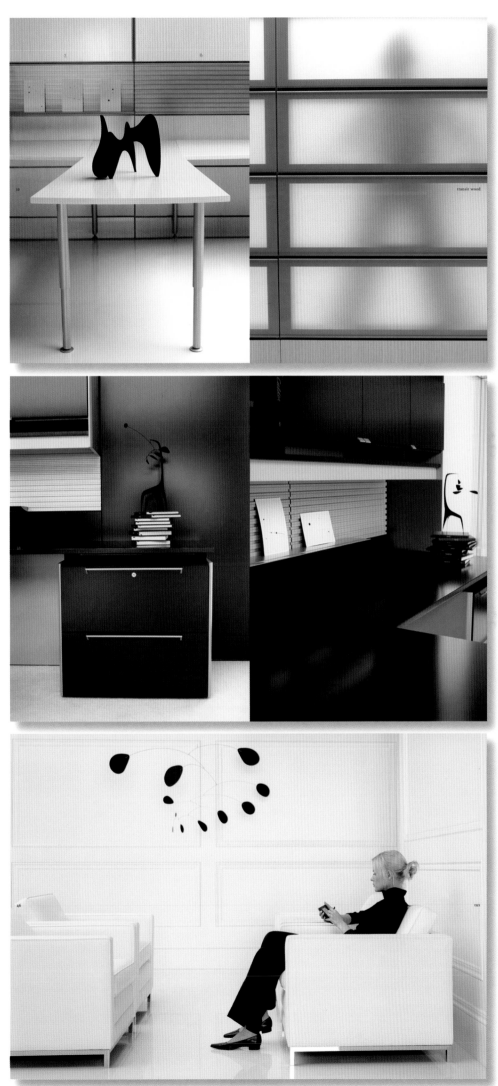

Milliken Contract
CORPORATE

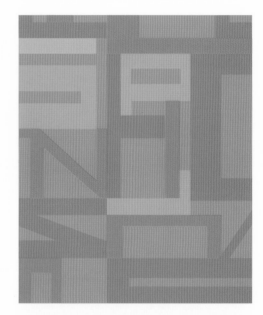

Milliken Contract
EDUCATION

SCHOOLS COLLEGES UNIVERSITIES LIBRARIES

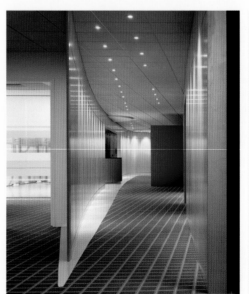

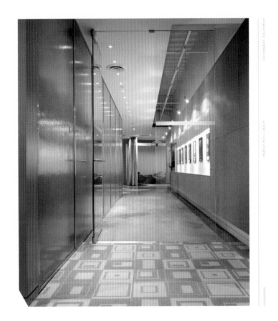

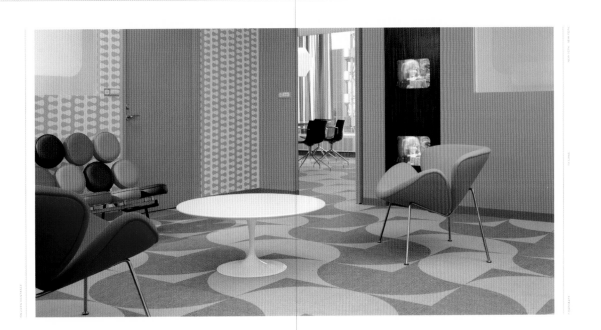

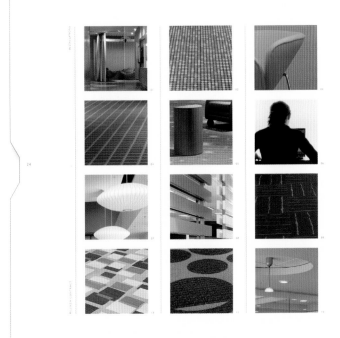

01 WARNER MUSIC GROUP LOS ANGELES, CA DESIGN: HLW PHOTO: FOTOWORKS 02 CANNON DESIGN NEW YORK, NY DESIGN: CANNON DESIGN PHOTO: BJORG MAGNEA 03 TV LAND NEW YORK, NY DESIGN: HLW PHOTO: ELIZABETH FELICELLA PHOTOGRAPHY 04 FORMICA HEADQUARTERS CINCINNATI, OH DESIGN: SKIDMORE, OWINGS & MERRILL PHOTO: HEDRICH BLESSING 05 DISCOVERY COMMUNICATIONS SILVER SPRING, MD DESIGN: GENSLER PHOTO: WARCHOL PHOTOGRAPHY 06 BROWN BROTHERS HARRIMAN NEW YORK, NY DESIGN: SWANKE HAYDEN CONNELL ARCHITECTS, PHOTO: ELIZABETH FELICELLA PHOTOGRAPHY 07 UMPQUA BANK PORTLAND, OR DESIGN: THOMPSON, VAIVODA & ASSOCIATES ARCHITECTS INC (TVA), ZIBA PHOTO: STRODE PHOTOGRAPHIC LLC 08 HEWLETT PACKARD HONG KONG DESIGN: M. MOSER ASSOCIATES 09 BBDO ATLANTA, GA DESIGN: BBDO PHOTO: GARY KNIGHT AND ASSOCIATES 10 EATON CORPORATION WILLOUGHBY HILLS, OH DESIGN: WADDELL + ASSOCIATES, ARCHITECTS, INC. PHOTO: ATLAS PHOTOGRAPHY 11 SWISS RE MEXICO CITY, MEXICO DESIGN: KMD + JUAN MANUEL LEMUS 12 PLANFIA MEXICO CITY, MEXICO DESIGN: KMD + JUAN MANUEL LEMUS

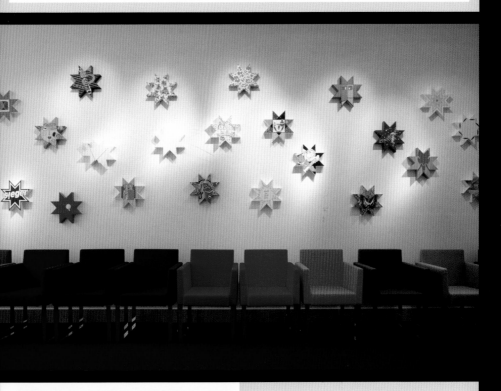

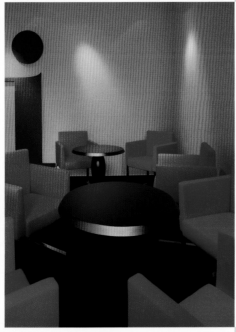

OCEAN BLUE EYES DEEP BLUE

CAPRI HOLY PURPLE PASSION

BILLARD GREIGE NOIR

CHAIR

ℝ finerefine
furniture

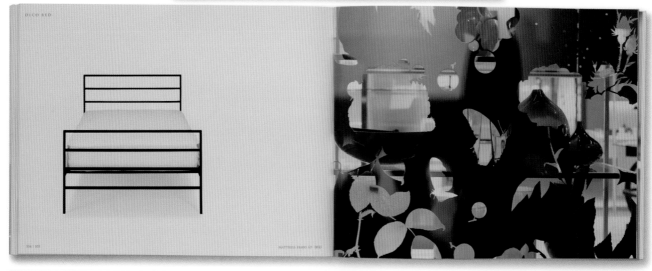

MATTRESS FRAME SIZE (BED)

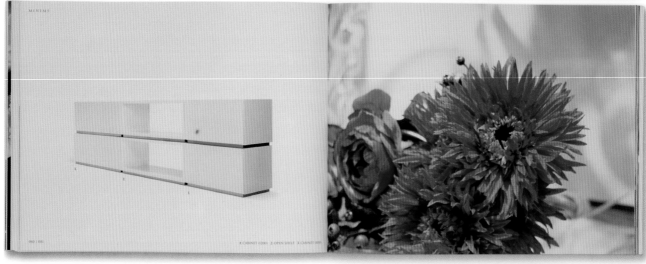

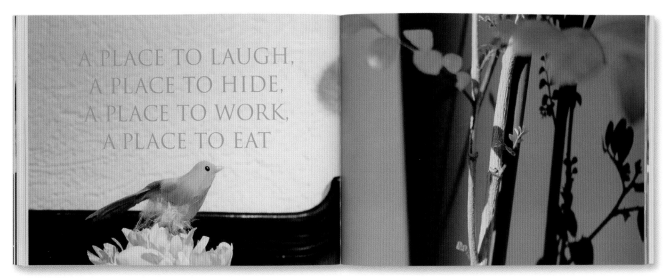

A PLACE TO LAUGH,
A PLACE TO HIDE,
A PLACE TO WORK,
A PLACE TO EAT

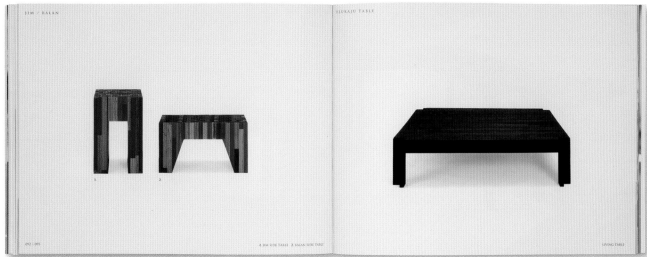

JIM / BALAN

HUKAJU TABLE

1. 2.

092 | 093 1. JIM SIDE TABLE 2. BALAN SIDE TABLE LIVING TABLE

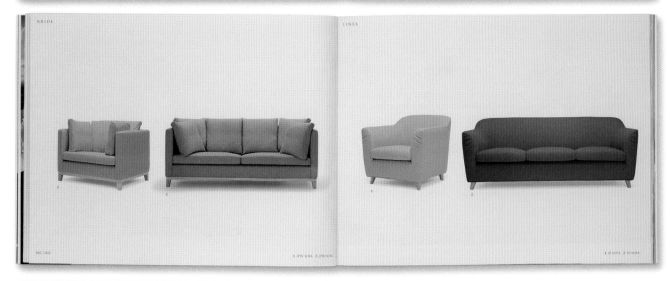

BRIDE

LINEA

042 | 043 1. 1PW SOFA 2. 2PW SOFA 1. 1P SOFA 2. 3P SOFA

FULFILLMENT OF LIFE

scott howard

September, 2005

raw

Scallops & caviar
Fennel pollen
Yuzu
Almond oil
$14

Lightly smoked salmon
Cucumber
Yogurt
Salmon caviar
$10

Fluke sashimi
Muscat grape gelée
Keffir lime
Hon shimeji mushrooms
$12

Hog Island Oysters
Gazpacho
Vodka
Cumin
$14

Sea urchin
Toro
Avocado
Fresh wasabi
$16

Big eye tuna
Serrano ham
Pineapple
Rau ram
$12

charcuterie

Foie gras terrine
Mint
Summer melon salad
Honey
$14

Country pork pâté
Purslane
Pickled shallots
Fruit mustards
$8

Pintade gallantine
Pistachio
Truffles
Pigs feet
$12

Spiced Oxtail Terrine
Port
Shiitake mushrooms
Watercress
$12

salads

White Crane Ranch greens
Olio verde
Meyer lemon
Chives
$10

Heirloom tomato
Heart of palm
Lemon verbena
Petite lemongrass
$10

Summer Beans
Black mission figs
Summer truffles
Fig vinegar
$10

appetizers

Sweetbreads
Truffled Madeira
Smoked bacon
Potato purée
$10

Foie gras
Ancho jam
Brioche
Watercress
$14

soups

Carrot broth
Sabayon
Chervil
Truffle oil
$8

Hama Hama oysters
Saffron
Orange
Star anise
$10

seafood

Salmon
Mer noir
Montpellier butter
Leeks
$20

Tuna
Foie gras
Onion marmalade
Pinot noir reduction
$24

Maine scallops
Golden raisins
Capers
Almonds
$21

Halibut
Bouillabaisse
Fennel pollen
Squash
$21

meats

Short ribs
Celery root
Horseradish
Porcini jus
$22

Duck breast
Leek fondue
Red wine gastrique
Black pepper
$24

Lamb loin
Herb jus
Orange saffron
Picholine olives
$28

Rib steak
Beef marrow
Bordelaise
Béarnaise
$32 per person
(serves 2)

vegetables

Cauliflower
Saffron
Pear
$6

Chanterelles
Spinach
Caper berries
$8

Cranberry beans
Bacon
Tomato
$6

Baby beets & carrots
Cumin
Walnuts
$6

potatoes

Gratin
Goat cheese
Thyme
$6

Gnocchi
Parmesan
Sage
$6

Purée
Truffle oil
Chives
$6

Confit
Garlic
Aioli
$6

grains

Risotto
Maitake mushrooms
Parmesan
$8

Polenta
Eggplant
Peppers
$6

scott howard

carrot broth
try this at home

5-6 servings
3 cups diced carrots (small dice)
6 1/2 cups carrot juice
Salt & pepper to taste
1 cup heavy cream
1/2 tablespoon curry powder

technique
1. Put diced carrots in a small pot.
2. Cover with carrot juice (reserve remaining for later).
3. Cook carrots in juice until the juice is reduced until dry.
4. In blender, puree cooked carrots (in small batches) with remaining juice until smooth.
5. Return to stove. Slowly heat to a simmer.
6. Add curry powder and then salt and pepper to taste.
7. Add cream
8. Strain through Chinoise (fine mesh strainer).
9. Garnish with cream fraiche and truffle oil.

(415) 956 7040
500 Jackson Street, San Francisco, CA 94133
www.scotthowardsf.com

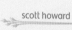
scott howard

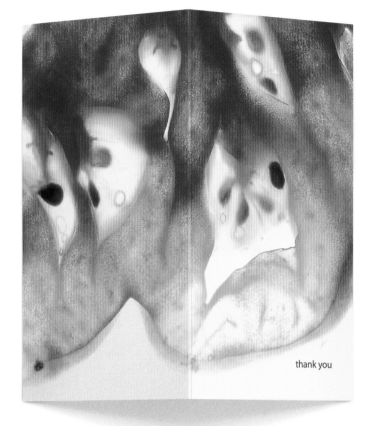
thank you

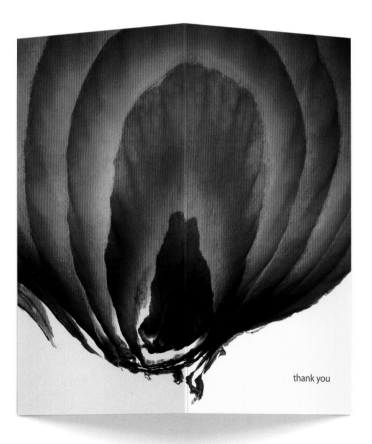
thank you

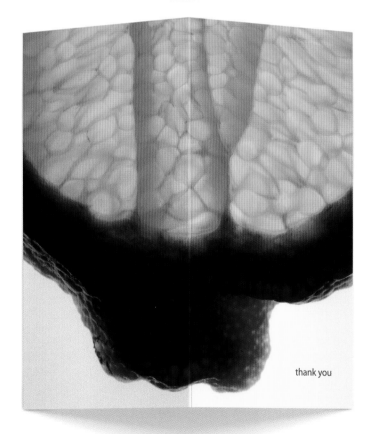
thank you

Wolf Mask
Tsimshian
Northern British Columbia
ca. 1860

length: 11"
wood, hide, human hair, stone,
cedar bark, graphite black, red
and white pigments

Provenance:
Collected at Kitwancool, British Columbia

Reference:
Haberland 1979, pl. 63
Macnair 2018, pl. 14

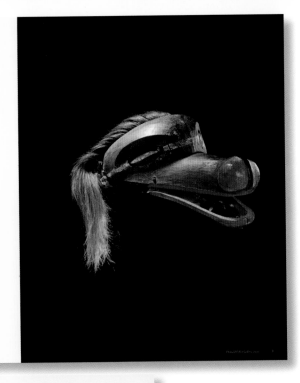

Donald Ellis Gallery
2006

Sun Mask
Kwakwaka'wakw
Northern Vancouver Island
ca. 1870

height: 11.5"
wood, red, blue, green and
black pigments

Provenance:
Collected by the anthropologist Edward Malinowski
John Hauberg collection

Reference:
Davis 1952, pl. 56
Jonaitis 1981, no. 1

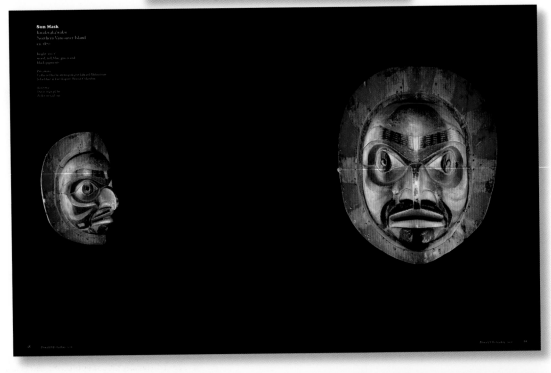

Kachina Mask
Old Man or Chief Kachina
("Wuwuyomo")
Arizona or New Mexico
early 19th century (?)

height: 15" (incl. feathers)
buffalo hide, gourd, pigments,
corn husk, domestic swan feathers

References:
Wright 1973, pg. 51

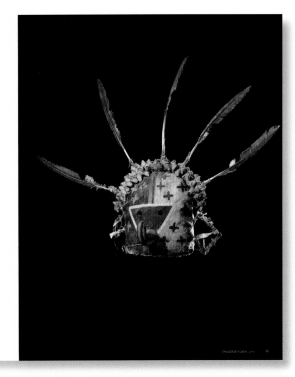

Portrait Mask
Tsimshian
Northern British Columbia
ca. 1820–1840

height: 7 1/2"
wood, human hair,
red and black pigments

References:
Hill 1994, pg. 118

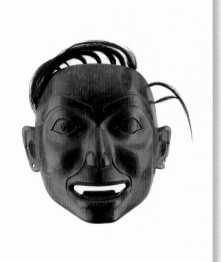

Moccasins
Iroquois (Seneca)
Ontario or New York State
ca. 1850

length: 10 1/8"
hide, porcupine quills, glass beads,
silk ribbon

Provenance:
An old note accompanying the moccasins reads
"Indian moccasins presented to Lafayette (recorded)
by a chief of the Iroquois Tribe sometime between
1824 & 1841."

References:
Ledernmuseum 1976, pl. 3

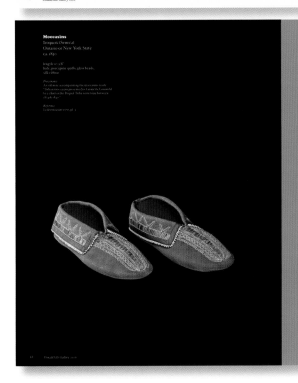

Bibliography

AIA 1976
American Indian Art
Magazine, Scottsdale.
Spring 1976.

Anderson 1973
Anderson, Stephen R., and
Sargent, Dorian A. Problems
in the Ethnic History of
the Bering Sea: Eleven
Cemetery Mounds. Institut
Geografi Insem N.N.
Mikhkho-Makhaia, 1975.

Beverley 1884
Beverley, W. Henry. Life and
Labour in the Far, Far West:
Being Notes of a Tour in
the Western States, British
Columbia, Manitoba, and
the North-West Territory.
London: Cassel & Company,
1884.

Batkin 1995
Batkin, Jonathan (ed.).
Splendid Heritage:
Masterpieces of Native
American Art from the
Masco Collection. Santa Fe:
Wheelwright Museum of
the American Indian, 1995.

Bernstein and McMaster 2004
Bernstein, Bruce and
McMaster, Gerald (eds).
First American Art: The
Charles and Valerie Diker
Collection of American
Indian Art. Seattle:
University of Washington
Press, 2004.

Brown 1998
Brown, Steven C. Native
Visions: Evolution in
Northwest Coast Art from
the Eighteenth Through the
Twentieth Century. Seattle:
University of Washington
Press, 1998.

Brown 2000
Brown, Steven C. Spirits
in the Water: Native Art
Collected On Expeditions
to Alaska and British
Columbia 1774–1910. Seattle:
University of Washington
Press, 2000.

Coe 1977
Coe, Ralph T. Sacred
Circles: Two Thousand
Years of North American
Indian Art. Kansas City:
Nelson Gallery of Art, 1977.

Davis 1949
Davis, Robert Tyler.
Native Arts of the Pacific
Northwest. Stanford:
Stanford University Press,
1949.

Dalsatlle 1990
Dalsatlle, Emile. Schatten
Uit De Nieuwe Wereld.
Brussels: Musee Royaux
d'Art et d'Histoire, 1990.

Dockstader 1973
Dockstader, Frederick J.
Indian Art in America: The
Arts and Craft of the North
American Indian. New
York: Promontory Press,
1973.

Douglas 1941
Douglas, Frederic and
D'Harnoncourt, Rene.
Indian Art of the United
States. New York: Museum
of Modern Art, 1941.

Duncan 1989
Duncan, Leslie and Wilson.
Douglas. AngElikw Art
of the Haida. Vancouver:
Hancock House Publishers,
1989.

Ellis 1996
Ellis, Donald. Donald
Ellis Gallery (Catalogue).
Toronto, 1996.

Ellis 2004
Ellis, Donald. Donald
Ellis Gallery (Catalogue).
Toronto, 2004.

Ewers 1986
Ewers, John C. Plains
Indian Sculpture: A
Traditional Art From
America's Heartland.
Washington: Smithsonian
Institution Press, 1986.

Feder 1971
Feder, Norman. American
Indian Art (photeo edition).
New York: Harry N.
Abrams Inc., 1971.

Gunsaldusu 1972
Gunsaldukus, T.
Kunstsmoksun, R. and
Shserini, I. Museum
of Anthropology and
Ethnography. Leningrad:
Aurora Arts Publishers,
1972.

Glenbow 1987
Glenbow Museum. The
Spirit Sings: Artistic
Traditions of Canada's
First Peoples. Toronto:
McClelland and Stewart,
1987.

Haberland 1979
Haberland, Wolfgang.
Donnervogel and Raubwal.
Die indianische Kunst
der Nordwestkuste.
Nordamerikas. Hamburg:
Hamburgisches Museum fur
Volkerkunde und Christlenn
Verlag, 1979.

Hill 1994
Hill, Tom and Hill, Richard
W. Sr. Creation's Journey:
Native American Identity
and Belief. Washington:
Smithsonian Institution
Press, 1994.

Inverarity 1950
Inverarity, Robert B.
Art of the Northwest
Coast Indians. Berkeley:
University of California
Press, 1950.

Jennings 1984
Jennings, Francis. The
Ambiguous Iroquois
Empire: The Covenant
Chain Confederation of
Indian Tribes with English
Colonies from its beginnings
to the Lancaster Treaty of
1744. New York: Norton &
Company, 1984.

Ledermuseum 1976
Deutsches Ledermuseum.
Kendag 4. Offenbach, 1976.

Macnair 1998
Macnair, Peter, Joseph,
Robert and Grenville,
Bruce. Down From the
Shimmering Sky: Masks
of the Northwest Coast.
Vancouver: Douglas &
McIntyre, 1998.

Morel 1984
La Route et le Raison:
Les Collections Menil
(Houston: New York). Paris:
Editions de la Reunion des
Musees Nationaux, 1984.

Morris 1887
Morris, Alexander. The
treaties of Canada with the
Indians of Manitoba and
the North West Territories,
including the negotiations
on which they were based,
and other information
relating thereto. Toronto:
Belfords, Clarke & Co.,
1880.

Murray 2000
Murray, Thomas.
Thomas Murray America
Ethnographica (catalogue).
Mill Valley, 2000.

Museo Chilean 1983
Los Platos the los Dioses
(catalogo). Santiago:
Museo Chileno de Arte
Precolumbino & Fundacion
Cultural Quinpac, 1983.

Peguot Museum 2000
Lofts of the Forest: Native
Traditions in Wood &
Bark. Mashantucket
Mashantucket Pequot
Museum & Research
Center, 2000.

Schaaf 1990
Schaaf, Gregory.
Wampum Belts and Peace
Trees: George Morgan,
Native Americans, and
Revolutionary Diplomacy.
Golden Col.: Fulcrum
Publishing, 1990.

Olde 1890
Uhle, Max., Stubel, A. Reiss.
W., and Koppel, B. Kultur
und Industrie
Sudamerikanischer Volker,
nach den im Besitze des
Museums fur Volkerkunde
zu Leipzig infindlichen
Simmlungen u.viks. Berlin:
Verlag von A. Asher & Co.
(First writings on South
America)

Wardwell 1996
Wardwell, Allen. Ancient
Eskimo Ivories of the Bering
Strait. New York: Hudson
Hills, 1986.

Wright 1973
Wright, Barton.
Kachinas: A Hopi Artist's
Documentary. Phoenix:
Northland Press, 1973.

Wright 1978
Wright, Barton. Pueblo
Shields From the Fred
Harvey Arts Collection.
Flagstaff: Northlands Press,
1976.

Wright 2001
Wright, Robin K. Northern
Haida Master Carvers.
Seattle: University of
Washington Press, 2001.

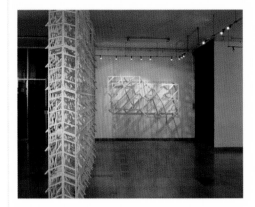

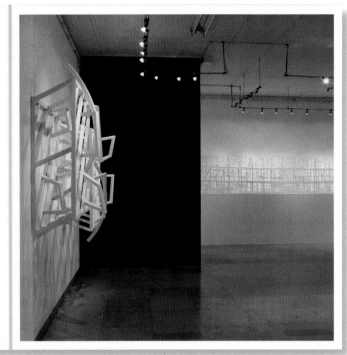

SLO
SZ
ENC
C
12345

94
PETAR BARISIC

PETAR BARIŠIĆ ROĐEN JE 7. LISTOPADA 1954. U VRLICI, GDJE JE POHAĐAO OSNOVNU ŠKOLU. ŠKOLU ZA PRIMIJENJENU
UMJETNOST ZAVRŠIO JE 1973. U SPLITU, A AKADEMIJU LIKOVNIH UMJETNOSTI U KIPARSKOJ KLASI PROF. IVANA SABOLIĆA
1978. U ZAGREBU. OD 1978. DO 1981. BIO JE SURADNIK MAJSTORSKE RADIONICE PROF. FRANE KRŠINIĆA. ŽIVI I RADI U
ZAGREBU. DOCENT JE NA AKADEMIJI LIKOVNIH UMJETNOSTI U ZAGREBU OD 2002. GODINE.

PETAR BARIŠIĆ WAS BORN IN 1954 IN VRLIKA, WHERE HE WENT TO ELEMENTARY SCHOOL. HE GRADUATED FROM THE
APPLIED ART SCHOOL IN SPLIT IN 1973, AND THEN SCULPTURE IN 1978 IN THE ACADEMY OF FINE ARTS IN ZAGREB,
CLASS OF IVAN SABOLIĆ. FROM 1978 TO 1981 HE WAS AN ASSOCIATE OF THE MASTER WORKSHOP OF FRANO KRŠINIĆ.
SINCE 2002, HE HAS BEEN AN ASSISTANT PROFESSOR AT THE ACADEMY OF FINE ARTS IN ZAGREB. HE LIVES AND WORKS
IN ZAGREB.

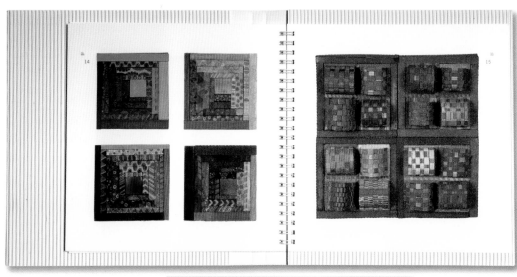

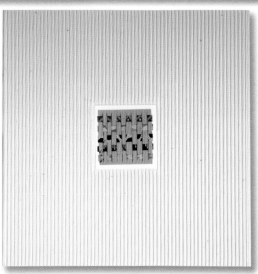

BROOKLYN
BOTANIC
GARDEN

MASTER PLAN

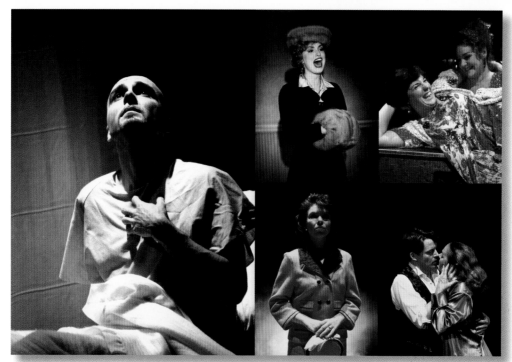

signature
A Story in 3 Acts

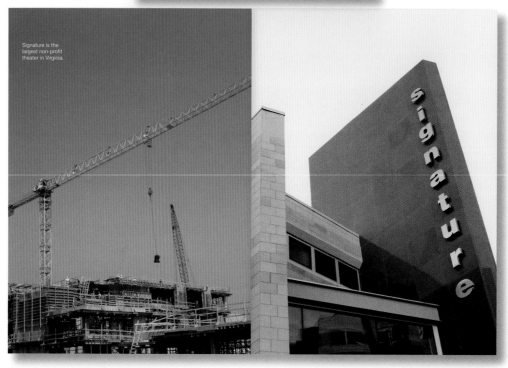

Signature is the
largest non-profit
theater in Virginia.

299 SEAT MAX THEATRE

THE SIGNATURE YOU LOVE. ONLY BETTER

ACOUSTICALLY TREATED THEATERS FOR SUPERIOR UN-AMPLIFIED PRODUCTIONS WITH LIVE ORCHESTRAL ACCOMPANIMENT

THE SIGNATURE TRADEMARK OF FLEXIBLE STAGES AND SEATING IN BOTH THEATERS

15

LOTS OF FREE PARKING

42 DRESSING ROOMS FOR UP TO 134

STATE-OF-THE-ART TECHNICAL EQUIPMENT

BETTER

PROFESSIONAL ADMINISTRATIVE OFFICES AND MEETING SPACE

LOCATED IN A VIBRANT, EXPANDED NEIGHBORHOOD THAT'S HOME TO MORE THAN 15 RESTAURANTS

TOTAL PROJECT COST $16 MILLION

16M **99** SEAT ARK THEATRE

NEW THEATER SEATS AND INCREASED LEG ROOM

SPACIOUS SCENERY/COSTUME SHOPS

DRAMATIC

CLIMATE-CONTROLLED

WINDOWED LOBBY OVER-LOOKING SHIRLINGTON VILLAGE

2 GREEN ROOMS

EXPANDED CONCESSIONS AND WINE BAR PLUS A RETAIL STORE

3

STREET-ACCESSIBLE BOX OFFICE

COMPLIMENTARY COAT CHECK

REHEARSAL ROOMS

SIGNATURE UNVEILED ITS NEW BUILD-ING DESIGNS ON SEPTEMBER 10, 2004.

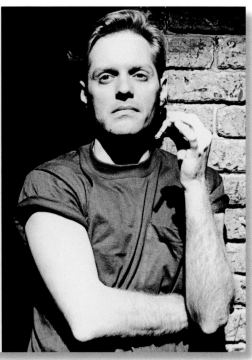

"SIGNATURE THEATRE IS AN UNUSUAL ARTS ORGANIZATION: IT REFLECTS ITS DIRECTOR'S REMARKABLE TASTE AND VISION WHILE GIVING ITS ARTISTS THE LATITUDE TO CREATE. AS A RESULT, SIGNATURE HAS PRODUCED AN ASTONISHING RANGE OF WORK THAT PROVIDES THE TRUE FOUNDATION FOR ITS NEW HOME."

MICHAEL KAISER

PRESIDENT THE JOHN F. KENNEDY CENTER FOR THE PERFORMING ARTS

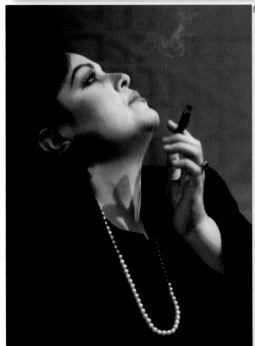

THE THING IS, YOU COULDN'T KEEP ME OUT. ALWAYS UPSTAIRS WHEN I DO THE COSTUME SHOP. SOMEONE WOULD GET A PAINT CALL, OR I'D BUILD THE SETS. I COULD CLIMB UP AND HANG A LIGHT THROUGH THE WINDOW.

SIGNATURE ARTISTIC ASSOCIATE AND COSTUME DESIGNER

SIGNATURE IS ALL ABOUT SURPRISE.

DONNA MIGLIACCIO

SIGNATURE CO-FOUNDER AND ARTISTIC ASSOCIATE

TED AND MARY JO SHEN

WHEN PEOPLE ASK ME WHAT IT'S LIKE TO WORK AT SIGNATURE, I SAY THAT IT'S LIKE THE BEST SANDBOX YOU COULD EVER PLAY IN.

SIGNATURE ARTISTIC DIRECTOR AND PLAYWRIGHT

ERIC SCHAEFFER

KALB FLEISCH ON

KRUEGER DANA

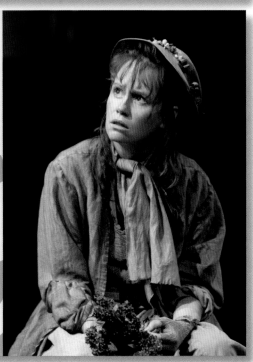

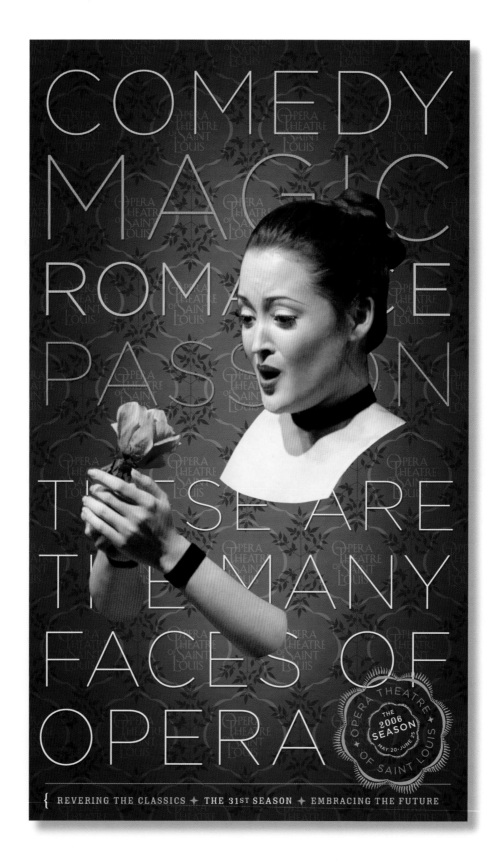

WE TOLD 10 PEOPLE THAT *Buntin Reid* IS HAVING ANOTHER PAPER SHOW AT THE HARD ROCK CAFÉ AND THIS IS WHAT THEY HAD TO SAY:

Time is
a revealer
of a man's
sincerity.

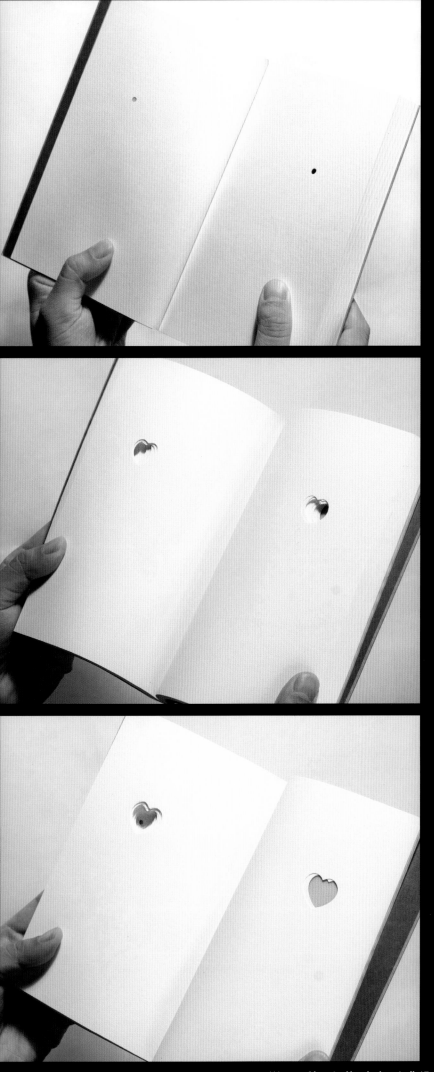

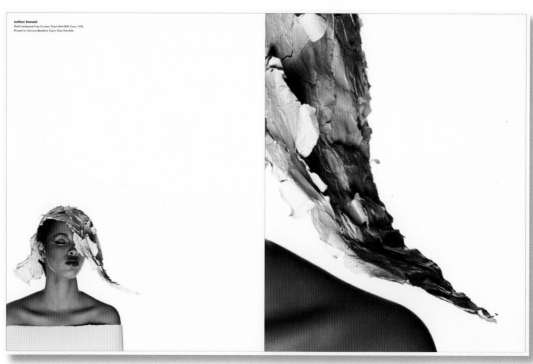

esther bonnet
Outfit fashioned from Curious Touch Soft Milk Cover 111lb.
Printed on Curious Metallics Cyber Grey Text 80lb.

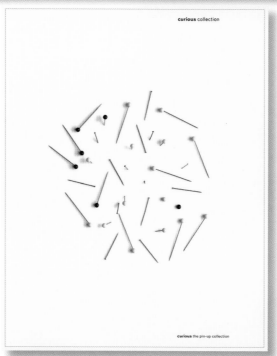

curious collection

curious the pin-up collection

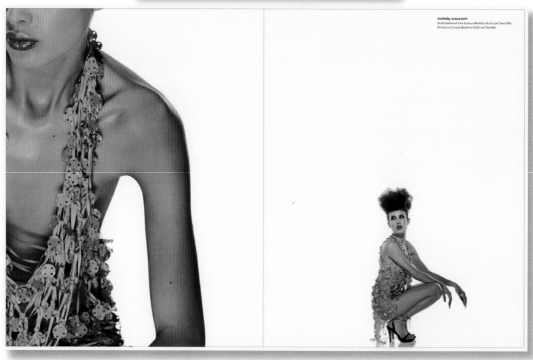

melody macaroni
Outfit fashioned from Curious Metallics Gold Leaf Cover 92lb.
Printed on Curious Metallics Gold Leaf Text 80lb.

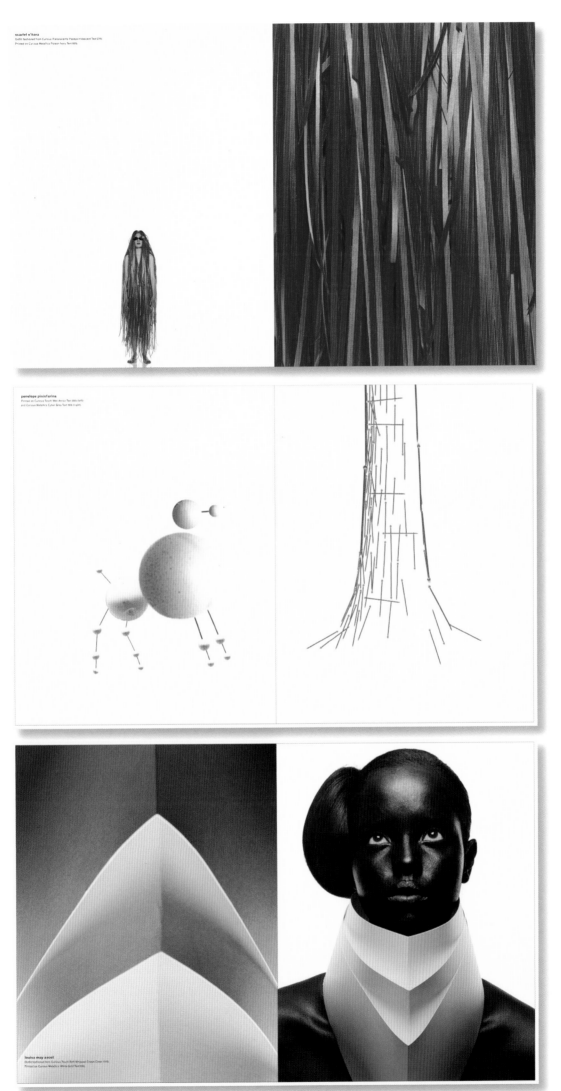

scarlet o'hara
Outfit fashioned from Curious Translucents Flexisol Iridescent Text 27%
Printed on Curious Metallics Poison Ivory Text 98lb

penelope pininfarina
Printed on Curious Touch Wet Arctic Text 98lb (left)
and Curious Metallics Cyber Grey Text 98lb (right)

louisa may ascot
Outfit fashioned from Curious Touch Soft Whipped Cream Cover 111lb
Printed on Curious Metallics White Gold Text 98lb

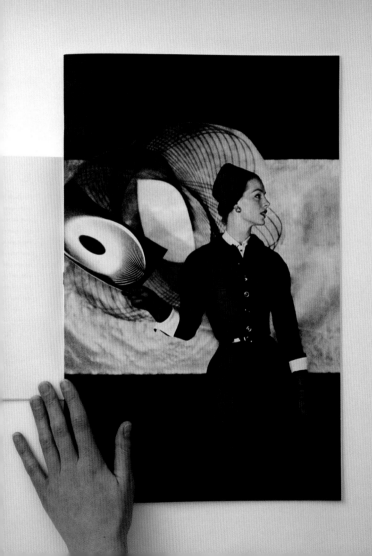

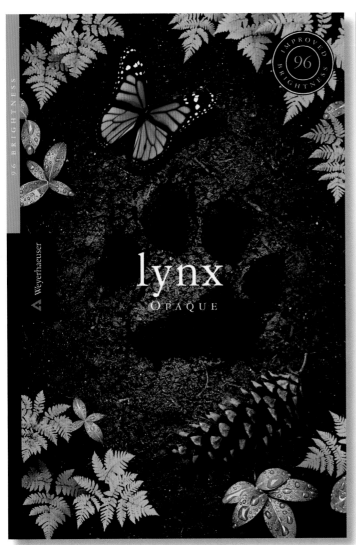

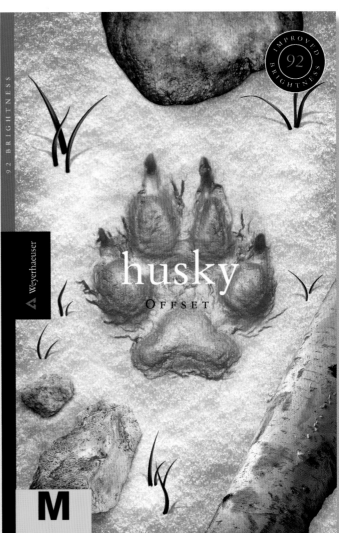

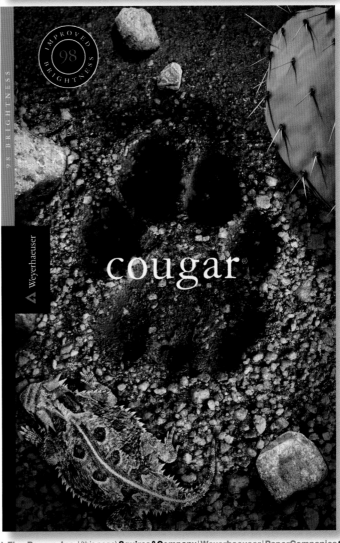

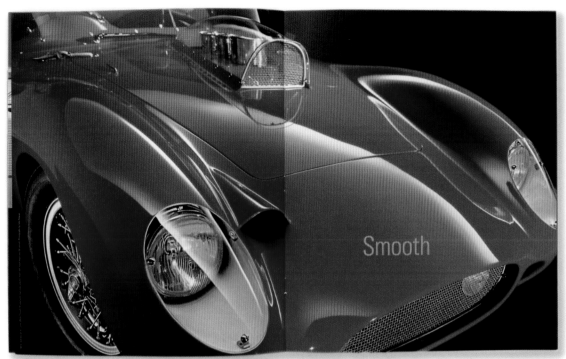

Smooth

Why Titanium?

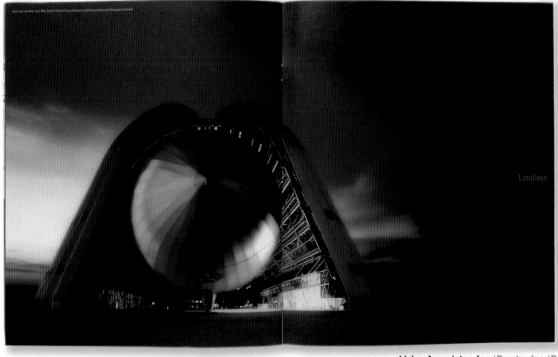

Limitless

Yes, it's about Cougar, and printed on Cougar. Let's face it, you already know

about Cougar Opaque. Everybody knows Cougar Opaque—Jilly, Wendy, Steve,

A paper promo on Cougar Opaque.

everybody. Even Mike knows Cougar and he's a writer (he didn't write this

although, in hindsight, he probably should have because it could have been much

it's cheap. Stack it up against some of those more expensive sheets and check

it out for yourself. Cougar's now even brighter (a 96 brightness) and comparing

Any **PANTONE®** color like 151 U, 659 U, or 240 U lays beautifully on Cougar.

Metallics also print great, like PMS® 877 U. Florescent inks pop nicely too, here's

Call Paul Weibel at 630-818-1107 or Molly Ann Bourgeois at 773-506-1091 with

Weyerhaeuser. To spec it call Andrew Dembitz at 630-693-5930 with Unisource.

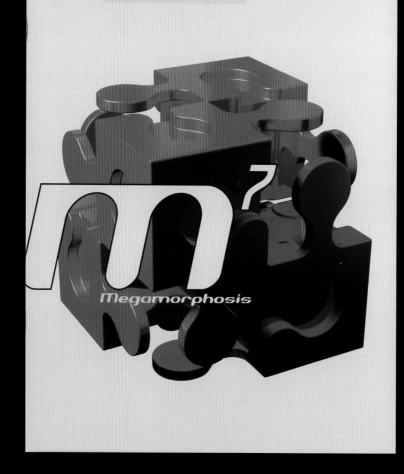

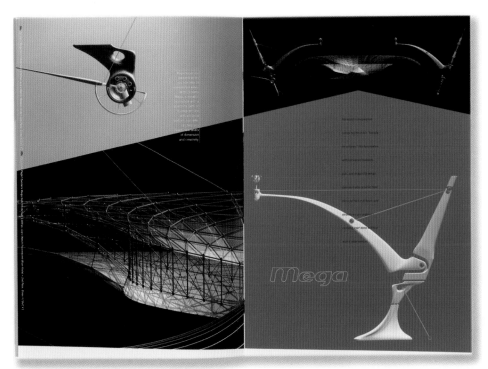

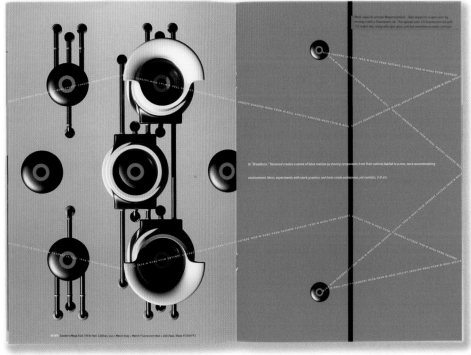

sappi

The

1 Standard

A Sappi Guide to Designing for Print:
Tips, Techniques and Methods for
Achieving Optimum Printing Results

Prepress:

Preparing

Files

for Print

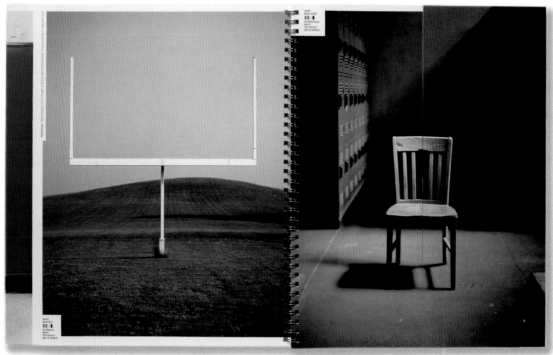

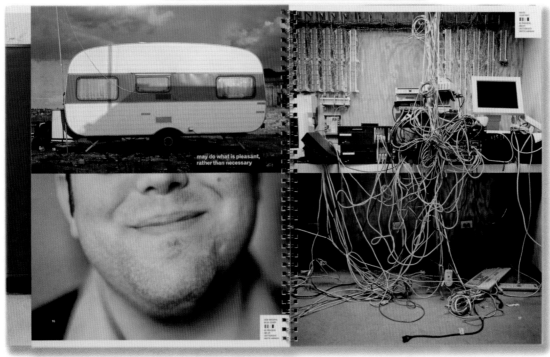

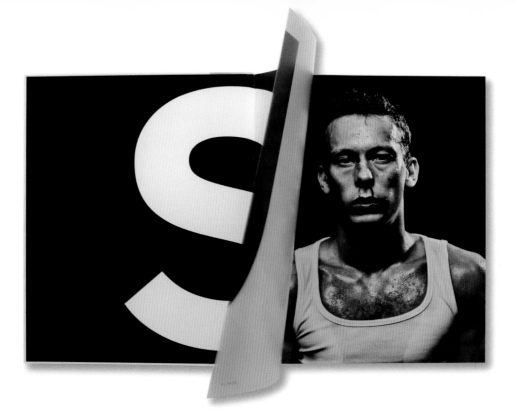

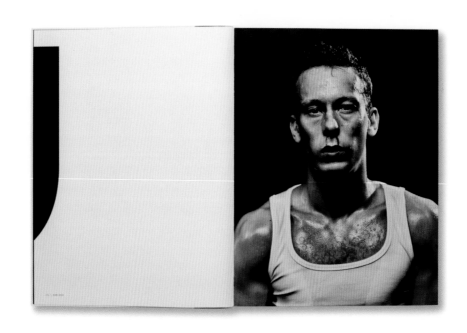

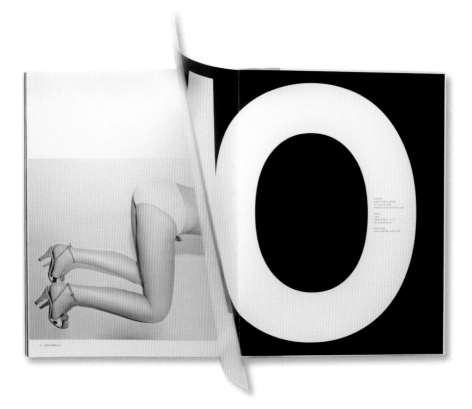

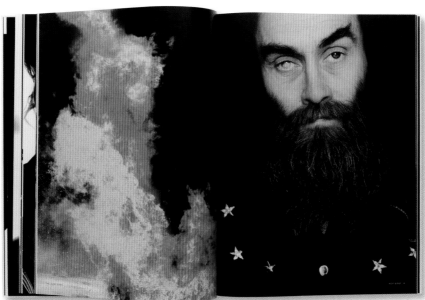

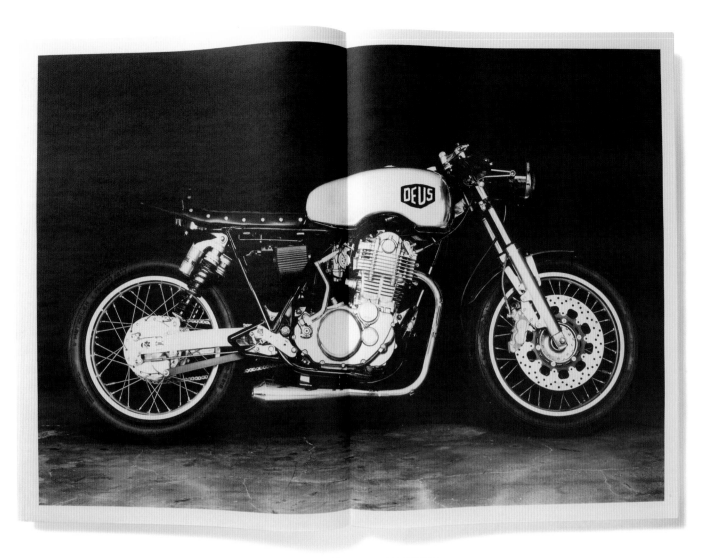

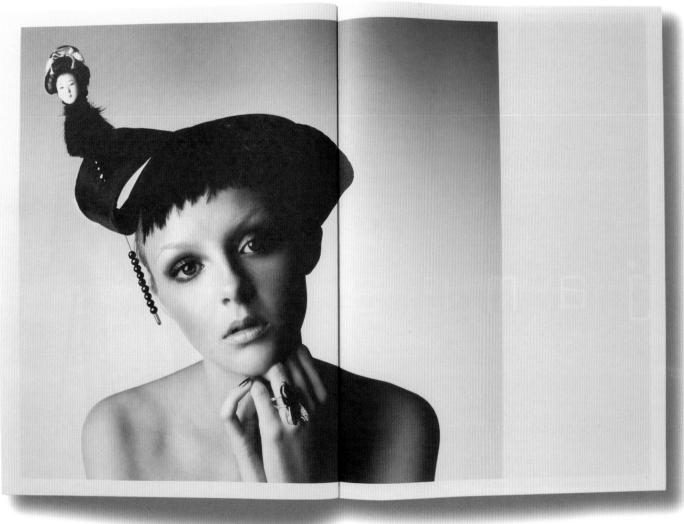

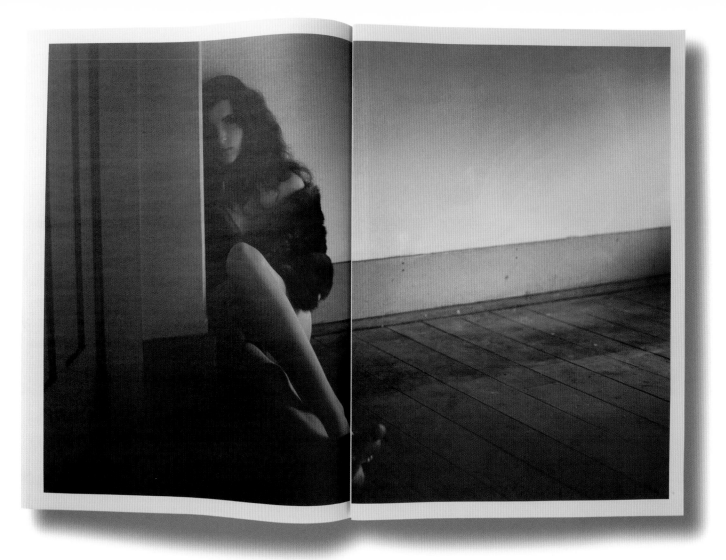

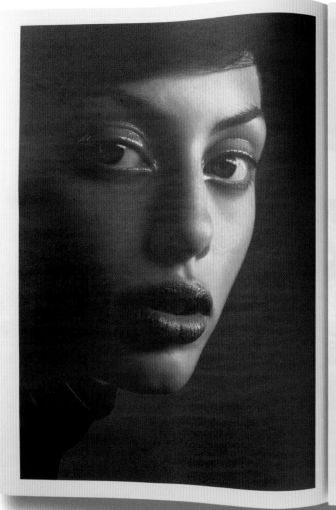

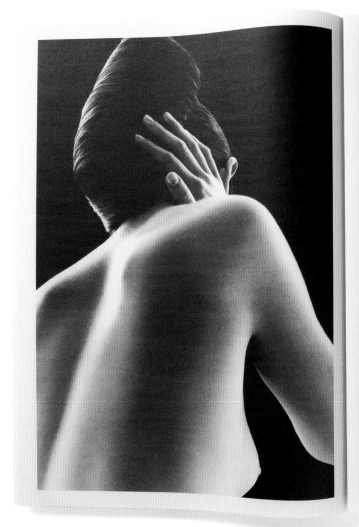
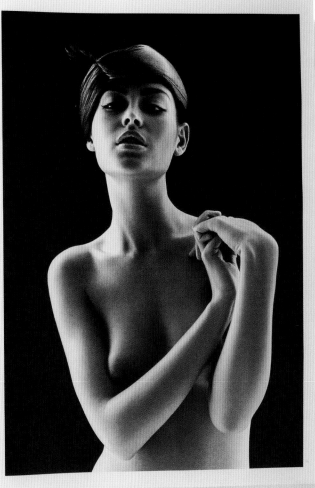

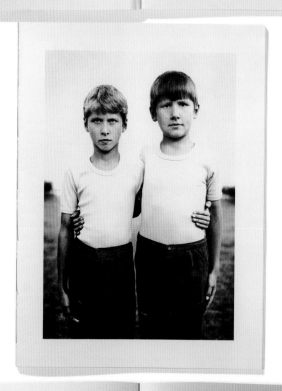

Unbound
3
IMAGES
REAL AND IMPLIED

RIGHTS-MANAGED
AND
ROYALTY-FREE
IMAGES

masterfile.com
1 800 387 9010
unbound3@masterfile.com

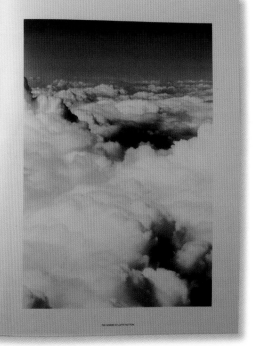

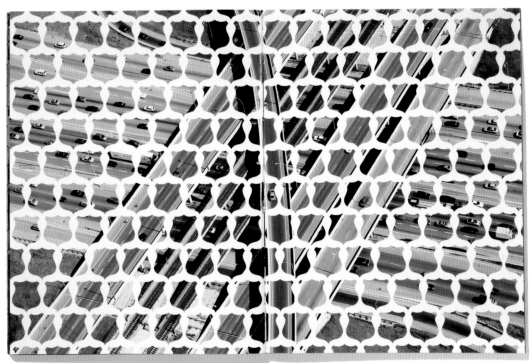

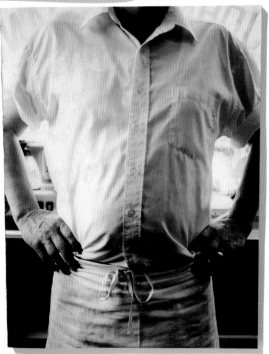

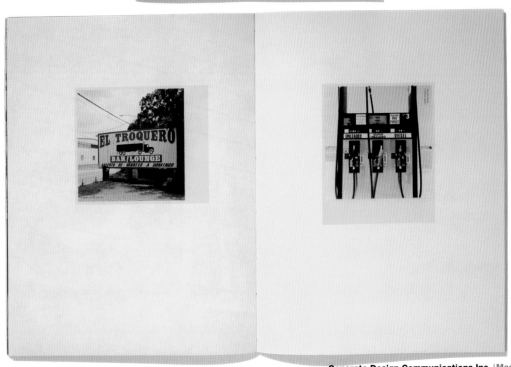

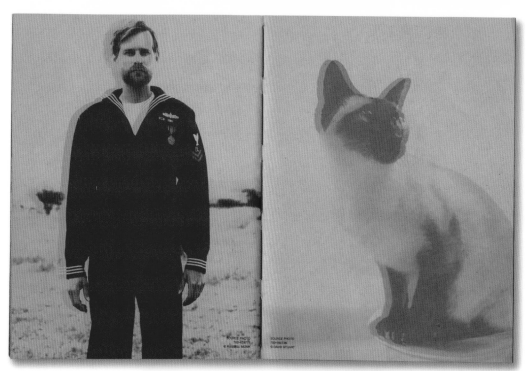

rights-
man
aged
and

roy
alty-
free
images

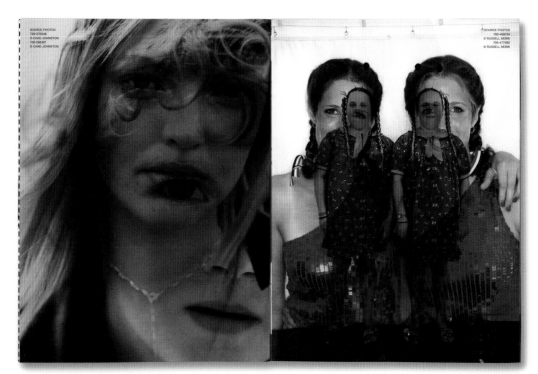

SOURCE PHOTOS
700-270246
© CHAD JOHNSTON
700-296351
© CHAD JOHNSTON

SOURCE PHOTOS
700-458134
© RUSSELL MONK
700-477092
© RUSSELL MONK

SOURCE PHOTO
700-477212
© MICHAEL CLEMENT

THE NAYLOR COLLECTION
THE COMPLETE HISTORY OF PHOTOGRAPHY

Jonathan Barken
395 Massachusetts Avenue
Arlington, Massachusetts
0 2 4 7 4

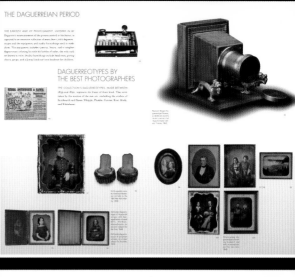

THE DAGUERREIAN PERIOD

THE EARLIEST AGE OF PHOTOGRAPHY, USHERED IN BY Daguerre's announcement of the process worked in his favor, as captured in an extensive collection of more than 1,000 daguerreian shapes and the equipment and studio furnishings used to make them. The equipment includes cameras, lenses, and a complete daguerreotype relating to each 65 bottles of scales, the only scale not known to exist. Studio furnishings include head rests, posing chairs, props, and a jenny Lind cast iron headrest for children.

DAGUERREOTYPES BY THE BEST PHOTOGRAPHERS

THE COLLECTION'S DAGUERREOTYPES, MADE BETWEEN 1839 and 1855, represent the finest of their kind. They were taken by the masters of the new art, including the studios of Southworth and Hawes, Whipple, Plumbe, Gurney, Root, Brady, and Whitehurst.

EDWARD SHERIFF CURTIS (1868-1952)
FROM ORIGINAL GLASS PLATES

WITH THE ENCOURAGEMENT OF PRESIDENT THEODORE ROOSEVELT and the patronage of J. P. Morgan, Edward S. Curtis traveled the American West photographing Native Americans and their vanishing cultures. In the course of 30 years he published his 20-volume set of photography and anthropological narrative entitled *The North American Indian*. Curtis' elegiac depictions of Native Americans displays both a romantic sensibility and a masterful eye for composition. The Curtis glass plates in The Collection are rare, since of his plates were destroyed.

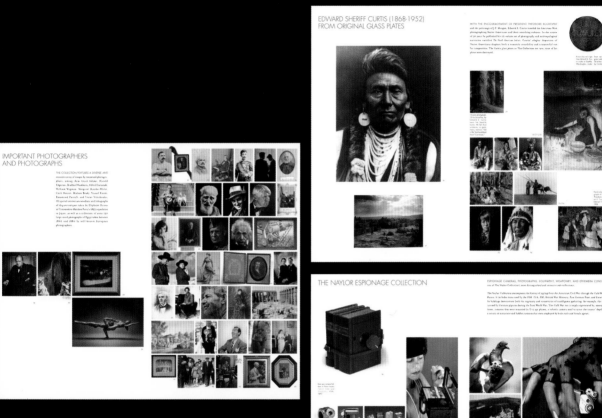

THE NAYLOR ESPIONAGE COLLECTION

ESPIONAGE CAMERAS, PHOTOGRAPHS, EQUIPMENT, WEAPONRY, AND EPHEMERA CONSTITUTE one of The Naylor Collection's most distinguished and extensive sub-collections.

The Naylor Collection encompasses the history of spying from the American Civil War through the Cold War with Russia. It includes items used by the OSS, CIA, FBI, British War Ministry, East German Stasi, and Soviet KGB.

IMPORTANT PHOTOGRAPHERS
AND PHOTOGRAPHS

THE COLLECTION FEATURES A DIVERSE AND extensive array of images by renowned photographers, among them Ansel Adams, Harold Edgerton, Bradford Washburn, Alfred Eisenstaedt, William Wegman, Margaret Bourke-White, Cecil Beaton, Mathew Brady, Yousuf Karsh, Raymond Parcell, and Victor Velechenko. Of special interest are woodcuts and lithographs of daguerreotype tales by Eliphalet Brown in Japan, as well as a collection of some 250 large-sized photographs of Egypt taken between 1865 and 1880 by well-known European photographers.

DR. HAROLD E. EDGERTON (1903-1990)
TECHNOLOGY AND SIGNED PHOTOGRAPHS

THE EDGERTON HOLDINGS CONSTITUTE AN EXTENSIVE collection of their sort. In the course of a decades-long friendship with "Doc" Edgerton, MIT professor and inventor of electronic flash photography, Jack Naylor assembled equipment and images representing the inventor-photographer's long and varied career. These include examples of the inventor's renowned "stop-action" photographs, underwater cameras from his long association with Jacques Cousteau, photographs of the first tungsten atomic bomb test, and classified aerial images made in preparation for the D-Day invasion of France.

THE FIRST PRINT MADE IN AMERICA:
REVEREND COTTON MATHER OF BOSTON

THIS 1727 ENGRAVING WAS made by Joseph Church from a mezzotint portrait in Reverend Cotton Mather painted by Boston's Peter Pelham. Reverend Mather (1663-1728), a scholar of history, science, biography and theology, wrote over 380 works and recorded his father, Reverend Increase Mather, as pastor of Boston's Old North Church.

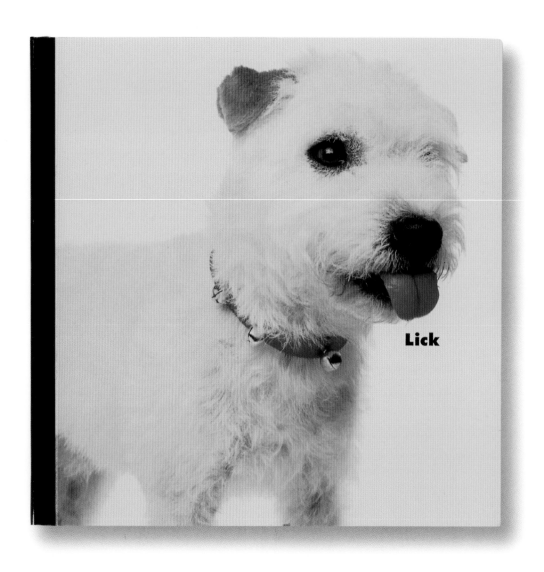

Lick

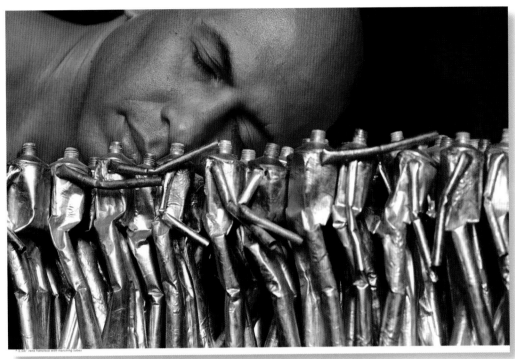

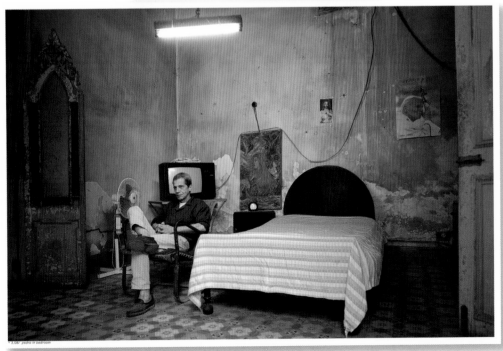

Illustration: The juxtaposition of textures, shapes and sizes are the elements that you can play with when creating a still life. From there you need to get a feel for the scale of objects and how they relate to each other. **Work.** During the grape harvest season in the Napa Valley, I worked out an arrangement with a grower to photograph some of his workers. I shot on my usual large format, setting up a neutral background and using available light. In the short time I spent with this man in the photo, I grew to admire him. He had worked the fields for all the years of his life and had picked a whole lot of produce during that time. He was very proud and rooted in his culture and his family.

Terry Heffernan—known in the worlds of advertising and design for his exquisite large-format still lifes—has quietly pursued his passion of photographing iconic images that capture the soul of America. All of the portraits shown were shot on location using an 8x10 camera with available light.

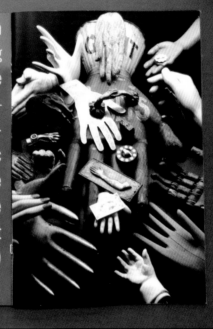

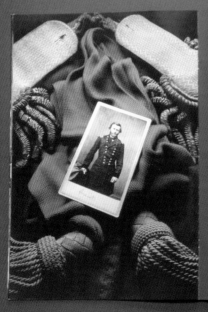

"When you find the right object, photographing it is easy"

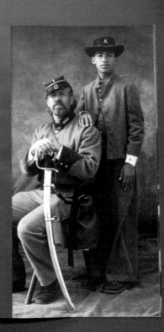

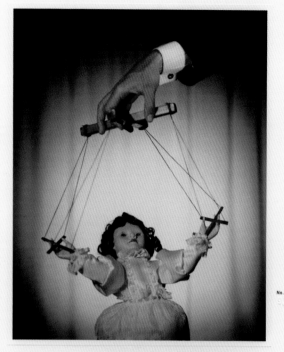

PORTLAND CENTER STAGE CLIENT

MARK HOOPER

PHOTOGRAPHER : **503 223 3135** : mark@hooperstudio.com

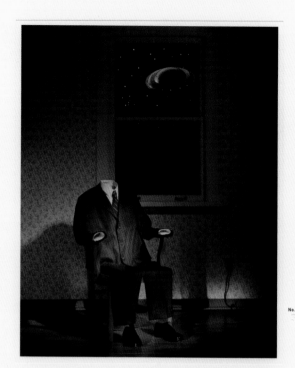

VANITY FAIR MAGAZINE

MARK HOOPER

PHOTOGRAPHER : **503 223 3135** : mark@hooperstudio.com

MARK HOOPER : PERSONAL

MARK HOOPER : PERSONAL

MARK HOOPER : PERSONAL

MARK HOOPER : PERSONAL

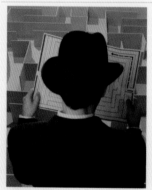

MARK HOOPER : MONEY

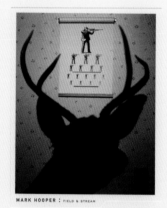

MARK HOOPER : FIELD & STREAM

MARK HOOPER : 'O' MAGAZINE

MARK HOOPER : OUTSIDE

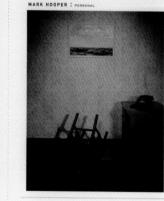

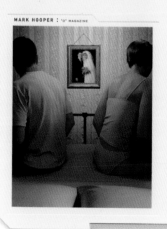

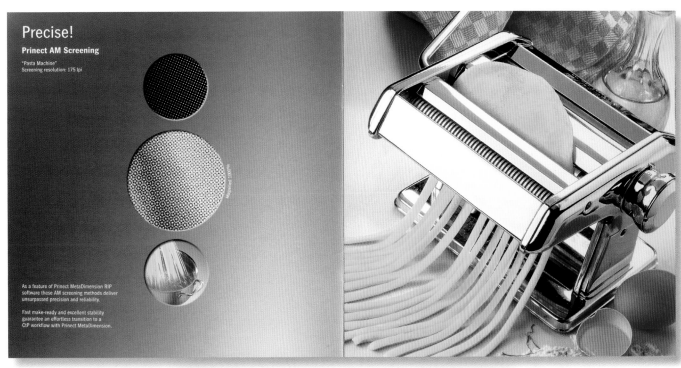

Precise!

Prinect AM Screening

"Pasta Machine"
Screening resolution: 175 lpi

As a feature of Prinect MetaDimension RIP software these AM screening methods deliver unsurpassed precision and reliability.

Fast make-ready and excellent stability guarantee an effortless transition to a CtP workflow with Prinect MetaDimension.

E X C E L L E N T !

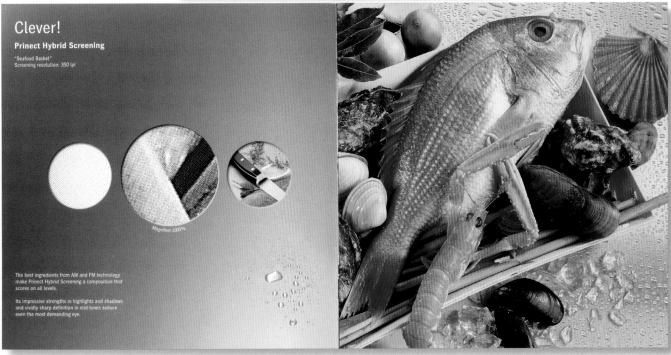

Clever!

Prinect Hybrid Screening

"Seafood Basket"
Screening resolution: 350 lpi

The best ingredients from AM and FM technology make Prinect Hybrid Screening a composition that scores on all levels.

Its impressive strengths in highlights and shadows and vividly sharp definition in mid-tones seduce even the most demanding eye.

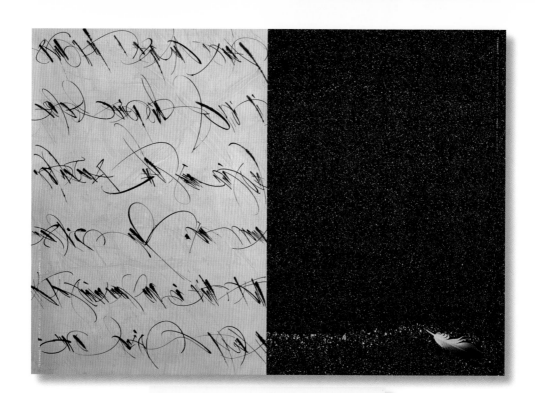

{visual side}

THE STEALLMOOR PRINTING CORPORATION | ANNUAL REPORT REPORT

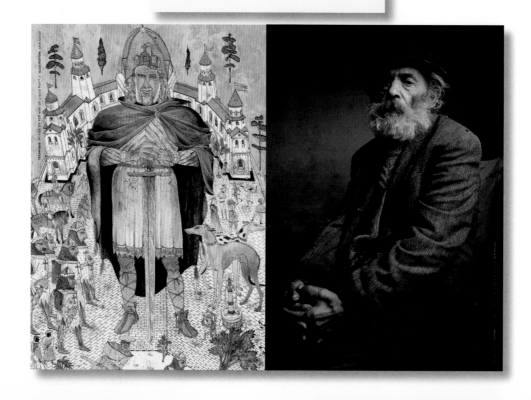

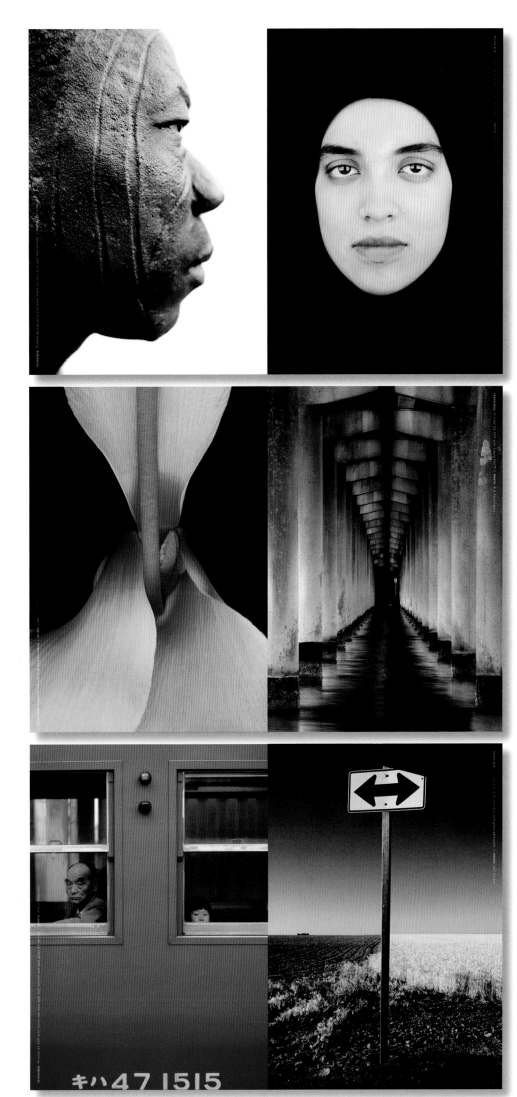

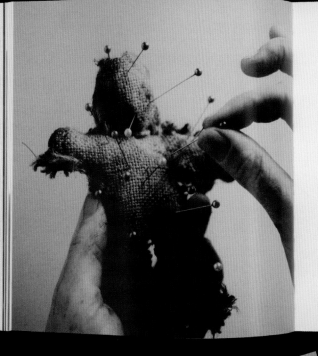

Rhymes with

Which company has printing, packaging, promotions, mail and fulfilment under one roof?

Here's a clue

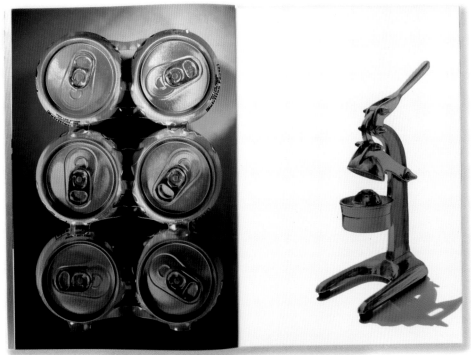

liquid foil™

Another Bright Innovation From Williamson Printing

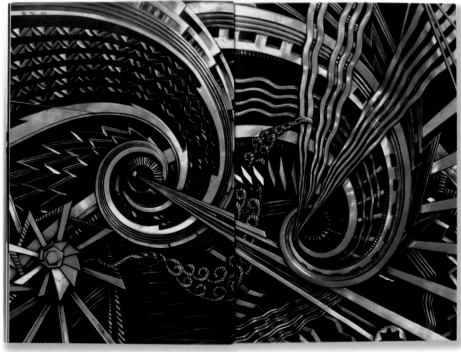

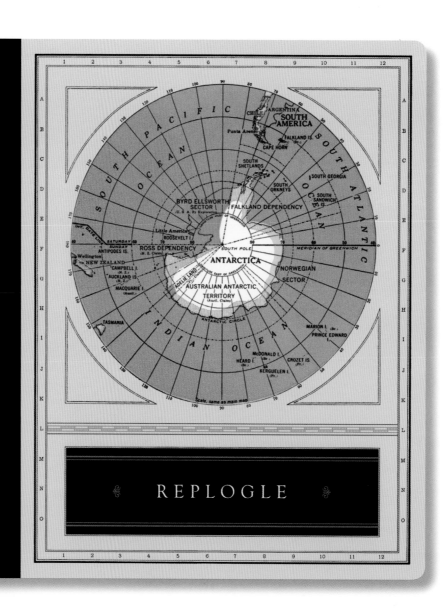

REPLOGLE

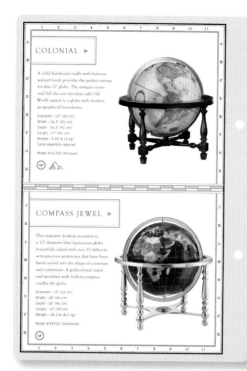

COLONIAL ➤

A solid hardwood cradle with lustrous
walnut finish provides the perfect setting
for this 12" globe. The antique ocean
and full die-cast meridian add Old
World appeal to a globe with modern
geographical boundaries.

Diameter - 12" (30 cm)
Width - 16.3" (41 cm)
Depth - 16.3" (41 cm)
Height - 17" (43 cm)
Weight - 4.25 lb (2 kg)
Some assembly required

Model #31700 (Antique)

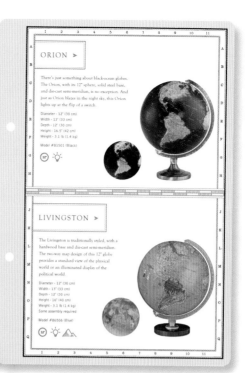

ORION ➤

There's just something about black-ocean globes.
The Orion, with its 12" sphere, solid steel base,
and die-cast semi-meridian, is no exception. And
just as Orion blazes in the night sky, this Orion
lights up at the flip of a switch.

Diameter - 12" (30 cm)
Width - 13" (33 cm)
Depth - 12" (30 cm)
Height - 16.5" (42 cm)
Weight - 3.1 lb (1.4 kg)

Model #81501 (Black)

COMPASS JEWEL ➤

This exquisite desktop accessory is
a 13" diameter blue lapis-ocean globe
beautifully inlaid with over 25 different
semi-precious gemstones that have been
hand carved into the shape of countries
and continents. A gold-colored stand
and meridian with built-in compass
cradles the globe.

Diameter - 13" (33 cm)
Width - 18" (46 cm)
Depth - 18" (46 cm)
Height - 19" (49 cm)
Weight - 18.1 lb (8.2 kg)

Model #38700 (Gemstone)

LIVINGSTON ➤

The Livingston is traditionally styled, with a
hardwood base and die-cast semi-meridian.
The two-way map design of this 12" globe
provides a standard view of the physical
world or an illuminated display of the
political world.

Diameter - 12" (30 cm)
Width - 13" (33 cm)
Depth - 12" (30 cm)
Height - 16" (40 cm)
Weight - 3.1 lb (1.4 kg)
Some assembly required

Model #86506 (Blue)

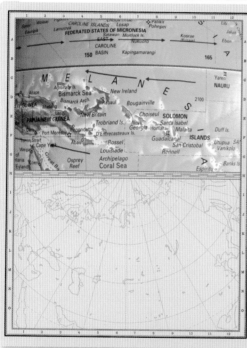

100 WAYS
AROUND THE WORLD

SINCE 1930, REPLOGLE

HAS MANUFACTURED GLOBES.

WE CURRENTLY OFFER MORE THAN

100 MODELS, RANGING FROM

HANDCRAFTED MASTERPIECES TO

DURABLE CLASSROOM TOOLS.

Replogle

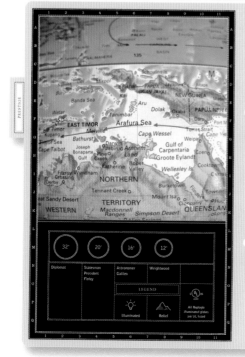

32"	20"	16"	12"

| Diplomat | Statesman President Finley | Astronomer Galileo | Wrightwood |

LEGEND

Illuminated Relief

All Replogle
illuminated globes
are UL listed

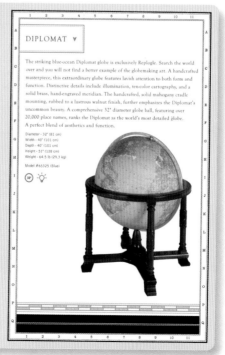

DIPLOMAT ▾

The striking blue-ocean Diplomat globe is exclusively Replogle. Search the world
over and you will not find a better example of the globemaking art. A handcrafted
masterpiece, this extraordinary globe features lavish attention to both form and
function. Distinctive details include illumination, ten-color cartography, and a
solid brass, hand-engraved meridian. The handcrafted, solid mahogany cradle
mounting, rubbed to a lustrous walnut finish, further emphasizes the Diplomat's
uncommon beauty. A comprehensive 32" diameter globe ball, featuring over
20,000 place names, ranks the Diplomat as the world's most detailed globe.
A perfect blend of aesthetics and function.

Diameter - 32" (81 cm)
Width - 40" (101 cm)
Depth - 40" (101 cm)
Height - 51" (128 cm)
Weight - 64.5 lb (29.3 kg)

Model #65325 (Blue)

Celebrating the 800 Series Everything moves on. Our enjoyment of music, for example, has undergone a revolution in the last few years. That album you thought you'd never hear again after the kids played Frisbee with it? It can now be downloaded in a full, stereo, scratch-free, digital format, within a few clicks of a button. Technology has made music more accessible. It's also made it more enjoyable. B&W's pursuit of the perfect loudspeaker has led to continuous improvements in the listening experience. A few years ago, our Nautilus™ 800 Series introduced advances in acoustic engineering that revealed music in a new light. But we didn't stop there. We kept moving on. We continued to refine and experiment, and now we've raised the standard again. We discovered the incredible difference made by a diamond tweeter dome. We've simplified the crossover to the purest, subtlest and most harmonious group of components. Improvements have been made to all the drive units. Subwoofers now include a room optimisation system that tailors their output to the acoustic of the surroundings. And we've widened the range to better encompass home theatre. You'll find much more on these advances on the following pages plus interviews with well-known B&W enthusiasts and some stunning images of our latest creations. Finally, take a look at the DVD we've put together for the full story on how we keep everything moving on at B&W.

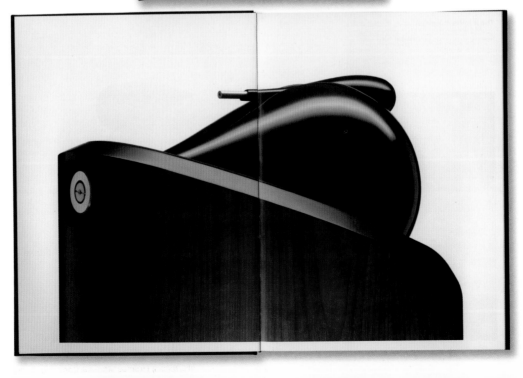

Fit for purpose Technological advances, groundbreaking research and world-class design have all helped keep B&W at the top of the tree. But equally has the dedication, skill and experience of our workforce in preserving the build quality of our products. Once the speaker cabinet has arrived in Worthing from Denmark, a small dedicated team oversees its

entire final assembly and testing. The bass drive units and crossover are installed in the main cabinet, and the midrange driver and tweeter fitted to their respective enclosures, before the three units are positioned and secured together. It's all carried out with total commitment and care.

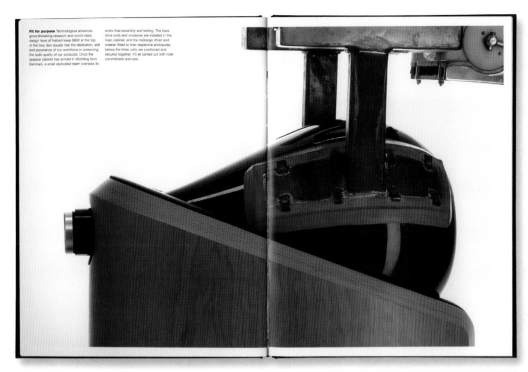

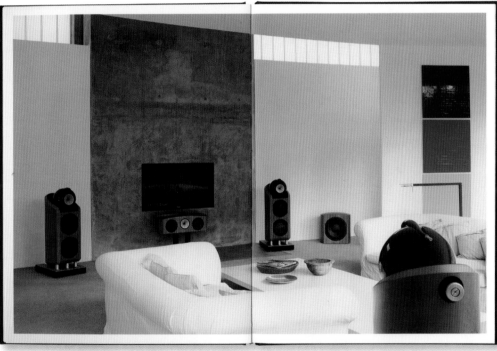

Outer stillness, inner strength Why are seashells round? Answer: edges and corners are potential weak points against the buffeting and banging of an oceanic existence. A continuous, curved surface creates a much stronger structure using the same volume of material. Forces from pressures and impacts are spread evenly across it. Similar mechanics are behind classical architecture's discovery of the arch and the shape of the wheel.

It's an ancient principle. It's just taken a while to reach the design of speaker cabinets. Fortunately, B&W's development of shell-like bass cabinets means the wait for the resonance-free enclosure is over. The thick, multi-layered wall holds the drive unit assemblies stiff and secure, and absorbs shocks and vibrations that might send straighter cabinets round the bend. As if a naturally strong shell wasn't enough, the cabinet walls are held firm against exceptional vibration by their own internal skeleton.

B&W introduced its Matrix internal bracing system more than 15 years ago and has been refining its design and construction continuously. A structure of interlocking panels works like the ribs in a ship's hull, defusing stresses and strains and bracing the cabinet sides against movement. Laser measurement (left) shows that while straight-sided cabinets flex and vibrate under heavy use, B&W's Matrix-braced, curved cabinets hold still.

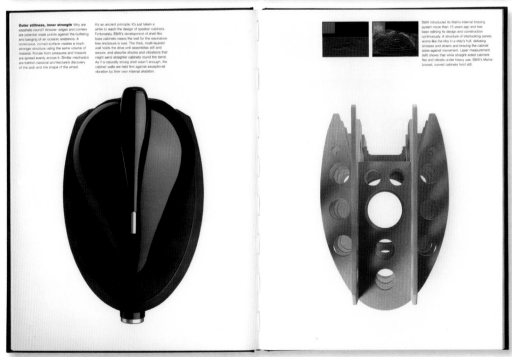

MY CHINA!

MICHAEL SIEGER

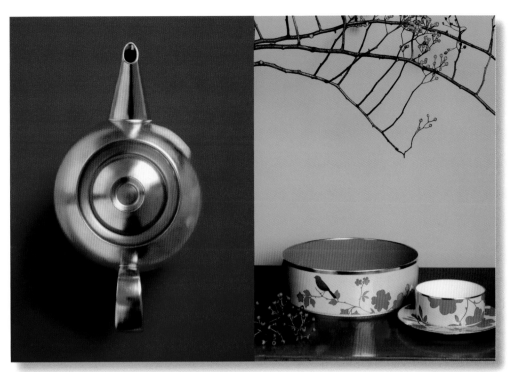

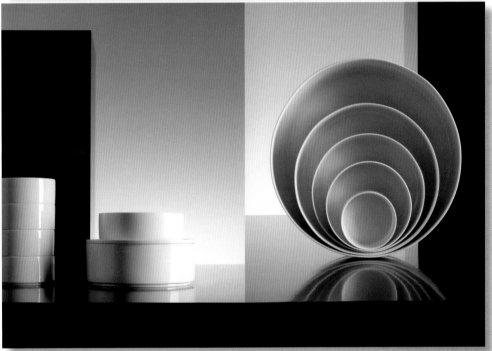

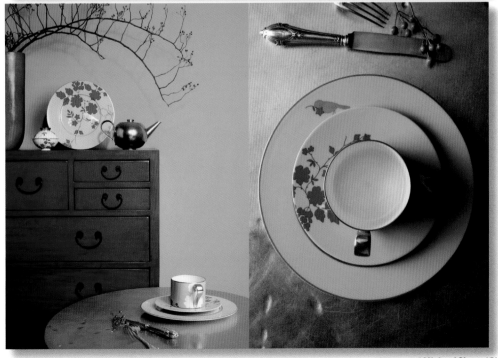

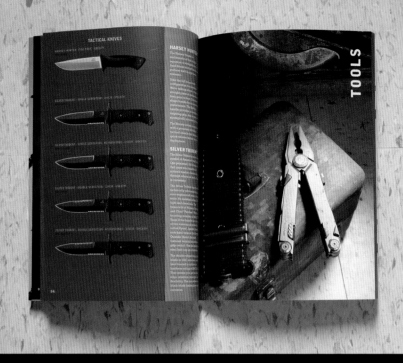

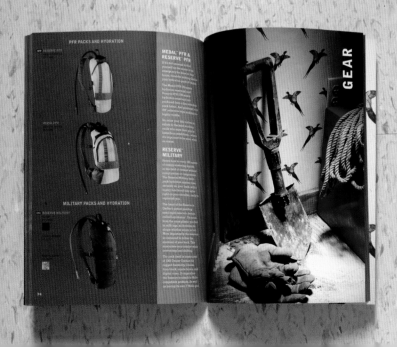

Maki-e is an ancient art form believed to have arrived from China during the Heian period (794-1185), but developed to its greatest artistic expression by Japanese artists. The Japanese word maki-e literally means 'sprinkled picture', as it involves sprinkling gold or silver dust over designs drawn in the lacquer surface while it is still damp and sticky. Maki-e itself is a general term covering three main techniques. Hiramaki-e is a relatively flat finish with a few layers of lacquer on the base pen, followed by applying the design onto the still-moist lacquer, typically covering it with a final clear layer for protection. Togidashi-e means 'brought out by polishing', the design is completely covered with lacquer, then buffed until the design reappears. Lastly, Takamaki-e features a surface that exhibits raised portions, created by building up relief on the design. Advanced maki-e typically involves combinations of these techniques. dunhill and Namiki believe that the Sakura-Rose represents the most ambitious application ever of maki-e to a fountain pen. To achieve the mix of colours and textures, and to provide the images with depth, the surface of the Sakura-Rose will exhibit all three applications: hiramaki-e, togidashi-e and takamaki-e. Additionally, details will be highlighted through the use of the finest gold leaf and minuscule slivers of mother-of-pearl acquired from abalone shells. Maki-e Master Kyusai Yoshida has conceived a pattern rich in significance to honour the 75th Anniversary of the dunhill-Namiki alliance. Held vertically, the pen displays a visual progression from heaven to earth. In-between the sky and the soil are, on the cap, cherry blossoms (sakura) to represent Japan, while the barrel bears golden roses to represent England. It is, without doubt, a perfectly apt symbol of this most highly-regarded and productive partnership.

How appropriate te brief span of the sakura's flowering: this delicate bloom is Japam's symbol for the ephemeral nature of life. Sakura is the Japanese name for the breathtakingly beautiful ornamental cherry trees that grew wild throughout the country but emerged as a symbol of pride during the Heian period. It was during the 8th to the 12th Centuries that the Japanese developed a national awareness, and the sakura emerged as the flower they most cherished. An enduring metaphor for life's brevity, the sakura appears throughout Japanese life, represented in both the precious and the mundane, from works of art to items of clothing. Perhaps the most beloved variety is the Somei Yoshino, nearly pure white with a hint of pink near the stem, developed in the 19th century, on the cusp of the Edo and Meiji periods. Other varieties include the yaezakura, with large flowers and rich pink petals, and shidarezakura, with branches reminiscent of a weeping willow, bearing cascades of pink flowers. With an intrinsic poignancy, the sakura's flowers bloom and normally fall within a week, adding an urgency to the experience of seeing these gorgeous flowers during the sakura zensen, or Cherry-Blossom Front. An annual obsession for the Japanese, it begins in February in Okinawa, proceeding north over the next few months. Friends and families hold 'flower viewing parties', or hanami, in parks, at shrines and at temples, perfect opportunities to relax and enjoy the beauty of the flowers. As a symbol of both the ephemeral nature of life and of Japan itself, the sakura has served as a token of friendship: the Japanese government gave 3,000 sakura as a gift in 1912 to the United States, where they line the Tidal Basin in Washington, DC. On the dunhill Sakura-Rose pen, sakura blossoms represent one-half of an enduring Anglo-Japanese partnership.

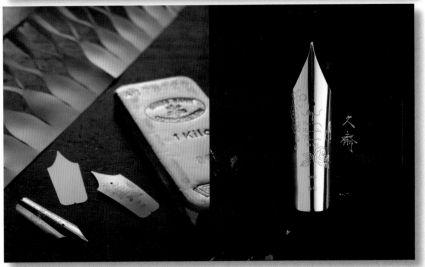

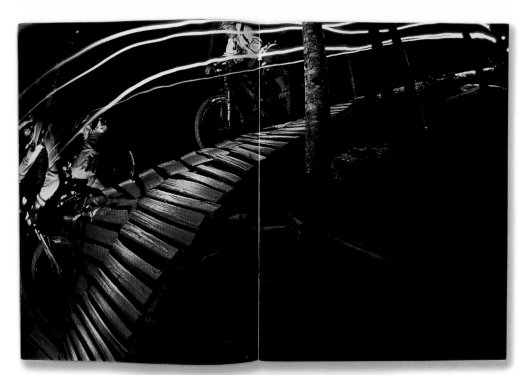

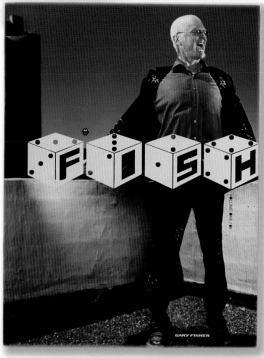

F·O·S·H

GARY FISHER

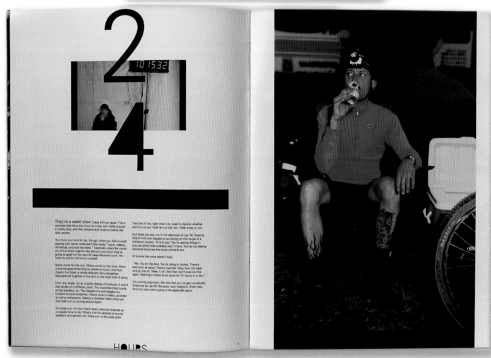

24

They're a weird draw, these 24-hour races. Full-on carnivals that blow into town for a day, spin wildly around a rickety axis, and then disband and move on before the dust settles.

You know you're in for fun, though, when you find yourself signing your name underneath the words "I waive, release, discharge, and hold harmless." Especially when the words are all bunched together like that and you know they've got to apply for the next 24 sleep-deprived hours. You have no one to blame but yourself.

Some come for the win. Others come for the sore. Many come because those friends needed a fourth. And then there's the Scene, a whole different story altogether. Sequestered together in the dark on the quiet side of camp.

From any angle, it's an ungodly display of fortitude. A world that exists on a different plane. The round-the-clock bustle of the transition pit. The hangers-out and hangers-on, huddled around campfires. People sunk in chairs, pounded dumb by exhaustion. Staring in disbelief when informed that their ruin is coming around again.

It's three a.m. An hour that's been roped by hospitals as a popular time to die. What's true for patients is true for pedalers and partiers too: three a.m. is the pivot point.

The time of the night when you need to decide whether you're in or out. Hold 'em or fold 'em. Walk away or run.

And there you are, out in the darkness of Lap 16. Passing Mile 9 with your headlamp soldiering on the verge of a full-blown crashin'. Or is it you? You're seeing things in your periphery that probably aren't there. You're not seeing eye-level branches that most certainly are.

Of course the voice doesn't help.

"Hey. You on the bike. You're riding in circles. There's beer back at camp. There's laydolls. Stop now. Go back and lie one on. Sleep it off. And then don't ever do this again. Nothing is meant to be done for 24 hours in a row."

It's a strong argument. But one that you've got completely bored out by Lap 20. Because soon happens. Every day. And this next one is going to be especially good.

HOURS

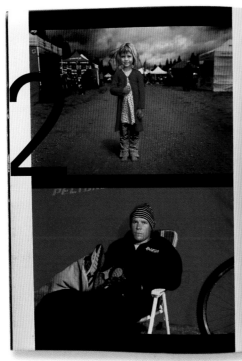

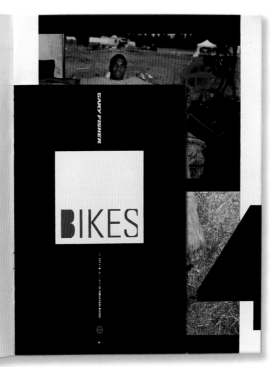

BIKES

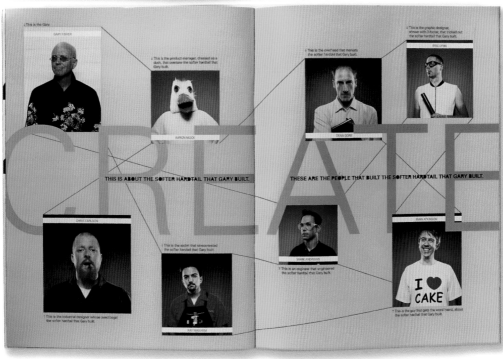

CREATE

THIS IS ABOUT THE SOFTER HARDTAIL THAT GARY BUILT.

THESE ARE THE PEOPLE THAT BUILT THE SOFTER HARDTAIL THAT GARY BUILT.

MOTOROLA: *75 YEARS OF INTELLIGENT THINKING*

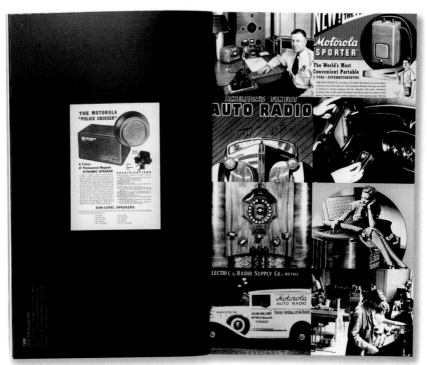

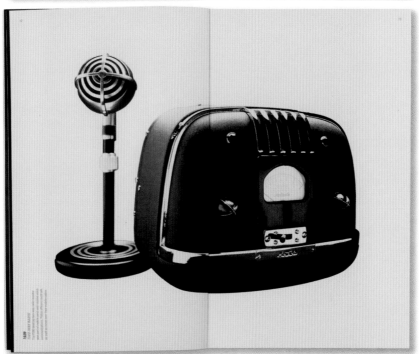

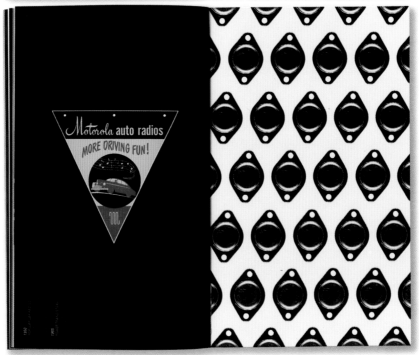

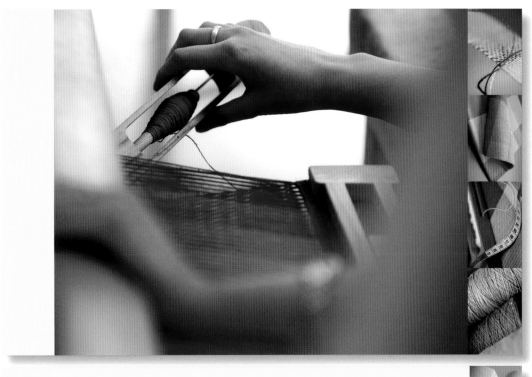

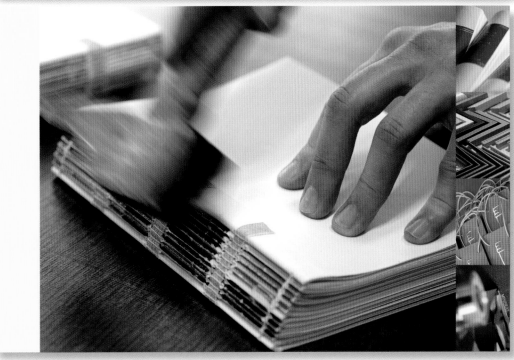

One of the first design consultants to bring international standard product design expertise to Taiwan. Center design is a full-service design consultancy with all the resources and experiences at its disposal to see a product through conception to marketplace. Center design emphasize on the quality and high value of services, this value is determined more by the quality of design and the ways it is made to meet customers' requirements, than by other factors.

CENTER DESIGN CO LTD 15F-5, No.79 Sin Tai 5th Road Section 1 Sin Jhih City Taipei County Taiwan
Tel 886 2 26989475 Fax 886 2 26989485 Email center@cen-design.com craik@cen-design.com

center ● design

A STRONG INNOVATOR
Branding Taiwan Design

Unikdesign has many dedicated designers and engineers who can provide clients with high quality innovations. We have the design and engineering capability to support your promotional material needs with high product quality, quick time-to-market and profitability. Today, unikdesign is a full-service design firm with a team formed by certified graphic designers, industrial designers, and mechanical engineers.

Our team members have bachelor of design and science degrees from accredited universities. All our designers and engineers have a vast experience working with international projects for international IT companies, such as HP, IBM, Dell, Agfa and Canon.
We have rich R&D experience in handling both small and large organizations' internal logistics, and we deliver timely solutions.

UNIKDESIGN CO LTD 1F, No.11 Lane 56 Jhang Sin Stree Wun Shan District Taipei Taiwan
Tel 886 2 29382862 Fax 886 2 29382877 mindy@unikdesign.com.tw www.unikdesign.com.tw

unikdesign

Products stand the test of time through quality design and reliability. From product concept to promotion kit, Unikdesign provides comprehensive design services to fulfill different clients' needs and proposes capable solutions to our clients.

Applying advanced design methodologies and tools, we strive to deliver to our clients an edge in the marketplace through innovative and original designs.

Taking into consideration individual client's capabilities, costs, market position, product life cycle, and customers, we see the 'Appropriate Design' crucial to achieve the project goal. A successful project is dependent on the 'Appropriate Design', representing the ability to address product positioning, features, styling, engineering, and packaging. Some would consider this design a compromise; Unikdesign sees it as the current design.

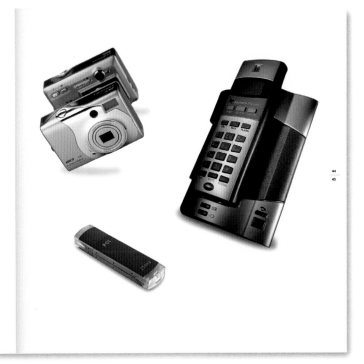

The core member Creative Director Daniel Koo grew up in U.S. After engaging in industrial design in U.S. for many years, he gathered together a group of talented young designers holding the same belief and established the [I+U] design force in Taiwan in 1991, setting the international standard as its goal. With the passion and persistence in industrial design, Daniel Koo injected the global view and design concept into the Chinese market, leading the Chinese industrial design to the world stage. In 2003 I+U joined the SQV Group and became SQV Design International Inc.

Field
● Design Brief
● Marketing
● Package Design
● Commercial Design
● Industrial Design
● Brand Design
● Marketing & Channel

Categories
● Market Research
● Design Planning & Analysis
● Customer Study
● Design Counseling
● Concept Developing

Visual Communication
● Corporate Identity System Design
● Brand Identity Design
○ Web Design
● Commercial Product Design
● Signage Design
● Display Design
● Retail Design
● Illustration & Copy
● Printing

Industrial Design
● Product Design
● Prototype
● Assembly
● Mechanism
● Modeling
● CAD/CAM
● Styling Design

Specialty
● User Interface Design
● Material Research
● Engineering Analysis
● Modeling Management
● Mass Product Management

Service Advantages
The advantages of SQV Design International Inc. are as follows:
1. Year's of 360° integrated strategic product panning ability
2. Abundant international (U.S. Europe and mainland China) experience
3. Familiar with manufacturing resources in the greater China region, able to build a complete industrial design service chain for the customers
4. World famous industrial design corporations' sole alliance in the greater China region, such as RKS etc.
With almost twenty years' experience in the field of industrial design, SQV provides customers with comprehensive services from the preliminary market research, product appearance design, mechanical design, molding, production, up to product launch planning, sales channel and marketing strategy.

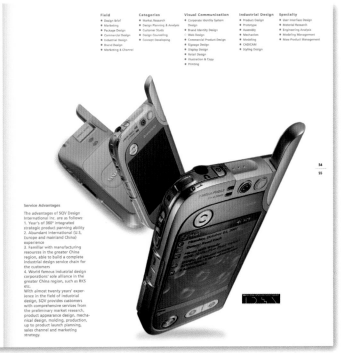

SQV DESIGN INTERNATIONAL INC 12A No.85 Ren Ai Road Section 4 Da An District Taipei Taiwan
Tel 886 2 55515888 Fax 886 2 55518899 Email gloria.sun@sqvgroup.com www.sqvgroup.com/design

漢邦集團

The vegetation is lush in front of our four-story hypothermal apartment near an abundant green park. Though the vegetation is not as stately as the office building, it still makes people feel the warmth and kindness of nature. Upon entering, the main tone of the whole office is set by a grainy material which matches the gray floor board. Top DESIGN combined changes of light and shadow with the warm color projected by the lighting. A bounty of nature has greeted us and our clients for the past fifteen years. There is no lack of prized design, such as home appliances and communication devices among the whole achievement, which places people in an artwork exhibition.

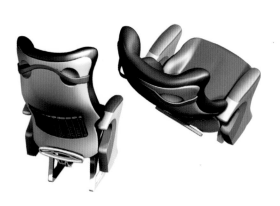

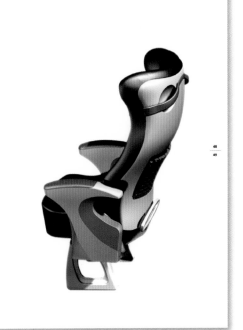

1939

One war ended when Franco became head of a Fascist Spain; a larger war—the most costly in history—began when Nazi troops blitzed through Poland, shortly after the signing of the Nazi-Soviet non-aggression pact and Britain and France honored their treaty with Poland. Forgotten here was the New York World's Fair as 45 million radios tuned in on the "phony war" and America tried to stick to strict neutrality. On campuses students swallowed goldfish instead of puzzling through just-published James Joyce's "Finnegan's Wake." Judy Garland triumphed in "The Wizard of Oz." So did Vivien Leigh as Scarlett O'Hara in "GWTW."

1940

The German juggernaut overran almost all of Western Europe. In Britain, now isolated, Churchill took over and managed to evacuate 340,000 troops from Dunkirk. A French general named DeGaulle also made it to London. Pétain formed a government at Vichy and Japan threw her hand in with the Axis. The U.S. helped Britain somewhat by providing 50 overage destroyers, started its first peacetime draft. Trotsky was assassinated in Mexico. Roosevelt won a third term over Wendell Willkie.

TIME
80
Years of Covers

COVERS HISTORY

TIME MAGAZINE COVERS 1923-2003

2001

The news events of 2001 were eclipsed by one date: 9/11. The terrorist attacks on the World Trade Center in New York City and the Pentagon in Washington, D.C., claimed more than 3,000 innocent lives. In November, U.S. troops toppled the terrorist-supporting Taliban regime in Afghanistan.

2002

It was "the year after," as Americans struggled to absorb the devastating attacks of Sept. 11, 2001 and move on. The war on terror dominated the news, as bombs exploded in Bali and Kenya, while President George W. Bush pushed for weapons inspection in Saddam Hussein's Iraq. It was also a year of disillusionment. In the Roman Catholic Church, priests were charged with sexual abuse, and higher-ups were accused of cover-ups; in big business, corrupt executives were perp-walked to justice. Happily, a glorious two weeks of Winter Olympics in Utah and Hollywood's "Spider-Man" lightened up a rather dark year.

THE
WALDORF=ASTORIA
COLLECTION™

THE WALDORF=ASTORIA COLLECTION IS LUXURIOUS,
BUT MOVES WELL BEYOND LUXURY INTO THE REALM
OF TOTAL GUEST ENGAGEMENT. FROM EXCITING
ADVENTURES AND EXPLORATIONS OF THE LOCAL
ENVIRONMENT TO QUIET INTELLECTUAL ESCAPE,
THE COLLECTION CREATES PEAK EXPERIENCES
ENCOMPASSING ALL POSSIBLE PURSUITS WITHIN
THE INTERNATIONAL LANDSCAPE. EACH HOTEL
IS SINGULAR — SEPARATE YET UNEQUALED — AND
EACH IS A SOLE TREASURE THAT WILL DELIGHT AND
INSPIRE A SENSE OF DISCOVERY IN THE MOST SOPHIS-
TICATED GUEST. ALL ARE BOUND BY THE SAME
MISSION: MAKING THE LEGACY OF THE FIRST
WALDORF=ASTORIA COME ALIVE FOR TODAY AND
TOMORROW'S GUEST.

This page from top left: A Botero sculpture at The Grand Wailea
Resort Hotel & Spa, the lobby mezzanine of The La Quinta Resort
& Club, the ballroom elevators at The Waldorf=Astoria.

From bottom left: The Biltmore Grill at The Arizona Biltmore Resort
& Spa, tiled steps at the La Quinta Resort & Club, the famous lobby
clock at The Waldorf=Astoria.

Page at right: The glorious mural in the Hollandale Ballroom at
The Grand Wailea Resort Hotel & Spa.

Following pages: La Casa Courtyard at the La Quinta Resort & Club.

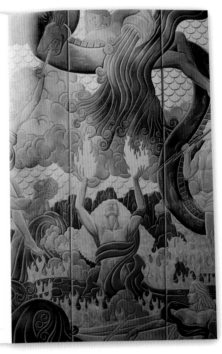

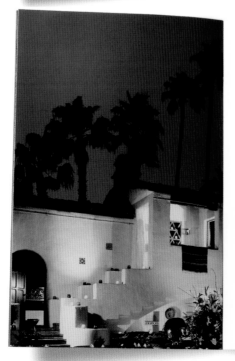

AN UNFORGETTABLE BLEND OF ICON AND MYTH,
EXHILARATION AND POSSIBILITY, THE WALDORF=ASTORIA
COLLECTION IS HOTEL PERFECTION MADE MANIFEST
THROUGH ARCHITECTURE, ART AND CIVILIZATION.
UNPARALLELED IN ELEGANCE AND APPOINTMENTS,
THE VERY BEST OF THE BEST IS SUMMONED TO LIFE IN
THE WALDORF=ASTORIA COLLECTION.

LEISURE

DINER

AND LEGEND

MILES DAVIS

THIS IS THE FILLMORE HERITAGE CENTER

CULTURE

SARAH VAUGHN

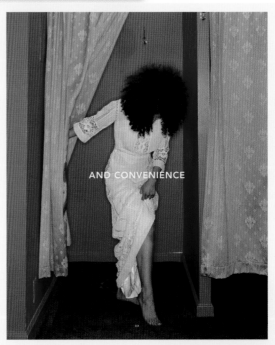

AND CONVENIENCE

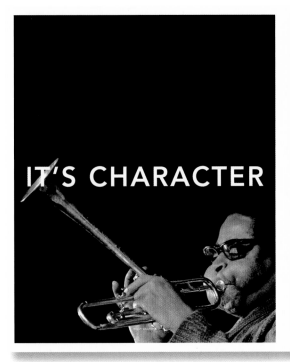

IT'S CHARACTER

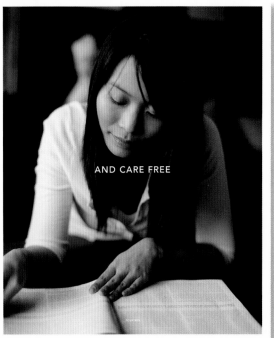

AND CARE FREE

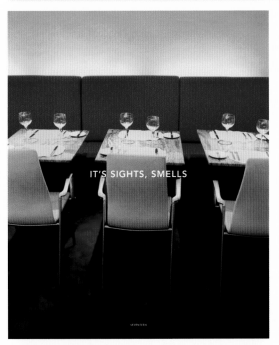

IT'S SIGHTS, SMELLS

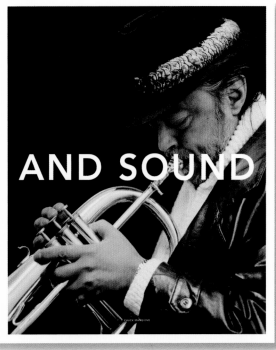

AND SOUND

IT'S HOME

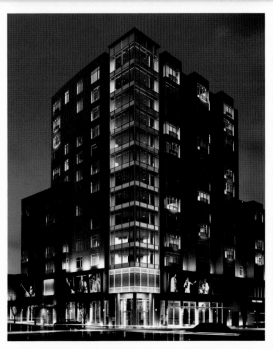

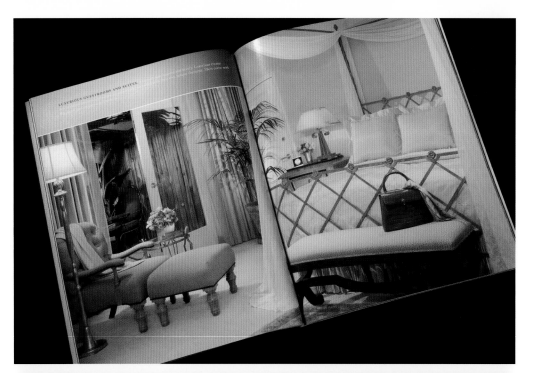

The Beverly Hills Hotel
and Bungalows

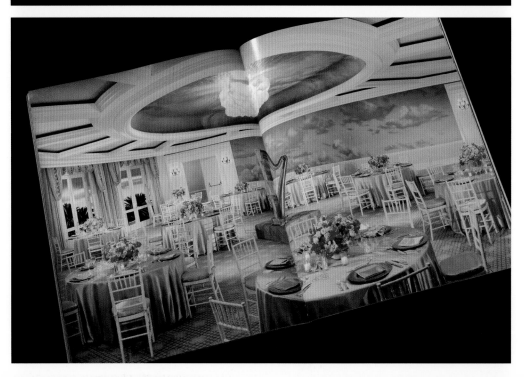

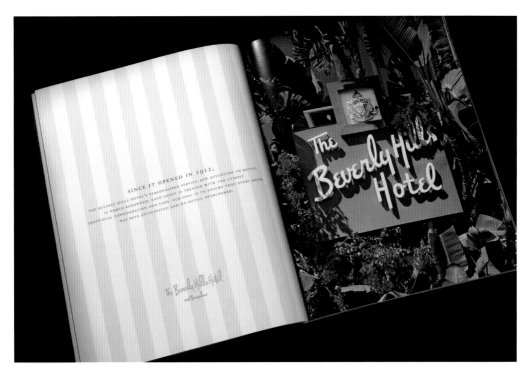

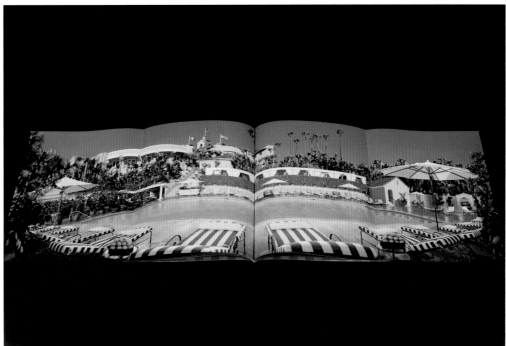

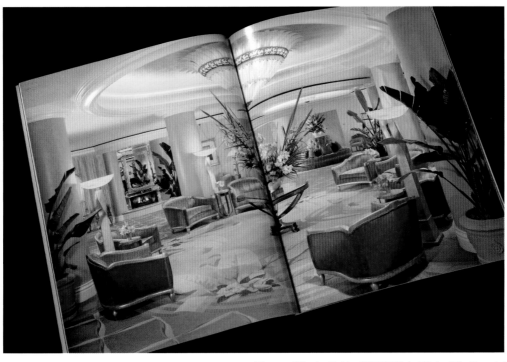

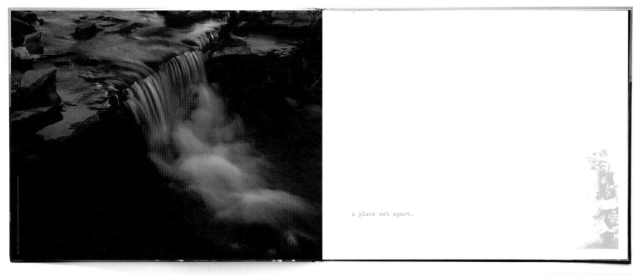

a place set apart.

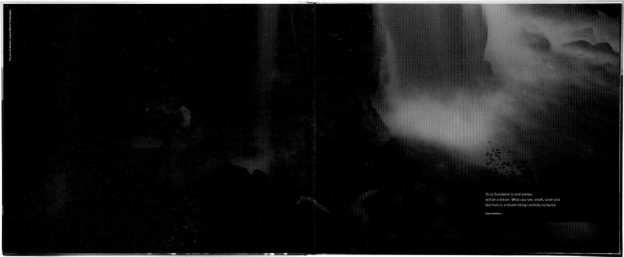

To us Sundance is and always
will be a dream. What you see, smell, taste and
feel here is a dream being carefully nurtured.

Robert Redford

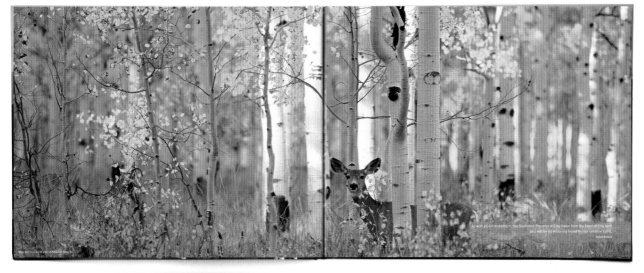

As with all our endeavors, the Sundance Preserve will be hewn from the heart of this land
and will be an enduring home for our creative spirit.

Robert Redford

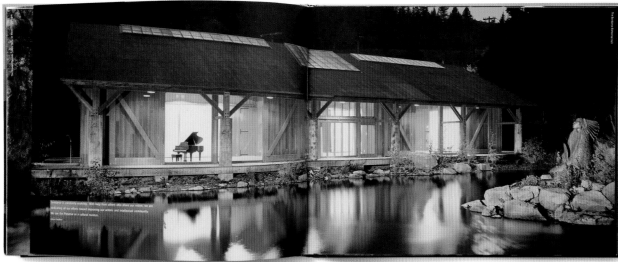

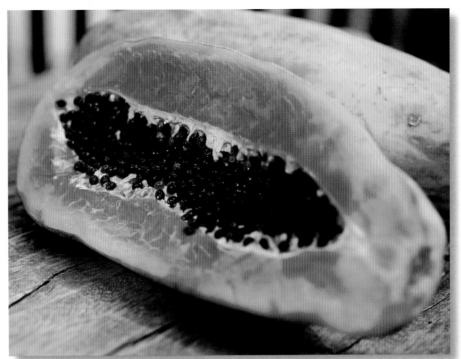

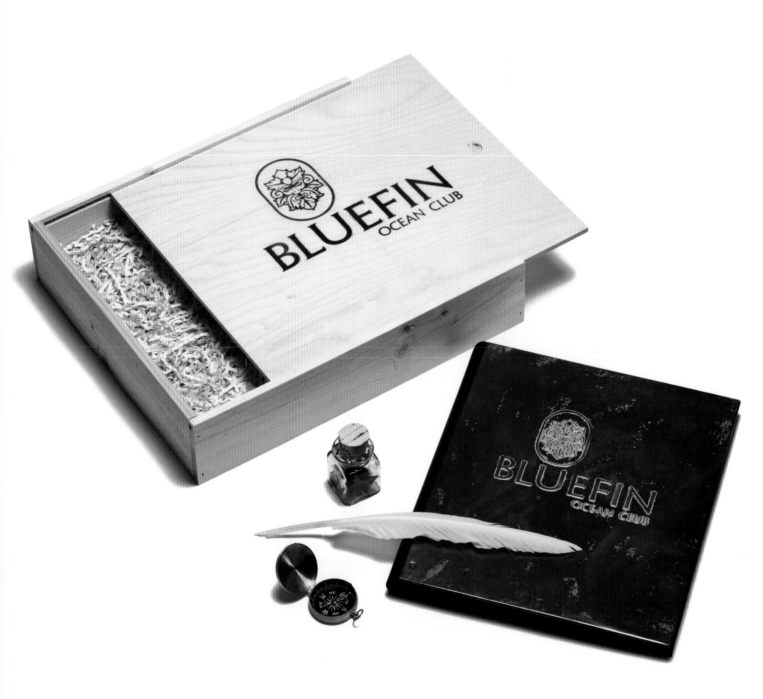

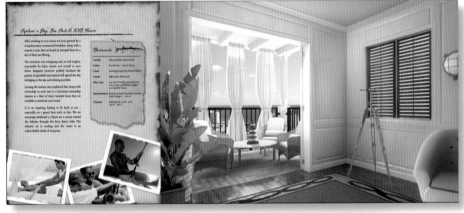

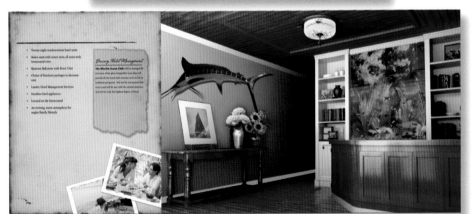

THE SOUTH WATERFRONT ARCHITECTURE SERIES

Robert Thompson, Architect, Block 35

john ross

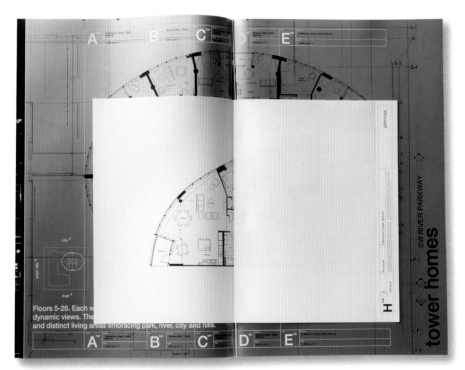

Floors 5-26. Each w...
dynamic views. The...
and distinct living areas embracing park, river, city and hills.

tower homes

SW RIVER PARKWAY

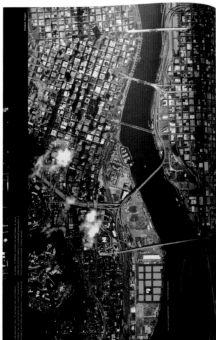

Manhattan is SOHO, Tribeca and the East Village. San Francisco is the Haight, the Mission district, SOMA and Nob Hill. Portland is the Pearl, Hawthorne and NW 23rd…

and
now
The River Blocks.

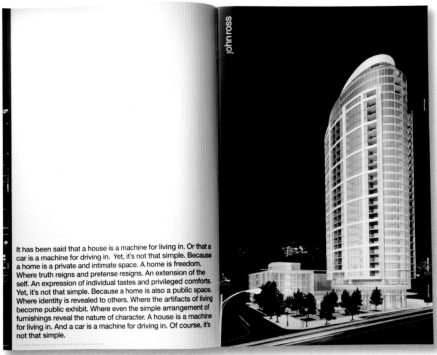

john ross

It has been said that a house is a machine for living in. Or that a car is a machine for driving in. Yet, it's not that simple. Because a home is a private and intimate space. A home is freedom. Where truth reigns and pretense resigns. An extension of the self. An expression of individual tastes and privileged comforts. Yet, it's not that simple. Because a home is also a public space. Where identity is revealed to others. Where the artifacts of living become public exhibit. Where even the simple arrangement of furnishings reveal the nature of character. A house is a machine for living in. And a car is a machine for driving in. Of course, it's not that simple.

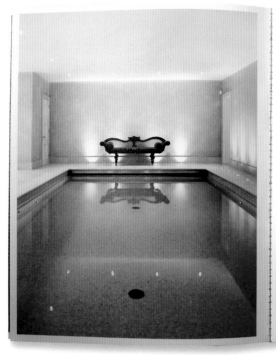

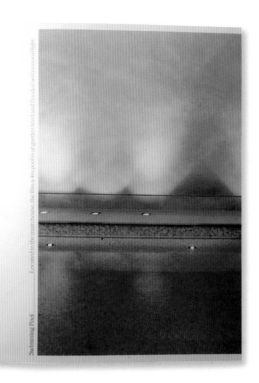

Swimming Pool Located in the main house, the 8m x 4m pool is at garden level and flooded with natural light.

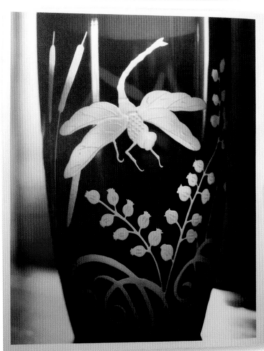

C issue 01 West Campus A
House
Seattle Church for Two Faiths

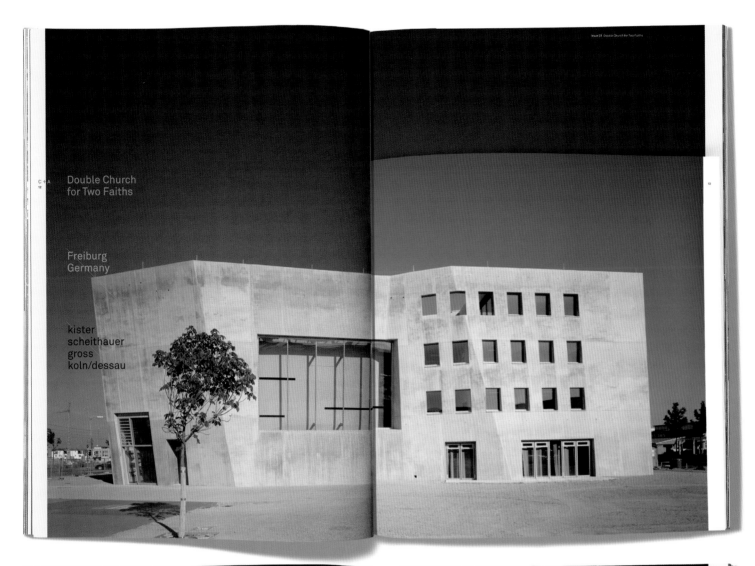

Double Church
for Two Faiths

Freiburg
Germany

kister
scheithauer
gross
koln/dessau

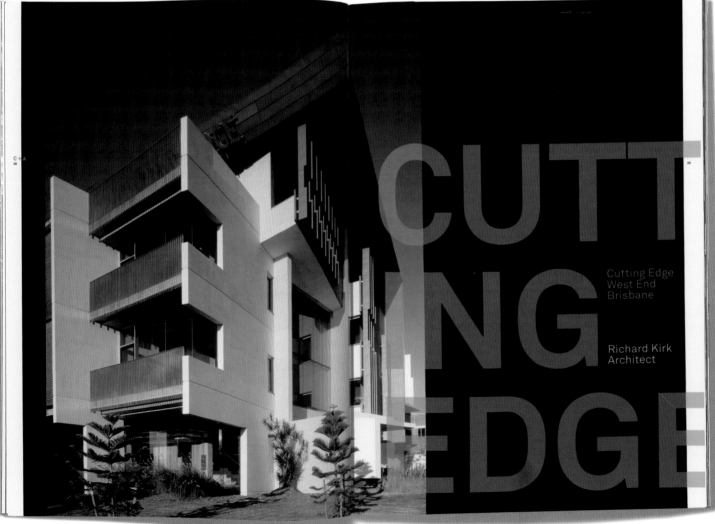

Cutting Edge
West End
Brisbane

Richard Kirk
Architect

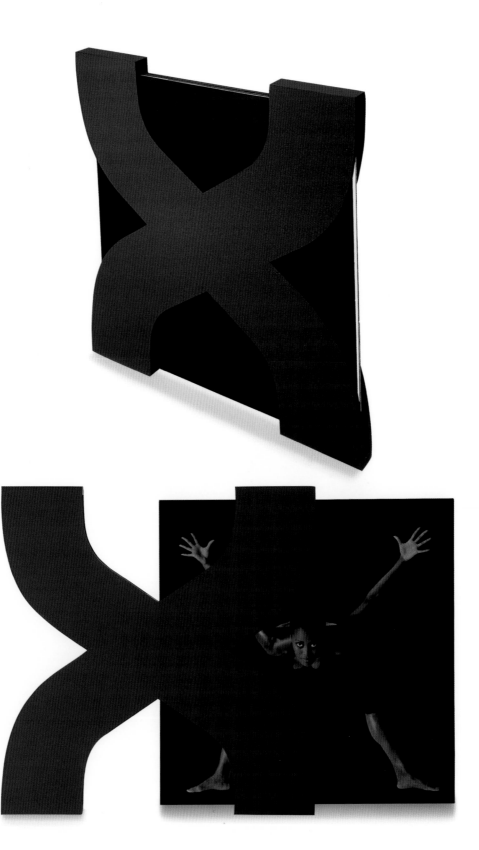

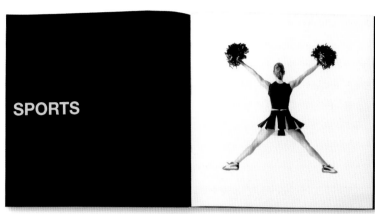

MEADOWLANDS
XANADU

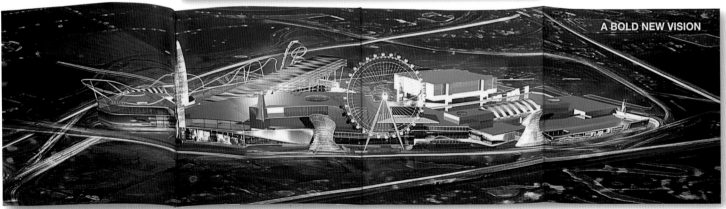

A BOLD NEW VISION

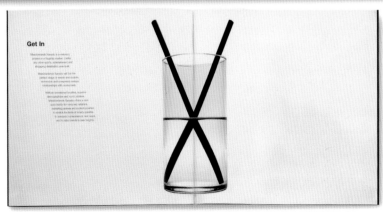

Get In

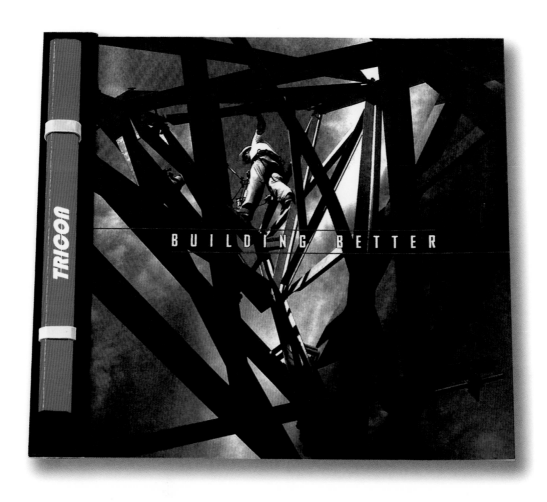

F rom savory Southwestern fare to gourmet cowboy cuisine, dining at Lajitas is a sensory experience designed to satisfy our guests' appetite for life as well their appreciation for fine foods.

Our culinary creations celebrate the native flavors of the region, including green chiles, prickly pear, wild game, and prime beef aged on site. Whether for breakfast, lunch, dinner or Sunday brunch, our world-class chefs make every dish extraordinary.

Lajitas boasts a variety of dining options – each designed to punctuate the meal with uncommon ambience. The casual patio of the Candelilla Café offers spectacular views of the golf course and the Rio Grande, and the dramatic glass walls of Ocotillo provide a perfect canvas for the colorful Southwestern sunset. All day long, the Frontier Soda Fountain serves a touch of nostalgia along with its cappuccino, baked goods, salads and fountain favorites. And for those with a penchant for the unconventional, an intimate dinner at the chef's table or our underground wine cellar is sure to etch a lasting memory.

T o the west, the banks of the Rio Grande outline the lush fairway – while to the east, Mexican sand palms create a textured silhouette against the morning sun. The beauty of the course is nothing short of inspiring. And with each stroke of the iron, the exhilaration builds.

Our golf courses are designed to challenge players of every skill level, with multiple tee placements that accommodate novice and expert players alike. Strategically placed bunkers and water hazards add technical intensity to the world-class course, and a unique par-one hole that plays into Mexico gives players the rare opportunity to sink an ace across international borders.

With the best grass greens underfoot, stunning native plants at every turn, and massive ridges rising just beyond the green, the greatest triumph on this awe-inspiring course may be to simply keep an eye on the ball.

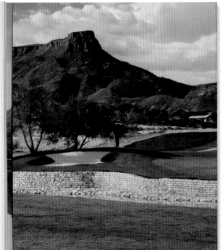

I n the Old West, a horse was considered essential transportation as well as a respected companion. Here at The Ultimate Hideout, that philosophy endures. Our Equestrian Center not only provides first-class boarding for our equine tenants – it also gives guests a chance to experience this desert wilderness from a cowboy's-eye view.

Over every ridge, a new surprise awaits – a soaring falcon, a striking rock formation, a shy jackrabbit. These are nature's priceless rewards, reserved especially for those who discover the breathtaking view of the Old West from horseback.

Beyond the peaceful seclusion of Lajitas lies a place even more remote – save for the abundance of mourning dove, white wing dove and Gambel's quail that make this range an ideal private hunting retreat.

Created exclusively for Lajitas members and resort guests, the Hunt Club handles every detail of the expedition. Attendants carry chairs and coolers, clean empty shells, and retrieve and clean game. After a successful harvest, our gourmet chef prepares the day's bounty. The camaraderie continues well into the evening, with coffee and conversation around a crackling campfire.

50 Crate&Barrel GiftRegistry™

13
Get rid of your old baking pans.

14 You can buy it for yourself later, but you probably won't.

8 Give guests a price range.

9 A kitchen cart makes a great group gift.

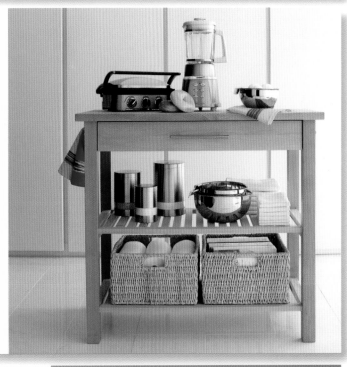

34
Layer the bed.

35 You'll want two sets of sheets for each room.

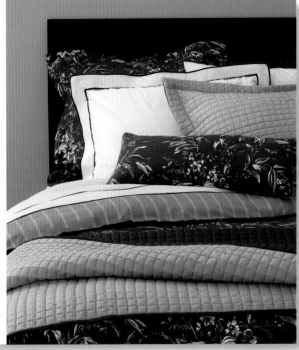

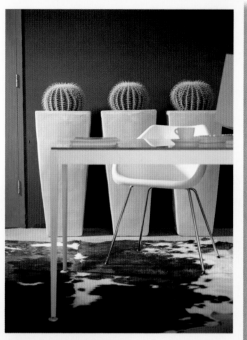

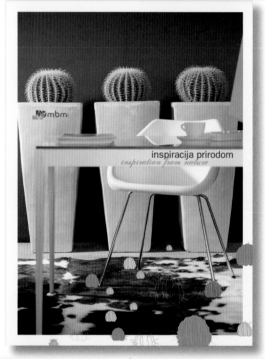

inspiracija prirodom
inspiration from nature

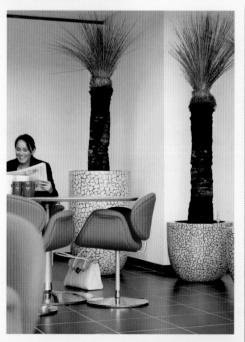

the strength of
the
natural form
is tamed in the
energ-implosion of the
container

rapsodija u crvenom okviru,

s nešto zelenih sadržaja u središtu

rhapsody in a red setting,

with something green in the centre

bromelija
bromeliaceae

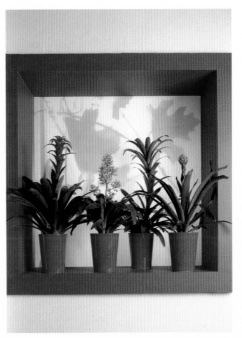

spatifolia
spathiphyllum

kao da smo na sajmu cvijeća i bilo umorno

baš sprema se

na put novome horizontu

as if we were at a flower show,

just gathered and on their way

to a new view

and plants

znaci koji će nas zacijelo odvesti prema željenom cilju

look, fixes that are bound to take us off towards our aimed destination

američka agava
agave americae
century plant

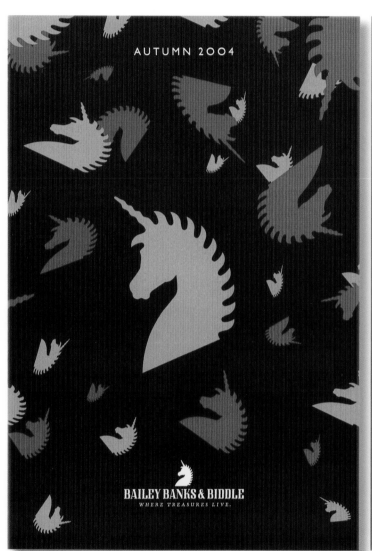

AUTUMN 2004

BAILEY BANKS & BIDDLE
WHERE TREASURES LIVE.

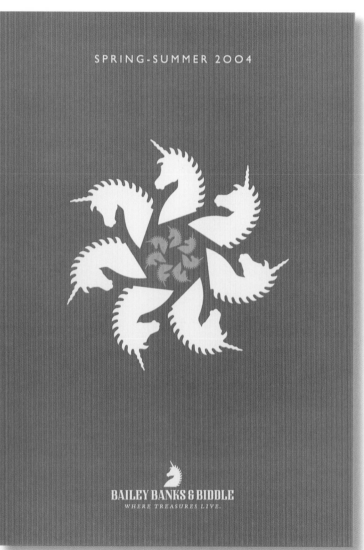

SPRING-SUMMER 2004

BAILEY BANKS & BIDDLE
WHERE TREASURES LIVE.

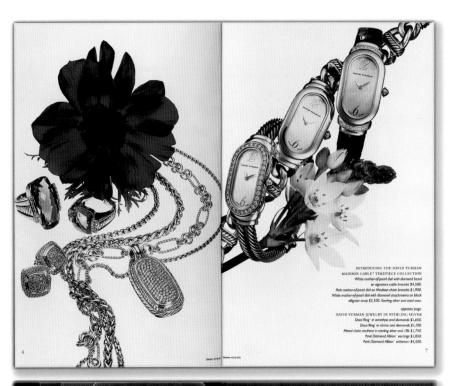

INTRODUCING THE DAVID YURMAN
MADISON CABLE™ TIMEPIECE COLLECTION
White mother-of-pearl dial with diamond bezel
on signature cable bracelet $4,500.
Pink mother-of-pearl dial on Madison chain bracelet $1,900.
White mother-of-pearl dial with diamond attachments on black
alligator strap $2,300. Sterling silver and steel case.

opposite page:
DAVID YURMAN JEWELRY IN STERLING SILVER
Deco Ring™ in amethyst and diamonds $1,650.
Deco Ring™ in citrine and diamonds $1,100.
Mixed chain necklace in sterling silver and 18k $1,750.
Pavé Diamond Albion™ earrings $1,850.
Pavé Diamond Albion™ enhancer $4,500.

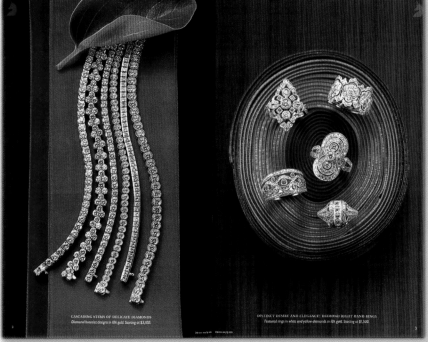

CASCADING STEMS OF DELICATE DIAMONDS
Diamond bracelet designs in 18k gold. Starting at $3,100.

DISTINCT DESIRE AND ELEGANCE: DIAMOND RIGHT HAND RINGS
Featured rings in white and yellow diamonds in 18k gold. Starting at $1,500.

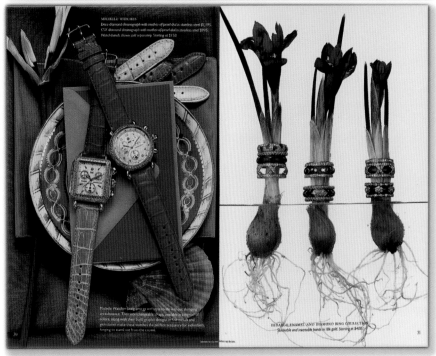

MICHELE WATCHES
Deco diamond chronograph with mother-of-pearl dial in stainless steel $3,195.
CSX diamond chronograph with mother-of-pearl dial in stainless steel $995.
Watch bands shown sold separately. Starting at $150.

HIDDEN ENAMEL AND DIAMOND RING COLLECTION
Stackable and insertable bands in 18k gold. Starting at $400.

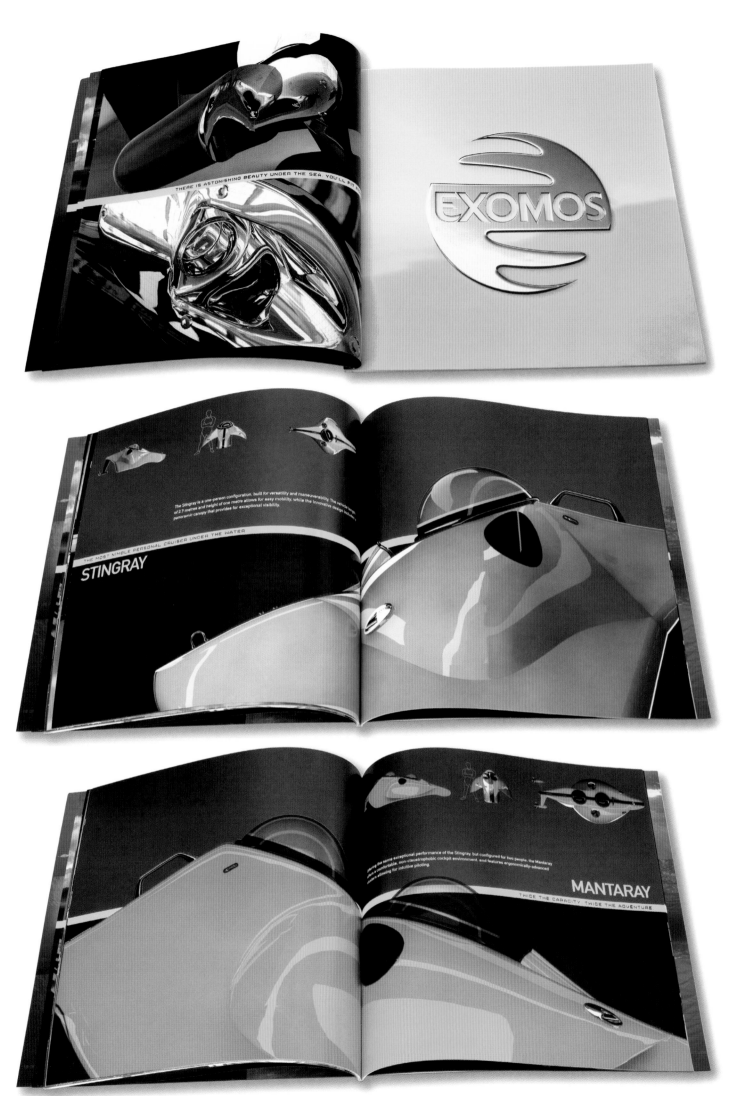

THERE IS ASTONISHING BEAUTY UNDER THE SEA, YOU'LL FIT

EXOMOS

The Stingray is a one-person configuration, built for versatility and maneuverability. The vehicle length of 3.7 metres and height of one metre allows for easy mobility, while the innovative design includes panoramic canopy that provides for exceptional visibility.

THE MOST NIMBLE PERSONAL CRUISER UNDER THE WATER

STINGRAY

...the same exceptional performance of the Stingray, but configured for two people, the Mantaray ...ers a comfortable, non-claustrophobic cockpit environment, and features ergonomically-advanced ...ora's seating for intuitive piloting.

MANTARAY

TWICE THE CAPACITY, TWICE THE ADVENTURE

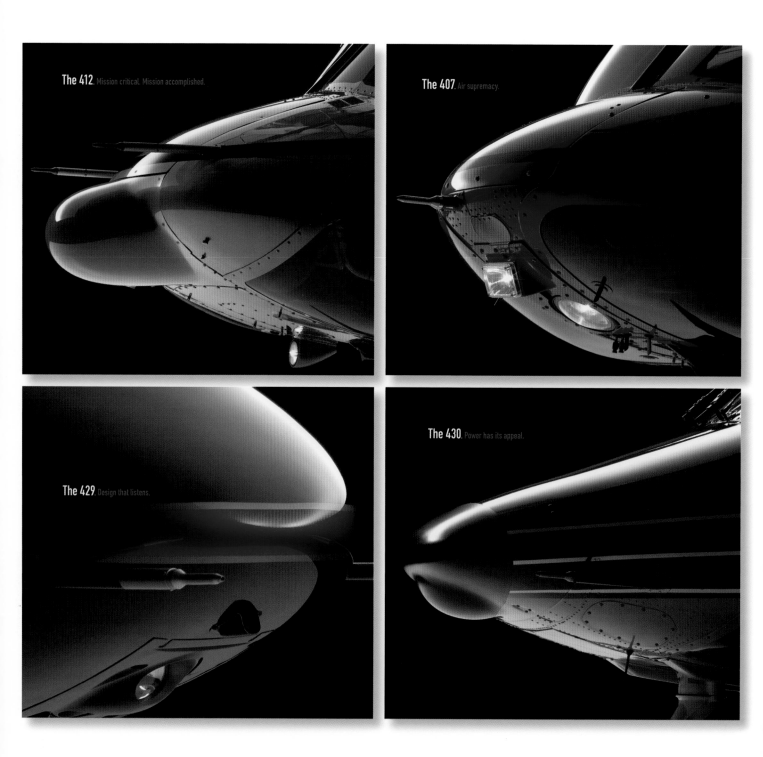

The 412. Mission critical. Mission accomplished.

The 407. Air supremacy.

The 429. Design that listens.

The 430. Power has its appeal.

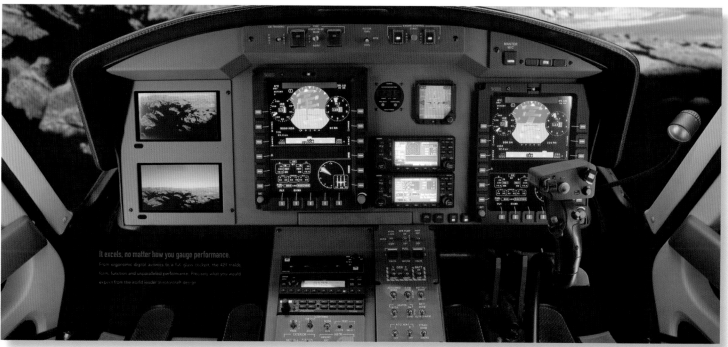

It excels, no matter how you gauge performance.

From ergonomic digital avionics to a full glass cockpit, the 429 melds form, function and unparalleled performance. Precisely what you would expect from the world leader in rotorcraft design.

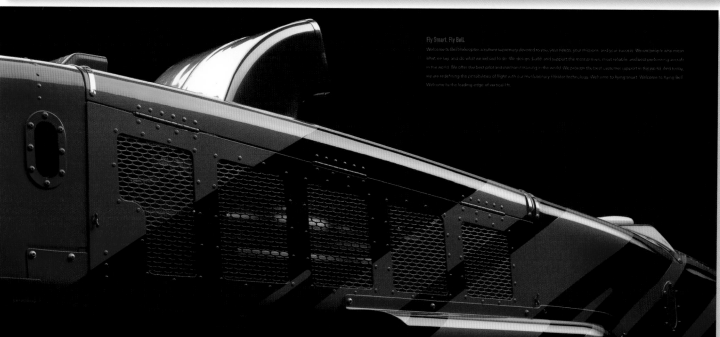

Fly Smart. Fly Bell.

Welcome to Bell Helicopter, a culture supremely devoted to you, your needs, your mission, and your success. We are people who mean what we say, and do what we set out to do. We design, build and support the most proven, most reliable, and best performing aircraft in the world. We offer the best pilot and maintenance training in the world. We provide the best customer support in the world. And today, we are redefining the possibilities of flight with our revolutionary tiltrotor technology. Welcome to flying smart. Welcome to flying Bell. Welcome to the leading edge of vertical lift.

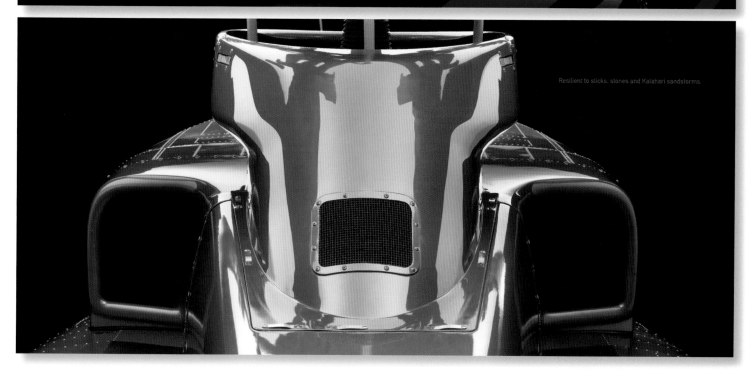

Resilient to sticks, stones and Kalahari sandstorms.

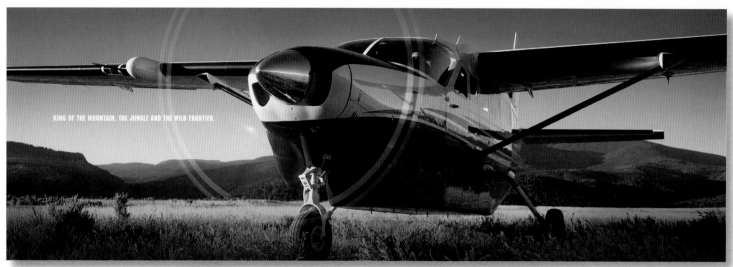

KING OF THE MOUNTAIN, THE JUNGLE AND THE WILD FRONTIER.

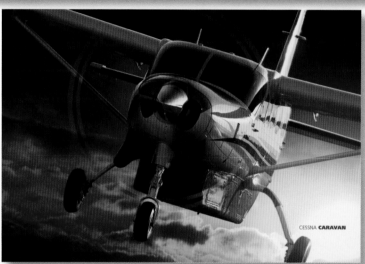

CESSNA **CARAVAN**

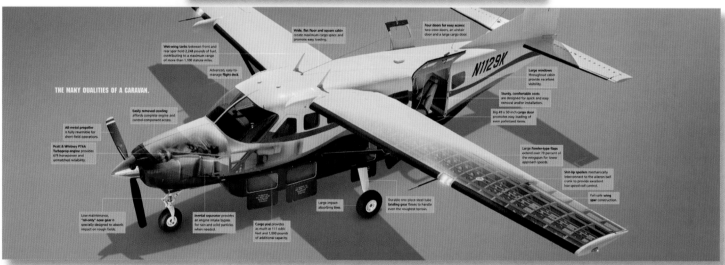

THE MANY QUALITIES OF A CARAVAN.

Wet-wing tanks between front and rear spar hold 2,248 pounds of fuel, contributing to a maximum range of more than 1,100 statute miles.

Wide, flat floor and square cabin create maximum cargo space and promote easy loading.

Four doors for easy access: two crew doors, an airstair door and a large cargo door.

Advanced, easy-to-manage flight deck.

Large windows throughout cabin provide excellent visibility.

Sturdy, comfortable seats are designed for quick and easy removal and/or installation.

Easily removed cowling affords complete engine and control-component access.

Big 49 x 50 inch cargo door promotes easy loading of even palletized items.

All-metal propeller is fully reversible for short-field operations.

Pratt & Whitney PT6A Turboprop engine provides 675 horsepower and unmatched reliability.

Large Fowler-type flaps extend over 70 percent of the wingspan for lower approach speeds.

Slot-lip spoilers mechanically interconnected to the aileron bell crank to provide excellent low-speed roll control.

Fail-safe wing spar construction.

Low-maintenance, "tail-only" nose gear is specially designed to absorb impact on rough fields.

Inertial separator provides an engine intake bypass for rain and solid particles when needed.

Cargo pod provides as much as 111 cubic feet and 1,000 pounds of additional capacity.

Large impact-absorbing tires.

Durable one-piece steel-tube landing gear flexes to handle even the roughest terrain.

THE WORLD'S AIRPLANE IS ALSO A PILOT'S AIRPLANE.

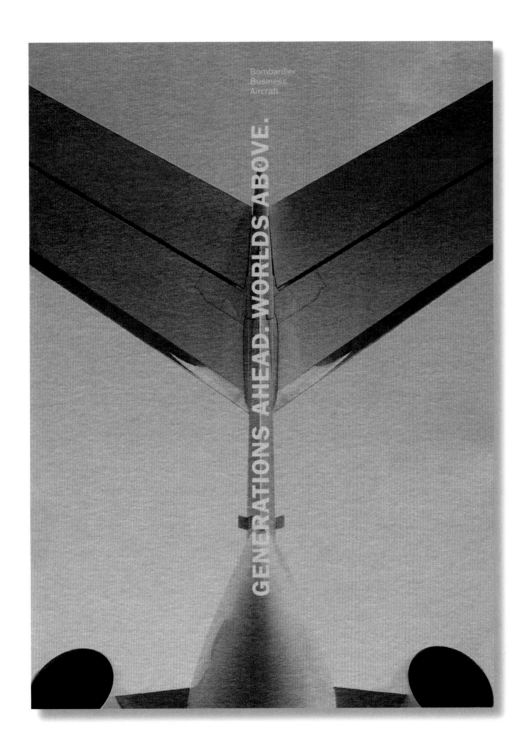

Bombardier
Business
Aircraft

GENERATIONS AHEAD. WORLDS ABOVE.

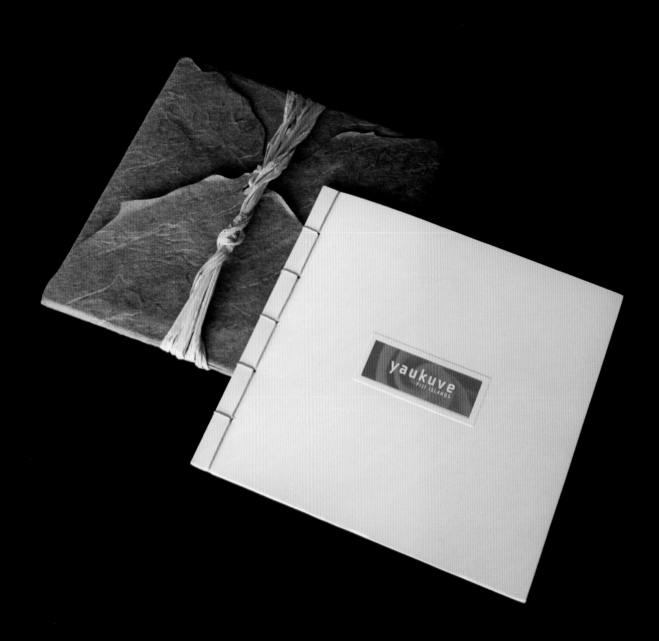

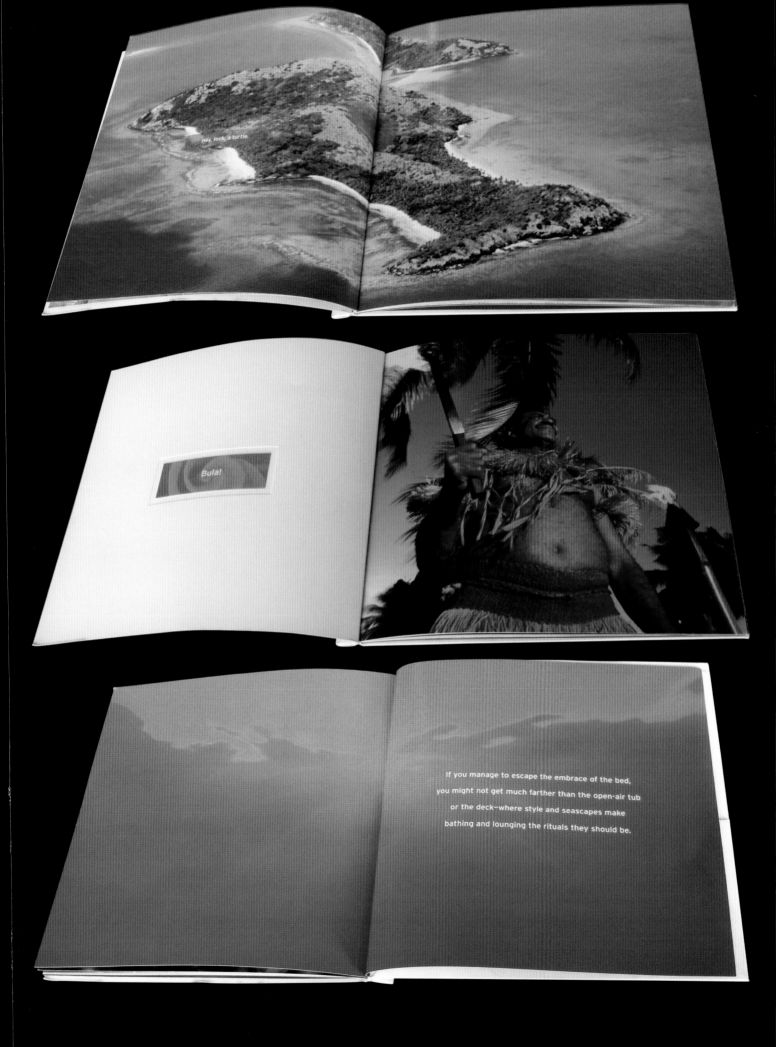

Hey, look, a turtle.

Bula!

If you manage to escape the embrace of the bed,
you might not get much farther than the open-air tub
or the deck—where style and seascapes make
bathing and lounging the rituals they should be.

in

The end is nigh. Burn all the books. Words are done for. Pictures are the future. If you believe everything you read, you wouldn't be reading. Books would be doorstops and brochures would be shelved. And as for direct mail and magazines, the less said about them the better. But the truth is different.

ink! is a team of copywriters, journalists and communication strategists who believe words can still have a huge impact. We work with design agencies and businesses offering strategic advice for their literature, writing words that jump off the page and making every letter count. Starting here.

k!

Words are a little like icebergs. Beneath the elegant bits on the surface is an unseen force holding everything together. In writing, this is the thought behind the words; the strategy that makes your communication stand out. So before we put pen to paper, we pause for a while.

And take a moment to fully understand your aims and challenges, your company's brand values and tone of voice, your audience's attitudes and behaviour. At these opening stages, our strategic thought can really add value. Then, when everything's in place, we start to write.

think

We'd all love the luxury of a lazy deadline, some time to put our feet up. But at ink, we know the clock is always ticking...

So we work fast:
Teaming up to meet tight deadlines.
Putting two, three or more writers onto large projects.
Using our team to handle sets of marketing literature.
Pooling talents for magazines, ads or branding exercises.
Conducting interviews around the country.
Providing you with your own, dedicated account manager.
And always being available when you need us.

But there's no point in a speedy service if quality slips. Which is why everything we write is checked by at least one other member of our team. So the end result is not just fast, but also flaw-free.

blink

What else do we do?

It's a tough world for words. For starters there's a lot of them about, jostling for our attention every day in press, posters, packaging and online. So we offer a wide range of services – all linked to our writing expertise – that make words work that bit harder. Each service is designed to help build your brand consistency through language and make sure your marketing's filled with meaning, not empty promises.

More than you'd expect:

Copy strategy: developing and implementing a language that reflects your brand.
Training: helping organisations improve writing skills and express their brand in communications.
Translation: adapting copy for most international languages using only the best mother-tongue writers.
Editing and proofing: providing a complete editorial service, from magazine content plans to fully proofing every item for printing.

link

Clients
Allianz
BBC
BBC Industrial
BT
Design Group
Direct Line
Friends Provident
Heartoil
KPMG Crucible
Monogo
Petrologo
Royal Mail
Sony
Toshiba

Experience
Advertising
Annual reports
Brand guidelines
Brochures
Direct mail
Emailers
Letters
Magazines
Newsletters
Point of sale
Proof reading
Tone of voice
Training
Translation
Websites

Financial newsletters, pub games, bread packaging and brand guidelines: you name it, there's a good chance we'll have written something like it. To find out more about what we do, or to join our band of happy clients, call us on 01225 731 373, email info@inkcopywriters.com or visit **www.inkcopywriters.com**

ww.ink!

ink!
+44 (0)1225 731 373
info@inkcopywriters.com
www.inkcopywriters.com

!

Credits

Advertising Agencies

20, 21 160over90 Brochure | Design Firm: 160over90 | Creative Director: Darryl Cilli | Associate Creative Director: Dan Shepelavy | Designers: Adam Flanagan, Stephen Penning | Copywriter: Brendan Quinn | Photographers: Matthew Bednarik, Michael Dwornik, Adam Wallacavage | Client: 160over90

22, 23 25th Anniversary Brochure | Design Firm: HSR Business to Business | Chief Creative Officer: Tom Rentschler | Creative Director: John Pattison | Designer: Amy Wolpert | Print Producer: Ruthie Ober | Writer: Debbie Davidson-Effler | Client: HSR Business to Business

HSR, a b-to-b marketing communications firm, wanted to commemorate its 25th anniversary and showcase what sets it apart—the high quality of its creative. The simple design of the brochure allows the work to take center stage, while also communicating relevant background information on each campaign. It was mailed to current clients and used as a new business tool.

Annual Reports

24 2004 Annual Report | Design Firm: SamataMason | Art Director: Pamela Lee | Creative Director: Dave Mason | Designers: Pamela Lee, Keith Leinweber | Photographer: Joaquin Pedrero | Writers: Dave Mason, TIR Systems Ltd. | Client: TIR Systems, Ltd.

25 Courier Corporation Book | Design Firm: Weymouth Design | Art Director: Robert Krivicich | Designer: Aaron Haesaert | Photographer: Michael Weymouth | Client: Courier Corporation

Case bound cover with tipped-in miniature tattoo, origami, and coloring book pages.

26, 27 2005 Annual Report an Image Book | Design Firm: Frost Design | Art Director: Vince Frost | Chief Creative Officer: Vince Frost | Creative Director: Vince Frost | Designers: Caroline Cox, Vince Frost, Ray Parslow | Illustrator: Kelvin Robertson | Client: Sydney Dance Company

Sydney Dance Company often has financial headaches running their organization and only had a small budget for their Annual Report. After noticing some sketches that Graeme Murphy had in his office of the dancers, our idea was to produce the AR as two pieces – a financial report and an image book. The image book is based on the artwork of Kelvin Robertson, who has been sitting on classes on a daily basis for 20 years, and captured the movement and style of the dance group. The book of his work was designed to be sold by the company to raise funds. It is mailed out with the statutory reporting to shareholders and supporters as a gift and a token of the company's appreciation.

28 Design Firm: Stoyan Design | Art Directors: Chi Hang, David Stoyan Wooters | Creative Director: David Stoyan Wooters | Designers: Chi Hang, David Stoyan Wooters | Client: Quicksilver

29 Station Casinos 2004 Annual | Design Firm: Kuhlmann Leavitt, Inc | Art Director: Deanna Kuhlmann-Leavitt | Creative Director: Deanna Kuhlmann-Leavitt | Designers: Deanna Kuhlmann-Leavitt, Kerry Layton | Photographer: Gregg Goldman | Client: Station Casinos, Inc.

30, 31 Stretching the Boundaries | Design Firm: Equus Design Consultants Pte Ltd | Art Director: Andrew Thomas | Creative Director: Andrew Thomas | Designers: Gan Mong Teng, Nicholas Paul | Client: Colourscan Co Pte Ltd

Architecture

32, 33 PLATINUM Under Construction! | Design Firm: Sonner, Vallee u. Partner | Art Director: Sonner, Vallee u. Partner | Creative Director: Sonner, Vallee u. Partner | Designer: Sonner, Vallee u. Partner | Photographer: Gecco Scene Construction Company | Writer: Gecco Scene Construction Company | Client: Gecco Scene Construction Company

The title, "Under Construction," symbolizes the offered services, namely the planning and completion of quality sets and interior Design. These themes were applied graphically using symbols such as construction lines and measurements. To optimize the attraction to our target group (Architects, Agencies, Marketing Directors), we applied the Design using inserted transparent paper, Japanese folding and binding, and UV spot varnishing, reflecting the variety of materials with which the business works and the precise craftsmanship offered. For more information, see pages 12 and 13.

34 Sustainable Brochure | Design Firm: HSR Business to Business | Chief Creative Officer: Tom Rentschler | Creative Director: John Pattison | Designer: Amy Wolpert | Illustrator: Jim Effler | Print Producer: Ruthie Ober | Writer: Debbie Davidson-Effler | Client: Steed Hammond Paul

This Architectural firm wanted a brochure about sustainable Architecture that would both educate and inspire potential clients. The concept of this piece highlights the many interconnected issues in sustainable architecture that are not always evident at first glance. The die-cut circles on the cover establish a dotted-line motif that is carried throughout the brochure, creating connections between environmental issues and the choices that are made in creating a new building.

35 Novum Structures | Design Firm: Grady Campbell, Inc. | Art Director: Kerry Grady | Creative Director: Kerry Grady | Designers: Kerry Grady, Brian Lueck | Photographers: Paul Elledge, Various | Print Producer: Blanchette Press | Writer: Ian Collins | Client: Ian Collins

Novum is a company with a new name and identity, and needed to establish themselves as sophisticated, high-end engineers to Architects, Designers and Building Engineers around the world. These brochures help describe the company's experience, expertise, process, products and services through a clear and intelligent voice.

36, 37 The New York Times Building | Design Firm: Pentagram Design NY | Editor: Amy Goldwasser | Computer Rendering: Artefactory, Screampoint | Photographers: Nelson Bakerman, Andrea Brizzi, Eagle Eye Aerial, Fox & Fowle Architects P.C., Andy Gordon, Hulton Archive, Jock Pottle / Esto, Renzo Piano Building Workshop | Printer: Finlay Printing | Clients: The New York Times Company, Forest City Ratner Companies, ING Real Estate

38, 39 Architecture Museum | Design Firm: Samantha Szocinski | Art Director: Samantha Szocinski | Creative Director: Fred Littlejohn | Designers: Anna Rogers, Samantha Szocinski | Print Producer: West Press Adelaide, Australia | Writer: Christine Garnaut | Client: UniSA Architecture Museum

Promotional tool used as an introduction to the University of South Australia Architecture Museum and Resource Centre.

Automotive

40, 41 Bugs | Design Firm: BBDO Detroit | Art Director: John O'Hea | Creative Directors: Robin Chrumka, Bill Morden, Mike Stocker | Designer: Paul Viola | Photographer: Madison Ford | Writer: Ty Hutchinson | Client: DaimlerChrysler Corporation

42, 43 The Story Behind the Star / Mercedes Benz | Design Firm: Batey Pte Ltd | Creative Director: Nicholas Paul | Designers: Gan Mong Teng, Nicholas Paul | Writer: Jason Hodges | Client: DaimlerChrysler Singapore

The challenge was to condense and package the rich history of Mercedes-Benz in a palatable form for young, so-called 'New Asians' – many of whom are unaware of the brand's rich pedigree. Even with such a story to tell, copy was secondary to imagery, which took the form of striking photography, vintage illustrations and even sketchy blueprints. A distinctive colour palette complemented an engaging mix of bold layout styles. The final communications piece had a freshness and vitality that remained sympathetic to core brand values and retained a quality feel echoing Gottlieb Daimler's famous maxim: "The best or nothing."

44 2004 Honda Element Brochure | Design Firm: Rubin Postaer & Associates | Art Director: Paula Neff | Creative Director: David Tanimoto | Illustrator: Ames Bros. | Photographers: Joe Carlson, Vincent Dente | Writers: Ryan Moore, Steve Stein | Client: Honda

45 2006 Infiniti Brochures | Design Firm: The Designory | Art Directors: Noah Huber, Schott Izuhara, Paula Neff, Andrew Reizuch | Creative Directors: Steve Davis, Chad Weiss | Photographers: Vincent Dente, Toshi Oku, Micahe Rupert | Writer: Jon King | Client: Infiniti Automotive

Objective: Present and reinforce a new brand position as progressive and emotionally stimulating automobiles by capitalizing on Infiniti's leadership in Design. Increase vehicle opinion and intentions by immersing readers in the rich vehicle experience, allowing them to feel the difference Design makes. *Result:* The brochure direction, since debuting in early 2005, has helped Infiniti increase overall opinion by 10% in the last year. And the Infiniti client has described the brochures as breathtaking, the best ever.

46, 47 2007 Cadillac Escalade Catalog | Design Firm: Leo Burnett | Art Director: Harriet Hitchcock | Creative Directors: Tor Myhren, Will Perry | Designer: Michele Hudak | Illustrator: Skidmore, Inc. | Photographers: Tim Kent, Sandro, Doug Rosa | Writer: Nick Bickner | Client: General Motors, Cadillac

48, 49 2007 Nissan Automobile Brochures | Design Firm: The Designory | Art Directors: Dean Fuller, Vince Ku | Chief Creative Officer: Lynne Grigg | Creative Directors: John Beck, Carol Fukunaga, Mike Monley | Designer: Kirby Williams | Photographers: Brian Garland, Charles Hopkins, Toshi Oku | Print Producer: Color Graphics | Writers: Cathy Edwards, Scott Goldenberg | Client: Nissan U.S.A.

Objective for "Pathfinder": Produce a product brochure that positions Pathfinder as expert-grade activity equipment that heightens the adventure of those who drive it. Communicate athletic physique, superior capability and advanced engineering/technology. Payoff and embody "Shift_" thinking of national advertising.

Objective for "Titan": Establish Titan as a full-size credible truck with power, hardware, capability and innovation that lead the competition. Payoff and embody the "Shift_" thinking of national advertising.

Calendars

50, 51 Colour Your Day | Design Firm: BARLOCK bv | Art Directors: Hélène Bergmans, Käthi Dübi, Saskia Wierinck | Creative Directors: Hélène Bergmans, Käthi Dübi, Saskia Wierinck | Designers: Hélène Bergmans, Käthi Dübi, Saskia Wierinck | Illustrator: Frederiek Westerveel | Writer: Jan Luijendijk | Client: BARLOCK bv

The theme of this diary is 'Colour your day'. It gives you a colourful and refreshing feeling through different types of papers, special binding and Design. The cover is printed on linen with a silk-look. A week per spread, full of inspiring colour experiences, take you by surprise and take your mind off stressful days! Extra special finishing techniques will keep you busy, such as thermo printed fortune cookies, sexy die-cuts, stickers, colour charts and good wine stains. This diary will colour your days in 2006!

52 Design Firm: Studio Lupi | Art Director: Italo Lupi | Creative Director: Italo Lupi | Designer: Italo Lupi | Client: Grafiche Mariano

53 Design Firm: Geyrhalter Design | Art Director: Fabian Geyrhalter | Creative Director: Fabian Geyrhalter | Designer: Fabian Geyrhalter | Illustrator: Fabian Geyrhalter | Product Designer: Yva Brighton | Client: Geyrhalter Design

This calendar-candle was produced as a season's greetings piece as well as a one-year anniversary gift. The monthly calendar sheets are based on the color wheel, symbolizing the seasonal colors of their respective month. With only the number of each month, the piece is re-usable year after year.

54, 55 365 & 36.5 communications | Design Firm: 601Bisang | Art Director: Kum-jun Park | Creative Director: Kum-jun Park | Designers: Jong-in Jung, Seung-youn Nam, Kum-jun Park | Illustrator: Kum-jun Park | Photographer: Joong-gyu Kang | Writers: Eun-ju Ahn, Joon-young Bae, Myoung Hwa Shin | Client: 601Bisang | Target Audience: Clients, etc. Communications Objective: VIP calendar, Limited edition

(601) Creative Strategy: Communication with 12 keywords from the sentence 'communication design'. For example, 'c mmu ication d sign' one…the world we dream of. 12 keywords and illustration of faces from the imagination represent the message for ourselves and the title '365 & 36.5 communications' represents communication with sensibility (36.5 degree is same as human body's temperature) for 365 days. Korean, English.

56 Masterfile Calendar 2006 | Design Firm: Concrete Design Communications Inc. | Art Directors: Diti Katona, John Pylypczak | Designer: Andrew Cloutier | Client: Masterfile

57 Coloratura | Design Firm: Riordon Design | Art Director: Shirley Riordon | Designers: Dawn Charney, Shirley Riordon | Client: Riordon Design

Corporate

58, 59 PLATINUM Six Short Stories and a Parable: Engineering and Why it Matters | Design Firm: Rigsby Hull | Art Director: Lana Rigsby | Creative Director: Thomas Hull | Designers: Thomas Hull, Lana Rigsby | Photographer: Terry Vine | Print Producer: Steve Woods Printing Company | Writer: JoAnn Stone | Client: Walter P Moore

Six Stories and a Parable: Engineering and Why it Matters is designed to create and enhance brand awareness for Walter P Moore. The piece is a high-impact, one-time communication introducing Walter P Moore to Architects, Project Managers, land and property owners and government and civic leaders. Designed to generate immediate impact, awareness and buzz, the booklet doesn't provide a comprehensive information packet about the firm, but is a 30,000 foot view of the company and engineering's impact on the built environment. For more information, see pages 14 and 15.

60 Almaty Financial District Book, English | Design Firm: Pentagram Design NY | Art Director: Michael Gericke | Designer: Dimitris Stefanidis | Illustrator: Dbox | Client: Capital Partners

Book promoting the largest urban development and financial center in Asia.

61 Provenance | Design Firm: Together Design | Creative Directors: Heidi Lightfoot, Katja Thielen | Designer: Matt Savidge | Illustrator: Matt Savidge | Writer: Alison Whelan | Client: Provenance

Launched as the new luxury brands consultancy division of M&C Saatchi, Provenance asked for our help to bring their new visual identity to life. The work required confidence and class befitting the client's background and status, so a luxurious slickness of approach was a must. As well as developing the identity and logo, we created items of stationery and a credentials book to appeal to potential clients within the luxury and fashion sector. In classic black and white, the logo encapsulates the boldness of the fashion and luxury brand sector and trades off the link with M&C Saatchi, whose monochrome block type logo is well known. We also created a credentials book, which is bright, bold, quirky and fashion-oriented – versatile enough to be updated and adapted to the client or audience being courted.

Designers

62, 63 Rant Magazine | Design Firm: emerystudio | Art Director: Garry Emery | Designer: Job van Dort | Client: emerystudio

Showcases current completed projects and contemporary Design ideas.

64, 65 Woody Pirtle: Object Lessons #1 catalogue | Design Firm: Pentagram Design NY | Art Director: Woody Pirtle | Client: AIGA Dallas-Fort Worth Chapter

Catalogue to accompany the first exhibition of Designer Woody Pirtle's personal work, which consists of assemblages made of found objects. The book features 17 pieces produced from 2000 to 2002. The design suggests a period scrapbook. The show was at the Temerlin Advertising Institute at Southern Methodist University in Dallas-Fort Worth from October 23, 2004.

66, 67 DIRECTORY | Design Firm: Sasha Vidakovic Design | Art Director: Sasha Vidakovic | Creative Director: Sasha Vidakovic | Designers: Aleksandar Bugarin, Sasha Vidakovic | Client: Extreme Information

Quarterly magazine/catalogue for best direct marketing campaigns from around the world, available only by subscription.

68, 69 High Five | Design Firm: Inaria | Creative Directors: Debora Berardi, Andrew Thomas | Designers: Debora Berardi, Anna Leaver, Anup Sharma-Yun, Andrew Thomas | Client: Inaria

A self-promotional book designed to mark five years of branding and design at Inaria, demonstrating our approach to combining original ideas with beautifully crafted work. The 164-page, A6 case-bound book showcases a collection of work created over the last five years and expresses our philosophy that beauty catches the attention, whilst personality captures the heart.

70, 71 Promo Brochure | Design Firm: Factor Design, Inc. | Art Director: Jeff Zwerner | Creative Director: Jeff Zwerner | Designers: Gabe Campodonico, Craig Williamson | Photographers: Doug Adesko, Dwight Eschliman | Writer: Kara Nichols | Client: Factor Design, Inc.

Designed to introduce and inform prospective clients of the capabilities and values of this strategic Design firm. It is divided into three distinct sections, which address the challenges inherent in successfully launching, sustaining, or altering the course of most businesses. The sections detail our role in launching a new product or company, renewing an existing brand, and envisioning new ways companies use Design to compete and win.

Education

72, 73 School Catalogue 05-08 | Design Firm: Vanderbyl Design | Art Director: Michael Vanderbyl | Creative Director: Michael Vanderbyl | Designers: Amanda Linder, Michael Vanderbyl | Photographers: Ed Kashi, Karl Petzke, Douglas Sandberg | Client: California College of Arts and Crafts

This catalogue is a glimpse into the CCA experience - and it comes from the actual people there - the students and faculty, not the marketing department.

74, 75 Where The Imagination Comes To Life | Design Firm: Sauce Design | Art Director: Christopher O'Shaugnessy | Creative Directors: Christopher O'Shaugnessy, Beverly Ritz | Designers: Dayle Brown, Christopher O'Shaugnessy | Photographers: Ingram Barss, Don Dixon | Print Producer: Thistle Printing | Writer: Peter O'Brien | Client: University of Toronto

A new way to present the University to its various audiences, including its alumni, donors and other supporters, political offices at all levels, and the public at large. Produced as an Annual Report, but without financial information or lists of donors (which are available in other documents the University produces and on its website) this document is a compelling overview of the extraordinary educational opportunities and pioneering research for which the University is renowned. With a strong emphasis on students and the role of UofT in making the world a better and more humane place, the report truly captures the imagination of the University's classrooms, labs, libraries and green spaces, and the many people who are enriched by its presence.

76 Spaces Catalog | Design Firm: Muller + Company | Art Director: Jeff Miller | Creative Director: John Muller | Designer: Jeff Miller | Illustrator: KCAI Students | Photographer: Tal Wilson | Client: Kansas City Art Institute

77 Identity Brochure | Design Firm: Matsumoto Incorporated | Art Director: Takaaki Matsumoto | Creative Director: Takaaki Matsumoto | Designers: Hisami Aoki, Takaaki Matsumoto | Photographer: Various | Client: Art Center College of Design

This promotional piece is distributed to a wide audience including Design professionals, corporate executives, and others. It gives a broad and concise view of the college through photos of students and student work. The use of bright orange adds visual punch and reinforces the school's identity. The gray die-cut cover opens up to a grid of brightly colored squares.

Events

78, 79 AIGA Design Legends | Design Firm: Pentagram SF | Chief Creative Officer: Kit Hinrichs | Creative Director: Kit Hinrichs | Designers: Kit Hinrichs, Jessica Rosenberger | Client: AIGA

A brochure for the annual gala event.

Exhibitions

80, 81 Native Tongues Dialog between Iran and Taiwan Exhibition | Design Firm: Leslie Chan Design Co Ltd | Art Director: Leslie, Wing Kei Chan | Creative Director: Leslie, Wing Kei Chan | Designers: Leslie, Wing Kei Chan, Ken Weng | Client: China Productivity Center

82, 83 AIGA 50 Catalog | Design Firm: Design Army | Creative Directors: Jake Lefebure, Pum Lefebure | Photographer: Renee Comet | Writer: Howard Kaplan | Client: AIGA

The AIGA 50 is a biennial juried competition honoring the 50 best Designs produced in the mid-Atlantic region. Each winning entry has a full spread (some got 2 spreads!) which delivered a well paced and uncluttered Design. Every Designer/Firm was asked to supply a single word of inspiration to summarize their winning entry. The catalog measures 5.5x11.75 and is 168 pages + Cover + Bellyband and printed in 5 color (4CP+Spot Gray).

84, 85, 86, 87 PLATINUM Black Intentions | Design Firm: emerystudio | Art Director: Garry Emery | Designers: Garry Emery, Tim Murphy | Photographer: Shannon McGrath | Writers: Justin Clemens, Virginia Trioli | Client: Susan Cohn | Workshop 3000

Purpose: To document the content of an exhibition of the work of Susan Cohn, held at the National Gallery of Victoria. The work was photographically recorded in detail as well as in an exhibition context, and supported by theoretical essays. The exhibition investigated the notion of blackness in the literal and emotional senses, and referred to notions of the wicked, the sinister, the erotic and to shadows of beauty. Aimed at being a true representation of the artist's intentions. For more information, please see pages 16 and 17.

Fashion

88, 89 Glory Utility Profile Brochure | Design Firm: Hans Heinrich Sures | Art Director: Hans Heinrich Sures | Creative Director: Hans Heinrich Sures | Designer: Hans Heinrich Sures | Photographers: Elke Bock, Hans Heinrich Sures | Print Producer: Hans Heinrich Sures | Client: Glory Utility

Introduces denim manufacturer/fashion brand to potential investors and distributors. Hardcover with embossed Glory logotype, covered in denim. Binding by bolts/screws allows easy updates for changes in the product range.

90, 91 Spring summer 06 | Design Firm: Designbolaget | Art Director: Claus Due | Creative Director: Claus Due | Designer: Claus Due | Photographer: Isak Hoffmeyer | Client: Baum und Pferdgarten

92 Spring / Summer 2006 Catalogue | Design Firm: Tangram Strategic Design s.r.l. | Art Director: Alberto Baccari | Creative Director: Enrico Semp | Designer: Anna Grimald | Photographer: Arcangelo Argento | Client: Davide Cenci

93 Sieger Couture | Design Firm: Sieger Design GmbH & Co. KG | Art Director: Michael Sieger | Designer: Michael Sieger | Photographers: Jorg Grosse Geldermann , Thai-Co ng Quach | Writer: Elke Dopelbauer | Client: Sieger Design

SIEGER, the first brand of the full-service agency, Sieger Design, intends to establish itself alongside famous luxury brands on the lifestyle sector.

94 Purse-everance | Design Firm: Moses Media | Art Director: Icarus Leung | Creative Director: Deborah Moses | Designer: Icarus Leung | Photographer: Ilan Rubin | Writer: Deborah Moses | Client: Edidi

This was the first catalog for Edidi by Wendy Lau and served as an image and branding piece as well. The company makes handcrafted, jeweled evening bags in precious metals with precious and semi-precious stones. As Edidi is new, we wanted to establish a personality that would appeal to fashionable, smart women who spend significant money on luxury goods and accessories. The catalog concept addresses the perennial struggle of woman and evening bag: What can you fit in your evening bag for a night out? What can be taken? What must be forsaken? And, what do your choices reveal about your personality? We created five global personality profiles - from women like Paris Hilton to Nan Kempner - that could be identified by their purse contents and interspersed them throughout the book using clear transfers to illustrate the message. It was also important to photograph the bags in a modern, quirky way, illustrating the individuality and personality each bag has. The reaction has been excellent and resulted in a reprint for Saks Fifth Avenue to send to 1500 customers. The sell through of the collection has topped at 92 percent...an auspicious beginning for a luxury brand.

95 Talisman | Design Firm: Osamu Misawa Design Room Co., Ltd. | Art Director: Osamu Misawa | Designer: Satomi Kajitani | Photographer: Kenji Aoki | Client: World Commerce Corporation

96 Y5 | Design Firm: Sweet Design | Art Director: Fiona Sweet | Creative Director: Fiona Sweet | Designer: Faye Triantos | Illustrator: Faye Triantos | Photographers: Paul Allen, Ray Barry, Duke Dinh, Guy Offerman, Georgie O'Shea, Damien Plemine | Client: Y Salon

Y5 book was designed to celebrate the five-year anniversary of Y Salon. The book features a range of hair designs from the salon stylists. Print features include foils and Spot UV.

97 Lida Baday Fall 2006 Brochure | Design Firm: Concrete Design Communications Inc. | Art Directors: Diti Katona, John Pylypczak | Designer: Natalie Do | Photographer: Chris Nocholls | Client: Lida Baday

Each spring and fall, Canadian Fashion Designer Lida Baday produces a brochure that serves as her primary Advertising vehicle. For Fall 2006, two brochures were produced to reflect two distinct clothing styles encompassed in a single collection. Sensual photography is used to showcase the clothes.

Credits

Uniqlo Paper #1, "From Tokyo to New York": A magazine/magalogue for a big Japanese basics clothing brand launching its US business in NY. The magazine introduced the brand and highlighted its key product lines using editorial content and fashion stories. The oversize, newspaper-like magazine was printed in Japan on uncoated stock with red contrast Japanese stitching. It was distributed in the flagship store and at select locations citywide. The paper was the key-tool to communicate the brand's identity/philosophy and showcase its diverse products.

Food & Beverage

House advertising of Lemon Design cookbook with main point of:LEMON

Furniture

This was developed as our client's industry was receovering from the recent recession. The concept engages the classic quandry of whether the glass is half-full or half-empty. The brochure encourages the positive perspective by presenting uplifting facts about the world around us.

Sales brochure for a new line of exclusive hardwood furniture.

A series of new product brochures using Izzy's "Simple Pleasures" theme – an idea we helped conceive - communicate information in a fun, cool way.

Highlight the selling points and installations that selected Milliken Contract products for the Corporate office and Education/Libraries segments.

SIEGER, the first brand of the full-service agency, Sieger Design, intends to establish itself alongside famous luxury brands on the lifestyle sector.

Menus

Chef Scott Howard carefully selects the very best seasonal ingredients, and, through a complex process of preparation and craftsmanship, extracts their essence to create dishes that are simply perfect. The logo for his restaurant reflects this precise method by creating an arrow out of a carrot. The menus, gift cards, and check presenters celebrate the ingredients with intense close-up photography, showing them at a scale most people never see.

Museums

Petar Barisic is a Croatian sculptor. Headline of catalogue is compounding. Pages in the catalogue were treated like space for the compound-letters, just as the author treated the gallery space for putting together the sculpture.

Copley Society of art sponsored an exhibit for artist Laurene Kransy Brown. Laurene's artworks are assemblages of paper and color, and the catalog was meant to exhibit the work while capturing the essence of her pieces.

Brooklyn Botanic Garden, designed by Olmsted Brothers (the sons of Frederick Law Olmsted) and McKim, Mead, and White in 1910, has grown into a world-class institution hosting more than 750,000 visitors a year, and a treasured community resource. Its mission is to display and conserve plants for the education and inspiration of the public, to teach children and adults about the importance of plants in their lives, and to conduct research to expand human knowledge about plants and the natural environment.
As the Garden nears its centennial in 2010, the need to improve its aging infrastructure and ensure that its programs and collections remain relevant in changing times are key goals for the institution. To develop a comprehensive vision and guide for capital improvements and long-term growth that address the institution's multifaceted needs and challenges of the future, a "road map" master plan for future planning and growth was established.
The plan includes an exciting range of projects that will strengthen and beautify,such as new gardens within the Garden, improvements to all entrances, and a new Science and Learning Center.With these changes, care has been taken to maintain the historic character of the Garden. The Master Plan is the result of a three-year, intensive planning process undertaken by the Brooklyn Botanic Garden, Cooper Robertson&Partners, and Poulin+Morris. This 96-page, full-color, bound volume provides a comprehensive plan for future growth of the 52-acre site over the next two decades, and has been designed to facilitate fundraising efforts undertaken to support these goals.The book's format, layout, and color palette are derived from the Garden's overall, initial plan by the Olmsted Brothers, as well as prominent Garden features including the Cherry Esplanade and Magnolia Plaza.

Music & Theatre

Signature Theatre (the largest non-profit theatre in Virginia) moved to a new location in 2007 and wanted a special give-away at the opening gala. A commemorative publication was designed to showcase the early days, the growth and current success of Signature Theatre. The publication covers 17 years in 3 Acts, and highlights the various productions, directors and supporters throughout. The cover is a die cut "S" with silver foil stamping; the interior is 5 color (4CP+Spot Orange)/76 pages + Cover + Slipcase.

Paper Companies

Brochure promotes paper distributor Buntin Reid's event at the Hard Rock Café in Ottawa Canada. It was sent out to agencies, studios and printers from around the national capital region.

The new chief of fine papers at ArjoWiggins saw potential in promoting the Curious Collection line of fine printing papers as a "luxury brand" ideal for use in the fashion industry... He wanted a promotion that would send this message to his target audience... Our response was to use samples of our client's actual products to design and photograph paper garments that referenced moments in the history of contemporary fashion.
For more information, please see pages 10 and 11.

This was a perfect opportunity to explore ideas about beauty and nuance and to gather examples of Design that embody those qualities. The most lasting and significant are imbued with elegance, clarity and beauty. These are ideals that seem to have always existed and for good reason. Beauty enriches life, making it more pleasurable and links us to the past. Beauty has a universal attraction, despite recent trends that push it aside.

The purpose was to educate Designers about the exceptional quality of Utopia. The book was used as a direct mail and was also used in sales presentations.

After naming and branding this new grade of paper for Domtar, we developed a marketing program to introduce it to paper specifiers. This brochure

was one element of the program. It challenges perceptions about the performance and quality of opaque sheets with its shockingly vibrant colors, heavy ink coverage, demanding crossover images and precisely reproduced detail.

142, 143 Design Firm: Pivot Design | Creative Director: Brock Haldeman | Designers; Don Emery, Steve Graziano, David Altholz | Client: Weyerhaeuser

The last thing to catch a Designer's attention is another overblown paper promotion. This piece for Cougar Opaque, a line of paper from Weyerhaeuser, was designed to reflect the inherent qualities of the paper while poking fun at the typical paper promo. The goal for this promotion was to speak to the reader in a straightforward, conversational tone, reflective of the paper's simple, hardworking qualities. The result is a piece that unabashedly has fun with itself, its audience, and the idea of a paper promotion as a whole.

144, 145 Design Firm: NDW | Creative Director: Bill Healey | Designer: Bill Healey | Ilustrator: John Harwood | Client: M-real paper manufacturer

Based on the theme "Explore New Dimensions," M7 is the seventh issue of Megamorphosis, an educational series produced on Zanders Mega.

146 The Standard | Design Firm: Pentagram SF | Art Director: Kit Hinrichs | Creative Director: Kit Hinrichs | Designers: Kit Hinrichs, Belle How, Jessica Siegel | Client: Sappi

147 Revealing Paper Promo | Design Firm: Larsen Design + Interactive | Art Director: Paul Wharton | Designer: Mark Saunders | Photographer: Michael Prince | Copywriter: Gwyneth Dwyer | Client: Wausau Papers

The reveal/discover theme of this promotion demonstrates the printability of Astropaque Natural while incorporating die cuts and folding techniques that "reveal" qualities of the paper and invite interaction with the piece.

Photography
148, 149 PLATINUM Vol. 1 | Design Firm: Designbolaget | Art Director: Claus Due | Creative Director: Claus Due | Designer: Claus Due | Photographer: SUMO | Client: SUMO

Client's directive: SUMO is a collaboration of 6 different Copenhagen-based Photographers, each working in a different area, from press photography to the fields of Fashion and Advertising. They wanted to look like a unit, but also show their individual skills and style. The target-group for the book is mostly Art Directors and/or buyers. For more information, see pages 8 and 9.

150, 151, 152, 153 James Cant Photographer | Design Firm: Frost Design | Art Director: Vince Frost | Chief Creative Officer: Vince Frost | Creative Director: Vince Frost | Designers: Lee Nichol, Vince Frost | Photographer: James Cant | Client: James Cant

Returning to Australia from London, where he was a highly respected beauty and fashion editor, James Cant was unknown to publishers and agencies in Sydney. He wanted a memorable DM piece to showcase the depth of his experience in a saturated market. A mailer was created to the scale of broadsheet newspaper using bulky newsprint stock. This ensured cut through in the glossy magazine industry. Future updates of his work were key in creating the magazine concept and a title for the mock magazine became a play on his surname. A simple cross through the 't' elevated the idea of his skill and the retention of his name. 'Cant' became 'Can'. Measures 16.5"wide x 23" long.

154 Unbound 3 | Design Firm: Concrete Design Communications Inc. | Art Directors: Diti Katona, John Pylypczak | Designer: Andrew Cloutier | Writer: Larry Gaudet | Client: Masterfile

155 Unbound 5 | Design Firm: Concrete Design Communications Inc. | Art Directors: Diti Katona, John Pylypczak | Designer: Andrew Cloutier | Photographer: Various | Client: Masterfile

156, 157 Unbound 2 | Design Firm: Concrete Design Comm unications Inc. | Art Directors: Diti Katona, John Pylypczak | Designer: Andrew Cloutier | Photographer: Various | Client: Masterfile

Masterfile had an image problem. Despite building an archive that represents some of the most creative talent around, the largest remaining independent stock image agency was perceived as too conservative. To address this, Concrete produced a strategic campaign including the development of direct-mail pieces called "Unbound," a collection of images "real and implied." Unbound uses the interpretation of imagery as a form of visual creative inspiration. While many images are from Masterfile's extensive library, just as many of the images have been modified, obscured or "implied."

158, 159 The Naylor Collection | Design Firm: Communications for Learning | Art Director: Yuly Mekler, Immedia Design | Creative Director: Jonathan Barkan | Designer: Yuly Mekler, Immedia Design | Client: The Naylor Collection

This package introduces for sale this premier collection on the history of Photography. It was sent to a carefully researched international list of museums, foundations, collectors, philanthropists, and entrepreneurs. It includes a reprint of a WSJ article; additional advance publicity included an NPR feature with web links to the catalog and streaming video.

160 Grubman Lick Book | Design Firm: Liska + Associates | Art Director: Kim Fry | Creative Director: Steve Liska | Designer: Kim Fry | Photographer: Steve Grubman | Client: Grubman

Grubman specializes in photographing all types of animals, from everyday companions like dogs and cats to the exotic. The Lick Book is a collection of Steve Grubman's photographs of animals in various states of licking. The images capture and project the personalities of creatures including sheep, leopard, lizards, binturongs and huskies. Liska designed this book as a fun promotional piece that Grubman could send to clients and business prospects.

161 Cuba Libre | Design Firm: SamataMason | Art Director: Greg Samata | Designer: Goretti Kao | Photographer: Stephen Wilkes | Client: Stephen Wilkes

162, 163 Heffernan Icons | Design Firm: Pentagram SF | Design: Pentagram SF | Text: Delphine Hirasuna | Photography: Terry Heffernan | Printing: H. MacDonald Printing | Client: Terry Heffernan

164 Mark Hooper 2004 Promotional Mailers | Design Firm: Sandstrom Design | Art Director: Steve Sandstrom | Creative Director: Steve Sandstrom | Designers: Kristy Adewumi, Kristin Anderson, Steve Sandstrom | Photographer: Mark Hooper | Client: Mark Hooper

National direct mail campaign for Photographer Mark Hooper sent to Ad Agency Creatives, Designers and publication Art Directors.

Printers
165 Exzellent! | Design Firm: Lemon Design GmbH & Co KG | Art Directors: Marcus Regensburger, Torsten Suter | Creative Directors: Marcus Regensburger, Torsten Suter | Designers: Timm Liedke , Marcus Regensburger, Torsten Suter | Illustrator: Katinka Haas | Photographer: Peter Rathmann | Print Producer: Heidelberger Druckmaschinen AG | Writer: Marcus Regensburger | Client: Heidelberger Druckmaschinen AG

Shows Heidelberger Druckmaschinen AG's screening technologies.

166, 167 Annual Report | Design Firm: RBMM | Art Directors: Steve Gibbs, Brian Owens | Creative Director: Dick Mitchell | Designer: Brian Owens | Illustrator: Various | Photographer: Various | Writer: Mike Renfro | Client: Williamson Printing Corporation

168, 169 Brand Launch Flipbook | Design Firm: Look | Creative Directors: Mary Schwedhelm, Betsy Todd | Designer: Monika Kegel | Writer: Tyler Cartier | Client: Lahlouh

Look launched the new Lahlouh brand with this rhyming flipbook. Helping people remember "Lahlouh" with the aid of a "tutu" and some "bamboo" was a fun project that gave personality to the brand.

170 IE Singapore-Printing Brochure | Design Firm: Equus Design Consultants Pte Ltd | Art Directors: Tay Chin Thiam, Chung Chi Ying | Creative Director: Andrew Michael Bain | Designers: Tay Chin Thiam, Chung Chi Ying | Illustrators: Tay Chin Thiam, Chung Chi Ying | Photographer: Ken Seet | Writers: Natalie Foo, Andrew Thomas | Client: International Enterprise Singapore

IE Singapore(the Singapore government's trade development arm) wanted a brochure to raise awareness about the quality of the Singapore printing industry among int'l print buyers. It also had to act as a showcase for the broad range of capabilities and printing techniques one can find in Singapore. Built around the theme of "Better things to do (than worry)," we take a humorous approach, communicating the message that with Singapore printers on the job, print buyers needn't worry about anything-they can just sit back and do all the things people do when they have time to kill, like popping bubble wrap, doodling, daydreaming about holidays, or doing the crossword. The brochure enables the reader to do all these things, in the process showcasing all the tricks & printing techniques that Singapore printers excel at.

171 Design Firm: Sibley Peteet Design – Dallas | Creative Director: Don Sibley | Designers: Tabitha Bogard, Brandon Kirk, Jeff Savage, Don Sibley, Evalyn Zwartjes | Client: Williamson Printing

Products
172, 173 Replogle catalog | Design Firm: Planet Propaganda | Creative Director: Dana Lytle | Designer: Curtis Jinkins | Client: Replogle Globes

Binder-and-looseleaf catalog system for globe manufacturer.

174, 175 Loudspeakers 800 Series | Design Firm: Thomas Manss & Company | Art Director: Thomas Manss | Designers: Kathrin Jacobsen, Damian Schober, Lisa Sjukur | Client: Bowers & Wilkins

Bowers & Wilkens is considered by the hi-fi specialist industry to be the #1 high-end loudspeaker manufacturer in the world and has become the reference speaker in nearly all of the world's classical recording studios (including EMI Abbey Road, Decca and Deutsche Grammophon).

The 800 Series hardbound brochure is aimed at music industry professionals and the discerning home theatre user. It is not only used for point of sale and retail purposes, but is also sent out as a direct marketing tool to every existing owner to entice them to upgrade. The content shows a mixture of the pioneering technical advances, interviews with well-known B&W enthusiasts and striking images. The cover shows a simple illustrated drawing of the diamond tweeter dome and incorporates the DVD, which has become the leitmotif for most printed collateral. The magazine-style layout helps make complex technical information easier to digest and interviews separate the sections, making it more engaging. The attached DVD tells the story of how everything keeps moving on at B&W. The DVD and hardbound brochure are designed to be too valuable to throw away. They provide multi-sensory access to the whole B&W story: analog/paper and digital/screen. The brochure with DVD was printed and distributed in January 2005.

176, 177 My China! | Design Firm: Sieger Design GmbH & Co. KG | Art Director: Michael Sieger | Designer: Michael Sieger | Photographers: Thai-Cong Quach, Jorg Grosse Geldermann | Writer: Elke Dopelbauer | Client: Sieger Design

SIEGER, the first brand of the full-service agency, Sieger Design, intends to establish itself alongside famous luxury brands on the lifestyle sector.

178 2006 Gerber Product Catalog | Design Firm: Sandstrom Design | Art Director: Jon Olsen | Creative Director: Jon Olsen | Designer: Chris Gardiner | Photographers: Mike Dahlstrom, Mark Hooper | Print Producer: Kelly Bohls | Writer: James Parker | Client: Gerber Legendary Blades

While talking with hunting enthusiasts, we were intrigued by how many have a full room, often a basement, dedicated to their pastime. A space where antlers are hung, gear is cleaned and stored, and photos of past hunting and fishing trips are displayed. This space is often referred to as "The Man Cave." Cheap wood paneling, well-worn pegboard, and a chewed up workbench evokes the environment where our target audience is most comfortable, and where they keep their stash of Gerber Blades products.

179 Namiki Pen | Design Firm: Sutton Cooper | Art Director: Linda Sutton | Creative Director: Linda Sutton | Designer: Roger Cooper | Photographer: Richard Foster | Writer: Ken Kessler | Client: Alfred Dunhill

To sell a limited edition $80,000 Namiki lacquer pen produced to celebrate 75 years of a partnership between Alfred Dunhill and Japan's Pilot Pen Co.

180, 181 FISH | Design Firm: Planet Propaganda | Creative Director: Dana Lytle | Designer: David Tyler | Writer: John Besme | Client: Gary Fisher Bicycles

The Gary Fisher Catalog is a magazine-like alternative that captures the culture of the sport that Gary helped create and showcases the 2005 bike lineup.

Credits

182, 183 Design Firm: SamataMason | Art Director: Goretti Kao | Creative Director: Greg Samata | Designers: Goretti Kao, Kevin Krueger | Photographer: Motorola Archives | Copywriter: Bill Seyle | Client: Motorola, Inc.

Motorola recently celebrated their 75th anniversary. They wanted a book that celebrated the company's history, innovations and employees.

Promotions

184, 185 Atelier Manus | Design Firm: visucom | Art Director: Frank Lynch | Photographer: Thomas Andenmatten | Writer: Erich Heynen | Client: Atelier Manus

Atelier Manus is a workplace for handicapped people. We wanted to present the people who work there and the products they produce. We did so using black & white and colour photography. We integrated the client into the production process - the embossing, binding, collating, dye-cutting, etc. was done by Atelier Manus. The end product has no text, except for the contents of the envelope at the back of the brochure. This gives the client flexibility to send different copy to different customers. The cd-rom contains an internet/flash presentation.

186, 187 Branding Taiwan Design | Design Firm: Leslie Chan Design Co Ltd. | Art Director: Leslie, Wing Kei Chan | Creative Director: Leslie, Wing Kei Chan | Designers: Leslie, Wing Kei Chan, Claire Ger, Ken Weng | Client: Taiwan Design Center

188 NB Studio Christmas Card | Design Firm: NB Studio | Art Directors: Alan Dye, Nick Finney, Ben Stott | Designer: Jodie Wightman | Writer: Howard Fletcher | Client: NB Studio

Publishing

189 Time Magazine Covers 1923-2003 | Design Firm: Time Marketing | Art Director: Andrea Costa | Designer: Andrea Costa | Client: Time Magazine

Real Estate

190, 191 The Waldorf Astoria Collection | Design Firm: Draftfcb San Francisco | Art Director: Eric Rindal | Chief Creative Officer: Brian Bacino | Creative Director: Eric Rindal | Designer: Ari Terkel | Print Producers: Steve Cross, Priscilla Warner | Writer: Suzanne Finnamore | Client: Hilton Hotels

Designed as a high-echelon marketing tool for the launch of the Waldorf Astoria Collection. Their business aims were to slowly and methodically grow over time. The target audience was prosperous businessmen 60+. The Collection is a group of luxury resorts presented under the overarching banner of Waldorf Astoria. When a resort is added, a specially designed insert is placed within a cache in the brochure, keeping the aesthetic clean yet practical as the business grows. Since the brochure, the Collection has spread to include the finest resorts in the US and several international properties as well.

192, 193 Fillmore Heritage Brochure | Design Firm: Cahan & Associates | Art Directors: Sharrie Brooks, Bill Cahan | Creative Director: Bill Cahan | Designers: Sharrie Brooks, Mark Gallo | Client: Fillmore Heritage Center

194, 195 Brochure | Design Firm: Regina Rubino / IMAGE: Global Vision | Creative Director: Regina Rubino | Designers: Javier Leguizamo, Claudia Pandji | Print Producer: Lithographix | Writer: Regina Rubino | Client: The Beverly Hills Hotel

196, 197 A Place Set Apart | Design Firm: 1919 Creative Studio NYC | Art Director: Peter Klueger | Chief Creative Officer: Peter Klueger | Creative Director: Peter Klueger | Designers: George Clarke, Peter Klueger | Illustrator: George Clarke | Photographer: Peter Klueger | Print Producer: Nick Wollner | Writer: Nick Wollner | Client: Sundance Preserve

For Robert Redford's Sundance, Peter Klueger and Nick Wollner were engaged to refine the vision, mission and motivation for the new ridges in Sundance, the culmination of Redford's 35 year quest to make Sundance, Utah a self sustaining retreat for artists, scientists and thoughtful citizens to share ideas and inspire and implement meaningful change. The design, look and feel set the identity of Sundance, and were entirely designed, shot and produced by 1919 NYC.

198, 199 Vispera | Design Firm: Decker Design | Art Director: Decker Design | Designer: Decker Design | Client: LaTessa Designs

200, 201 Bluefin Ocean Club Brochure | Design Firm: Corporate Grafix | Creative Director: Bob Tonda | Client: Modus Vivendi Partners

202, 203 John Ross Condominiums Sales Brochure | Design Firm: ZIBA Design, Inc. | Art Director: Chelsea Vandiver | Creative Directors: Clancy Boyer, Steve McCallion | Designer: Courtney Clingan | Photographer: Steve Bloch | Writer: Dennis Rockney | Client: Gerding Edlen Development/Williams & Dame Development

John Ross: a signature cosmopolitan condominium tower by Portland Architect Robert Thompson. The brochure celebrates the Architect and building.

204, 205 Design Firm: ico Design Consultancy | Art Director: Vivek Bhatia | Creative Director: Ben Tomlinson | Designer: Vivek Bhatia | Photographer: Lee Mawdsely | Client: Bath & Bath

Development company Bath & Bath commissioned us to produce a brochure to market an extravagant, Grade II listed house over five floors in the heart of Belgravia, London. It was redeveloped over two years with a vision and passion by its developers to provide the highest quality of living and interior Design. This was echoed in the solution by a host of complementary, tactile materials, production techniques and stylish Photography. This enabled us to capture the historic, prestigious nature of the house and its location, as well as contemporary benefits demanded by its market. With a price tag of over £30 million, the target audience consisted predominantly of international businessmen and women, looking to buy a family residence in London. It was important to appeal on an emotional level, engaging their families, too, so all could imagine living there. The principal goal was to generate interest by communicating the prestige of the house and its location. The piece itself acted as an exclusive invite for the house.

206, 207 C+A Magazine | Design Firm: emerystudio | Creative Director: Garry Emery | Designers: Tim Murphy, Sarah O'Keefe | Writer: Joe Rollo | Client: Cement Concrete and Aggregates Australia

The new flagship magazine of Cement Concrete & Aggregates Australia, the industry body representing concrete construction in Australia. C+A publishes detailed examples of concrete Architecture in Australia and internationally to promote the possibilities of concrete as a material of choice in Architecture. Each project is documented extensively using words, photographs, plans, elevation and, where appropriate, earliest conceptual sketches.

208, 209 Meadowlands Xanadu | Design Firm: Desgrippes Gobé | Art Director: Stewart Devlin | Creative Director: Phyllis Aragaki | Designers: Stewart Devlin, Sahar El-Hage | Photographers: Steve Vaccariello, James Worrell | Writer: Lee Rafkin | Client: Meadowlands Xanadu

Meadowlands Xanadu is a 4.7 million-square-foot, one-of-a-kind sports, leisure, shopping and family entertainment complex. The client needed a promotional piece for the launch party to wow and entice potential investors. This piece had to have a big impact and convey the project's magnitude.

210 Tricon Brochure | Design Firm: Ross Creative + Strategy | Art Director: Ross Creative + Strategy | Designer: Ross Creative + Strategy | Client: Tricon

211 Lajitas Sales Brochure | Design Firm: David Carter Design | Art Director: Donna Aldridge | Designer: Donna Aldridge | Client: Lajitas Resort & Spa

Retail

212, 213 50 | Design Firm: Crate&Barrel | Art Directors: Jill Ingrassia, Lisa Petrusky | Creative Director: Alessandro Franchini | Designer: Chrystine Doerr | Photographers: Steven McDonald, Alan Shortall | Writer: Donna Speigel | Client: Crate&Barrel

214, 215 Inspiration from Nature | Design Firm: Studio Rasic | Art Director: Ante Rasic | Designers: Lovorka Decker, Ante Rasic | Illustrator: Lovorka Decker | Photographer: kiplant | Writer: Fedja Vukic | Client: MBM

MBM is the biggest garden center in Croatia.

216, 217 Catalog | Design Firm: thompsondesign | Art Directors: Kristina Backlund, Philip Kelly | Creative Directors: Kristina Backlund, Philip Kelly | Designers: Philip Arias, Naoli Bray, Rei Fukui | Illustrator: Philip Kelly | Photographers: Keith Lathrop, Adam Savitch, Cleo Sullivan, Mark Squires, Lisa Charles Watson | Writers: Toby Barlow, Naoli Bray | Client: Bailey Banks and Biddle

Bailey Banks and Biddle is an old American brand founded almost 175 years ago in Philadelphia. They came to us to be re-invented, so we updated everything from their logotype to catalogs. We wanted the brand to appear classic with its own personality and wit. We've simplified the company's symbol, the unicorn, and let it live in playful illustrations on the cover. The catalog is printed in 350,000 copies and distributed in-store and to customers.

Transportation

218, 219 Exomos Brand Brochure | Design Firm: FutureBrand | Creative Director: Avrom Tobias | Designers: Tini Chen, Tom Li, Brendan Oneill, Mike Williams | Illustrators: Antonio Baglione, Oliver de la Rama | Writer: Stephanie Carroll | Client: Exomos

With unprecedented developments built on water (e.g. The Palm—the world's largest man-made islands), it is not surprising that a revolutionary submarine and submersible company emerged out of Dubai, one that offers a unique range of products for consumer, military and commercial audiences. Having created a high-tech, modern Design system used across all Exomos marketing materials, the company truly stands out as an innovative leader in aquatic engineering. Letting the brand speak for itself, we chose to highlight the submersibles as works of art and serious machines. We meticulously rendered each one using 3D programs, effectively communicating the scientific principles through diagrams and wireframes. The brochure reinforced the company's amazing achievements, while the use of neon and metallic inks and varnishes further suggests the boldness of the products. The brochure mirrored the visionary mission of the company and its inventor, and helped create a high-tech brand for those seeking new fields of discovery.

220, 221 2006 Sales Brochures | Design Firm: Vic Huber | Art Director: Ron Head/imatrix | Creative Director: Scott Brewer/t:m agency | Designer: Ron Head | Photographer: Vic Huber | Writer: Geoff Owens | Client: Bell Helicopters

Strategically speaking, this series was designed for Bell to break out of the traditional mold for the helicopter/aircraft industry. Much in the same fashion that any high-end car brochure might romance a customer with beautiful photography and the right voice, our goal was to captivate the prospect with with an artful representation of each of the aircraft's unique features.

222 Cessna Caravan | Design Firm: Sullivan Higdon & Sink | Designer: Sullivan Higdon & Sink | Client: Cessna Aircraft Company

223 Family and Series Brochures | Design Firm: Office 500 | Art Director: Caroline Reumont | Creative Director: Caroline Reumont | Illustrator: Jacqueline Otis/Computer Graphics | Photographer: Paul Bowen | Writer: Neil McGregor | Client: Bombardier Aerospace

For the first time, Bombardier produced a brochure encompassing its three families of aircraft (Learjet, Challenger and Global). Each aircraft has a strong visual identity, different positioning and colours, so it was important to find a visual platform to accommodate all existing visual identities.

Travel

224, 225 Yaukuve Brochure | Design Firm: McMillan | Art Director: Jim Keller | Designer: Jim Keller | Client: Serendipity Hotels and Resorts

Writers

226 Ink Launch Brochure | Design Firm: Mytton Williams | Creative Director: Bob Mytton | Designer: Tracey Bowes | Writers: Tom Chesher, Simon Jones | Client: Ink! Copywriters

Ink, a new team of Copywriters, required a launch brochure to build brand awareness, enforce the company's core messages and reflect its personality. It needed to capture the reader's attention and leave a lasting impression, appealing to 'the country's best agencies and most cynical designers'. The solution was to focus on words; these are Ink's bread and butter. We concentrated on the word 'ink', building brand awareness while also enforcing the company's core messages. 'Think', 'blink' and 'link' were used to highlight aspects of Ink's service. The large, A3 format brochure captures the attention of the reader and leaves a lasting impression. The use of just two colours and choice of an un-coated paper, Challenger Offset, adds to the impression of affordability.

Designers

Illustrators

Photographers

PrintProducers

Writers

Clients

AdditionalCreativeContributors

DesignersDirectory

160over90 www.160over90.com
One South Broad St. 10th Floor, Philadelphia, Pennsylvania, United States, 19107
Tel 215 732 3200 | Fax 215 732 1664

601Bisang www.601bisang.com
481-11 Seogyo-dong, Mapo-gu, Seoul, Republic of Korea
Tel +82 2 332 2601 | Fax +82 2 332 2602

1919 Creative Studio NYC www.1919.com
900 Broadway, Suite 1002 10th Floor, New York, NY 10003, United States
Tel 212 982 6400

BARLOCK bv www.barlock.nl
Pastoorswarande 56 The Hague Zuid, Holland 2513 tz, Netherlands
Tel 0031703451819

Batey Pte Ltd www.bateyredcell.com.sg
28 Ann Siang Road, Singapore, 169708 | Tel 65 6322 0338 | Fax 65 6224 1663

BBDO Detroit www.bbdodetroit.co
880 W. Long Lake Road Troy, MI, United States | Tel 248 293 3996 | Fax 248 293 3888

BBK Studio www.bbkstudio.com
648 Monroe Ave NW Suite 212, Grand Rapids, MI 49503, United States
Tel 616 459 4444

Cahan & Associates www.cahanassociates.com
171 Second Street, 5th Floor, San Francisco, CA 94105, United States | Tel 415 621 0915

Calibre Design & Marketing Group www.calibredesign.com
19 Duncan Street, Suite 503, Toronto, ON M5H 3H1, Canada
Tel 416 703 1062 | Fax 416 703 6235

Carmichael Lynch Thorburn www.clthorburn.com
800 Hennepin Avenue, Minneapolis, MN 55403, United States | Tel: 612-334-6000

Communications for Learning www.communicationsforlearning.com
395 Massachusetts Avenue, Arlington, MA 02474, United States
Tel 781 641 2350 | Fax 781 646 9873

Concrete Design Communications Inc. www.concrete.ca
2 Silver Avenue Toronto, Ontario M6R 3A2, Canada
Tel 416 534 9960 | Fax 416 534 2184

Corporate Grafix www.corporategrafix.com
4040 Aurora Street Coral Gables, FL 33146, United States
Tel 305 447 9820 | Fax 305 447 9860

Crate&Barrel www.crateandbarrel.com
1250 Techny Road Northbrook, IL 60062, United States | Tel 847 239 6083

David Carter Design www.dcadesign.com
4112 Swiss Avenue Dallas, TX 75204, United States
Tel 214 826 4631 | Fax 214 827 1938

Decker Design www.deckerdesign.com
14 W. 23rd Street New York, NY 10010, United States
Tel 212 633 8588 | Fax 212 633 8599

Desgrippes Gobé www.dga.com
411 Lafayette Street, New York, NY, United States
Tel 212 979 8900 | Fax 212 979 1404

Design Army www.designarmy.com
1312 9th Street, NW, #200, Washington, DC 20001, United States
Tel 202 797 1018 | Fax 202 478 1807

Designbolaget www.designbolaget.dk
Ryesgade 3f, 2. sal Copenhagen N, 2200, Denmark | Tel +45 26838715

Draftfcb San Francisco www.draftfcb.com
1160 Battery Street, Suite 250 San Francisco, CA 94111, United States
Tel 415 820 8000 | Fax 415 820 8087

Equus Design Consultants Pte Ltd www.equus-design.com
8B Murray Terrace Singapore 079522 | Tel +65 6323 2996 | Fax +65 6323 2991

emerystudio www.emerystudio.com
80 Market Street Southbank, Victoria, Australia
 Tel 61 3 9699 3822 | Fax 61 3 9690 7371

Factor Design, Inc. www.factordesign.com
580 Howard Street, Suite 303, San Francisco, CA 94105, United States
Tel 415-896-6051 | Fax 415-896-6053

Ferreira Design Company www.ferreiradesign.com
335 Stevens Creek Court Alpharetta, GA 30005, United States | Tel 678 297 1903

Fitzgerald + Co www.fitzco.com
3060 Peachtree Road NW Suite 300, Atlanta, GA 30305, United States | Tel 404 504 6900

Frost Design www.frostdesign.com.au
Level 1, 15 Foster Street Surry Hills, NSW, Australia
Tel +61 2 9280 4233 | Fax +61 2 9280 4266

FutureBrand www.futurebrand.com
300 Park Avenue South, 5th Floor, New York, NY 10010, United States
Tel 212 931 6300 | Fax 212 931 6601

Geyrhalter Design www.geyrhalter.com
2525 Main Street Suite 205, Santa Monica, CA 90405, United States
Tel 310 392 7615 | Fax 310 396 0096

Grady Campbell www.gradycampbell.com
900 N. Franklin Avenue, Suite 310, Chicago, IL 60610, United States
Tel 312 642 6511 | Fax 312 642 6511

Hambly&Woolley Inc. www.hamblywoolley.com
49 Bathurst Street, #400 Toronto, Ontario, Canada, M5V 2P2
Tel 416 504 2742 | Fax 416 504 2745

Hans Heinrich Sures
23 Barrington Road Crouch End, London, N8 8QT, United Kingdom
Tel +44 (0) 208 348 0995 | Fax +44 (0) 208 348 0995

HAS Design AG www.hasdesign.ch
Baselstrasse 15 CH-41215, Riehen, Switzerland
Tel 0041 (0)61 691 88 44 | Fax 0041 (0)61 691 88 43

HSR Business to Business www.hsrb2b.com
300 E-Business Way Suite 500, Cincinnati OH, 45241, United States
Tel 513-671-3811 | Fax 513-671-8163

ico Design Consultancy www.icodesign.co.uk
75-77 Great Portland Street, London, W1W 7LR, United Kingdom
Tel 020 7323 1088 | Fax 020 7323 1245

Inaria www.inaria-design.com
10 Plato Place 72-74 St Dionis Road, London, SW6 4TU, United Kingdom
Tel 020 7384 0905 | Fax 020 7751 0305

ken-tsai lee design studio
17# 31 Lane 49 Alley Chung Cheng Street, Peitou, Taipei 112, Taiwan, Province of China
Tel 886-2-28935236 | Fax 886-2-87803659

Kolegram www.kolegram.com
37 St. Joseph Boulevard Gatineau, Québec J8Y 3V8, Canada
Tel 819 777 5538 | Fax 819 777 8525

Kuhlmann Leavitt, Inc. www.kuhlmannleavitt.com
7810 Forsyth Boulevard, 2W St. Louis, MO 63105, United States
Tel 314 725 6616 | Fax 314 725 6618

Larsen Design+Interactive www.larsen.com
7101 York Avenue South Minneapolis, MN 55435, United States
Tel 952 835 2271 | Fax 952 921 3368

Lemon Design GmbH&Co KG www.lemon.de
Lorentzedamm 15, 24103 Kiel, Germany | Tel 0431 660 90 0 | Fax 0431 67 40 01

Leo Burnett www.leoburnett.com
35 W. Wacker Drive, Chicago, IL 60601, United States | Tel 312 220 5959 | Fax 312 220 3299

Leslie Chan Design Co Ltd
4 Floor 115 Nanjing East Road Section 4, Taipei, 105, Taiwan, Province Of China
Tel +886 2 2545 5435 #118 | Fax+886 2 27151630

Liska + Associates, Inc. www.liska.com
515 North State Street, 23rd Floor, Chicago, IL 60610, United States
Tel 312 644 4400 | Fax 312 644 9650

Look www.lookdesign.com.au
1594 Laurel Street, San Carlos, CA 94070, United States
Tel 650 595 8089 | Fax 650 595 1408

Matsumoto Incorporated www.matsumotoinc.com
127 West 26th Street, 9th Floor, New York, NY 10001, United States
Tel (212) 807-0248 | Fax (212) 807-1527

McMillan
541 Sussex Drive, Ottawa, Ontario KIN626, Canada
Tel 613 789 1234 | Fax 613 789 2255

Moses Media www.mosesmedia.com
584 Broadway Suite 607, New York, NY 10012, United States
Tel 212 625 0331 | Fax 212 625 0332

Muller+Company www.mullerco.com
4739 Belleview, Kansas City, MO 64112, United States | Tel 816 531 1992 | Fax 816 531 6692

Mytton Williams www.myttonwilliams.co.uk
15 St. James's Parade Bath BA1 1UL, England | Tel +44 (0)1225 442634 | Fax +44 (0)1225 442639

NB Studio www.nbstudio.co.uk
4-8 Emerson Street, London SE1 9DU, United Kingdom | Tel 020 7633 9046 | Fax 020 7580 9196

NDW www. ndwc.com
100 Tournament Drive, Suite 214, Horsham, PA 19044, United States
Tel 215 957 9871 | Fax 215 957 9872

Osamu Misawa Design Room Co.,Ltd. www.omdr.co.jp
#413, 5-4-35,minamiaoyama,minato-ku, Tokyo 107 0062, Japan
Tel +81 3 5766 3410 | Fax +81 3 5766 3411

Pentagram Design NY www.pentagram.com
204 Fifth Avenue, New York, NY 10010, United States
Tel 212 683 7000 | Fax 212 532 0181

Pentagram SF www.pentagram.com
387 Tehama Street, San Francisco, CA 94103, United States
Tel 415 896 0499 | Fax 415 541 9106

Pivot Design www.pivotdesign.com
230 W. Huron, 4th Floor, Chicago, IL 60610 | Tel 312 787 7707 | Fax 312 787 7737

Planet Propaganda www.planetpropaganda.com
605 Williamson Street Madison, WI 53703 | Tel 608 256 0000 | Fax 608 256 1975

Poulin + Morris Inc. www.poulinmorris.com
286 Spring Street, Sixth Floor, New York, NY 10013, United States
Tel 212 675 1332 | Fax 212 675 3027

RBMM www.rbmm.com
7007 Twin Hills, Suite 200, Dallas, TX 75231-5184, United States
Tel 214 987 6500 | Fax 214 987 3662

Regina Rubino / IMAGE: Global Vision www.imageglobalvision.com
2525 Main Street, Suite 204, Santa Monica, CA 90405, United States
Tel 310 998 8898 | Fax 310 396 1686

Rigsby Hull www.rigsbyhull.com
2309 University Boulevard, Houston, TX 77005-2641, United States
Tel 713 660 6057 | Fax 713 660 8514

Riordon Design www.riordondesign.com
131 George Street, Oakville, Ontario L6J3B9, Canada | Tel 905 339 0750

Ross Creative + Strategy www.rosscps.com
4th Floor, 305 SW Water Street Peoria, IL 61602, United States | Tel 309 680 4143

Rubin Postaer & Associates www.rpa.com
2525 Colorado Avenue, Santa Monica, CA, United States | Tel 310 394 4000

Samantha Szocinski www.samantic.net.au
3/24 Ashbrook Avenue, Payneham, Adelaide, South Australia, Australia | Tel 04 0244 8666

SamataMason www.samatamason.com
101 South First Street West, Dundee, IL 60118, United States
Tel 847 428 8600 | Fax 847 428 6564

Sandstrom Design www.sandstromdesign.com
808 SW 3rd Avenue, Ste 610, Portland, OR 97204, United States
Tel 503 248 9466 | Fax 503 227 5035

Sasha Vidakovic Design www.svidesign.com
Westbourne Studios 126, 242 Acklam Road, London W10 5JJ, United Kingdom
Tel +44 (0)20 7524 7808

Sauce Design www.saucedesign.com
160 Bloor Street East, Toronto, ON, M4W 3P7, Canada | Tel 416 926 7300

Sibley Peteet Design (Dallas) www.spddallas.com
3232 McKinney Avenue, Suite 1200, Dallas, TX 75204, United States
Tel 214 969 1050 | Fax 214 969 7585

Sieger Design GmbH & Co. KG www.sieger-design.com
Scholoss Harkotten, Sassenberg, Germany | Tel +49 54 26/94 92-22 | Fax +49 54 26/94 92-39

Sonner, Vallée u. Partner www.sonnervallee.de
Eduard-Schmid-Str. 2, 81541 Muenchen, Germany | Tel +49 (0) 89 767768 3

Squires & Company www.squirescompany.com
2913 Canton Street, Dallas, TX 75226, United States | Tel 214 939 9194 | Fax 214 939 3464

Stoyan Design www.stoyandesign.com
2482 Newport Boulevard, Suite 8, Costa Mesa, CA 92627, United States
Tel 949 631 6314 | Fax 949 631 2548

Studio Lupi
Via Vigevano 39, 20144 Milan, Italy | Tel +39 02 89403950 | Fax +39 02 89404042

Studio Rasic www.studio-rasic.hr
Meduliceva 1, Zagreb, 10 000, Croatia | Tel +38514847224 | Fax +38514847224

studio von birken www.studiovonbirken.com
475 Kent Avenue, Suite 607, Brooklyn, NY 11211 | Tel 718 782 6969 | Fax 718 782 6969

Sullivan Higdon & Sink www.wehatesheep.com
255 N Mead Street, Wichita, KS 67202, United States | Tel 316 263 0124

Sutton Cooper
7 King William IV Gardens, Penge, London SE20 7EG, United Kingdom
Tel 0208 776 8101 | Fax 0208 659 6692

Sweet Design www.sweetdesign.com.au
212 S. Kilda Road, Melbourne VIC 3182, Australia | Tel +61 3 9525 4400 | Fax +61 3 9525 4411

Tangram Strategic Design s.r.l. www.tangramsd.it
Viale Michelangelo Buonarroti 10B, 28100 Novara, Italy
Tel +39 0321 35 662 | Fax +39 0321 390 914

The Designory www.designory.com
211 East Ocean Boulevard Ste. 100, Long Beach, CA 90802, United States
Tel 562 624 0200 | Fax 562 432 3518

Thomas Manss & Company www.manss.com
3 Nile Street, London N1 7LX, United Kingdom | Tel +44 20 72517777 | Fax +44 20 72517778

thompsondesign
466 Lexington Avenue, 2nd Floor, New York, NY 10017, United States
Tel 212 210 6081 | Fax 212 210 7388

Time Marketing www.time.com
1271 Avenue of the Americas, New York, NY 10020, United States

Together Design www.togetherdesign.co.uk
106 Cleveland Street, London, W1T 6NX, United Kingdom | Tel +44 (0) 20 7387 7755

TOKY Branding+Design www.toky.com
3139 Olive Street, St. Louis, MO 63103, United States | Tel 314 534 2000 | Fax 314 534 2001

Turner & Duckworth (London) www.turnerduckworth.com
Voysey House, Barley Mow Passage, London W4 4PH, United Kingdom
Tel 020 8994 7190 | Fax 020 8994 7192

Turner & Duckworth (San Francisco) www.turnerduckworth.com
831 Montgomery Street, San Francisco, CA 94133, United States
Tel 415 675 7777 | Fax 415 675 7778

Vanderbyl Design www.vanderbyl.com
171 2nd Street, 2nd Floor, San Francisco, CA 94105, United States
Tel 415 543 8447 | Fax 415 543 9058

Vic Huber www.vichuber.com
1731 Reynolds Avenue, Irvine, CA 92614, United States | Tel 949 261 5844 | Fax 949 261 5973

visucom www.visucom.com
Winkelgasse 2, CH-39 Brig, VS, Switzerland | Tel 0041279221640 | Fax 0041279221641

Viva Dolan Communications and Design Inc. www.vivadolan.com
99 Crown's Lane Suite 500, Toronto, Canada M5R 3P4 | Tel 416 923 6355 | Fax 416 923 8136

Weymouth Design (CA) www.weymouthdesign.com
600 Townsend Street Suite 320 East, San Francisco, CA 94103, United States
Tel 415 487 7900 | Fax 415 431 7200

Weymouth Design (MA) www.weymouthdesign.com
332 Congress Street, Boston, MA 02210, United States | Tel 617 542 2647 | Fax 617 451 6233

ZIBA Design, Inc. www.ziba.com
334 NW 11th Avenue, Portland, OR 97209, United States | Tel 503 223 9606 | Fax 503 223 9785

Graphis Standing Orders (50% off):

Get 50% off the list price on new Graphis books when you sign up for a Standing Order on any of our periodical books (annuals or bi-annuals).
A Standing Order is a subscription to Graphis books with a 2 year commitment. Secure your copy of the latest Graphis titles, with our best deal, today online at *www.graphis.com*.
Click on Annuals, and add your selections to your Standing Order list, and save 50%.

Graphis Titles

DesignAnnual2008

Spring 2007
Hardcover: 256 pages
300 plus color illustrations

Trim: 8.5 x 11.75"
ISBN: 1-932026-43-6
US $70

GraphisDesignAnnual2008 is the definitive Design exhibition, featuring the year's most outstanding work in a variety of disciplines. Featured categories include Books, Brochures, Corporate Identity, Interactive, Letterhead, Signage, Stamps, Typography and more! All winners have earned the new Graphis Gold and/or Platinum Awards for excellence. Case studies of Platinum winning artists and their work complete the book.

Brochures6

Fall 2007
Hardcover: 256 pages
300 plus color illustrations

Trim: 8.5 x 11.75"
ISBN: 1-932026-48-7
US $70

GraphisBrochures6 demonstrates the potency of the brochure medium with close ups, reproductions of covers and inside spreads from the award winners. Each of these outstanding brochures has earned a Graphis Gold and/or Platinum Award for excellence. Case studies of a few, carefully selected Platinum winning artists and their work complete the book. The sixth volume of this popular series also features an index of firms, creative contributors and clients.

AdvertisingAnnual2008

Fall 2007
Hardcover: 256 pages
300 plus color illustrations

Trim: 8.5 x 11.75"
ISBN:1-932026-44-4
US $70

GraphisAdvertisingAnnual2008 showcases over 300 single ads and campaigns, from trade categories as varied as Automotive, Film, Financial Services, Music, Software and Travel. All have earned the new Graphis Gold Award for excellence, and some outstanding entries have earned the Graphis Platinum Award. This year's edition also includes case studies of a few Platinum-winning Advertisements. This is a must-have for anyone in the industry.

PosterAnnual2007

Summer 2007
Hardcover: 256 pages
200 plus color illustrations

Trim: 8.5 x 11.75"
ISBN: 1-932026-40-1
US $70

GraphisPosterAnnual2007 features the finest Poster designs of the last year, selected from thousands of international entries. These award winning Posters, produced for a variety of corporate and social causes, illustrate the power and potential of this forceful visual medium. This year's edition includes interviews with famed Japanese Designer **Shin Matsunaga**, **Marksteen Adamson** of Britain's ASHA and Swiss Poster Curator **Felix Studinka**.

PhotographyAnnual2007

Winter 2006
Hardcover: 240 pages
200 plus color illustrations

Trim: 8.5 x 11.75"
ISBN: 1-932026-39-8
US $70

GraphisPhotographyAnnual2007 is a moving collection of the year's best photographs. Shot by some of the world's most respected artists, these beautiful images are organized by category for easy referencing. This book includes interviews with *Albert Watson* on his latest work, "Shot in Vegas," *Joel Meyerowitz* on the dramatic September 11th recovery series, **Aftermath**, and **Paolo Ventura** on his recently released and haunting **War Souvenir** series.

AnnualReports2006

Spring 2006
Hardcover: 224 pages
200 plus color illustrations

Trim: 8.5 x 11.75"
ISBN: 1-932026-24-X
US $70

GraphisAnnualReports2006 presents 34 outstanding reports, selected for excellence in Design and clear expression of the client's message. Insightful essays by Designers and judges **Steve Frykholm, Delphine Hirasuna, John Klotnia, Douglas Oliver** and **Gilmar Wendt** on the role of AR Design in the current corporate climate make this a must have for anyone involved in this demanding medium. Detailed credits and indices complete this annual.